Gender Issues in Art Therapy

Gender Issues in Art Therapy

Edited by Susan Hogan

Foreword by Diane Waller

Jessica Kingsley Publishers
London and Philadelphia

First published in the United Kingdom in 2003
by Jessica Kingsley Publishers
116 Pentonville Road
London N1 9JB, UK
and
400 Market Street, Suite 400
Philadelphia, PA 19106, USA

www.jkp.com

Library of Congress Cataloging in Publication Data
Gender issues in art therapy / edited by Susan Hogan.
 p.cm.
Includes index.
ISBN 1-85302-798-7 (alk paper)
 1. Art therapy. 2. Sex role--Psychological aspects. I. Hogan, Susan.

RC489.A7 G46 2002
615.8'5156--dc21 2002021519

ISBN 978 1 85302 798 7

to Emile Hanif

Contents

List of Illustrations

Foreword

While reading the manuscript for this inspiring book, I was reminded of an incident which took place several years ago whilst I was organising student art therapy placements. I had been approached by a consultant physician from a well-known hospital in London for an art therapy placement with terminally ill clients. This being a particularly specialised and challenging area of work, I carefully consulted and asked for expressions of interest from students with relevant work and life experience. A well-qualified person asked to be considered, a man in his early 40s. I arranged a meeting with the consultant and the student through the consultant's secretary. On the morning following the meeting, the consultant phoned me, quite angrily, saying: 'I thought you'd be sending a woman!' Taken aback, I replied: 'I have sent you the best qualified person – is there a problem? Art therapists are also men!' He retorted that 'his ladies' would not want a man…'it would not go down well'. I am not sure if the clients, or the staff, had been asked, and if this was indeed their sentiment, but in any case exploration of the matter was impossible and I did not feel inclined to take the placement idea further at that time. I felt dismayed – and so did the male student – at such summary rejection on the basis of gender. Apparently the consultant was unwilling to countenance a male student, and had not wished to enter into discussion with him, so that had to be accepted. But I suppose it should not have come as such a surprise, because the 'caring professions', of which therapy is one, are composed mainly of women. However, they may be female dominated in terms of the workforce but have not until recently, with a few exceptions, been female managed nor led.

Art therapy in the UK is composed of roughly 70 per cent women and 30 per cent men, creeping up to 90 per cent women elsewhere and in some southern European countries, to 95 per cent women. This means that the majority of male and female clients will receive art therapy from a

woman. Likewise, the majority of gay or bisexual clients are likely to receive therapy from a heterosexual therapist (and this also applies to verbal psychotherapy). Furthermore, the majority of black clients will receive therapy from a white therapist, and the majority of elderly clients (over 65 and with dementia in particular) will not receive therapy at all.

Most clients within the public health and social care services will not get a choice as to the race, gender or sexual orientation of their therapist. And it has to be added, most will not get a choice of treatment and it will be quite unusual for them to be offered art therapy at all. These issues are hardly 'unproblematic'. Indeed, they require urgent analysis from a political, cultural and social standpoint.

Susan Hogan's book, made up as it is of contributions from authors who have been grappling with issues surrounding their own identity, as male or female, bisexual, heterosexual, homosexual, transsexual, black or white, challenges assumptions which, if remaining unconscious or unexplored, can have significant effects on the care and treatment of vulnerable clients.

Her previous book, *Feminist Approaches to Art Therapy*, began to address the social construction of gender and of therapy and drew attention to the frequent pathologizing of behaviour which appears to transgress social norms. This book extends the challenge, and demonstrates that there is a movement by a number of art therapists to contest the use of psychological models which, in Susan Hogan's own words, 'do not sufficiently address the socially constructed nature of individual distress' (p.2).

It is a valuable and timely contribution to our profession and discipline.

Professor Diane Waller
Professor of Art Therapy, Goldsmiths College, University of London:
Chair of the Education and Training Committee of the Health Professions Council

Bibliography
Hogan, S. (1997) Feminist Approaches to Art Therapy. London: Routledge.

Introduction: Contesting Identities

Susan Hogan

Why gender?

Sitting in Edinburgh buses with my newborn baby on my lap, I am asked by fellow travellers, 'Is it a boy or a girl?' Not until the sex of the infant is established can dialogue ensue. Sometimes one of the bus's inhabitants would hazard a guess – 'He's a bonny wee bairn' – and then look at me hopefully for confirmation that they had guessed the sex correctly. Often they would apologise if they had got the sex wrong. It was not just a structural linguistic problem of which singular pronoun to use, 'he' or 'she'; it was more complex than that. The sex determined the appropriate adjectives to be used in the description of the baby's behaviour. These were gendered exchanges: socially sanctioned and accepted ways of responding to a male or female infant. So 'gender' (for the purposes of my initial discussion) is the culture generated in conjunction with the body which constitutes basic rules of social exchange, and it kicks in from the word go, as my Edinburgh bus journeys confirmed.

Gender is of central importance to our social organisation. The kind of social organisation we have determines the sorts of ideas which are formulated about gender and gender difference. As I have illustrated, utterances cannot be made without deference to gender norms – without knowledge of biological sex we do not know how to start to respond in a simple social exchange.

Therapy and gender blindness

The importance of gender difference has been highlighted by many writers who have sought to illustrate how ideas about masculinity and femininity are linked to institutional norms and practices which are in a constant state of flux and reconstruction, rather than being fixed and *a priori* (Hogan 1997). This challenge to the idea of masculinity and femininity as immutable and part of 'human nature' has been very useful in allowing feminist writers to highlight how *biological arguments about 'natural' difference have been used to justify particular gendered practices and conventions (which often incorporate aspects of inequality and oppression).* This emphasis on the constructed nature of the self has also allowed many feminist writers (Howell and Bayes 1981; Russell 1995; Showalter 1987; Ussher 1992, 1997) to explore how dominant representations of 'femininity' are pathologised through institutional practices and discourses. Such ideas are clearly of relevance to practising therapists.

As art therapists we are very well placed to enable a multi-faceted exploration of self. This is not merely a theoretical exploration. Representations of gender position and limit the individual, playing a vital role in determining our subjective reality. That is why as therapists we must be concerned with gender. As I have previously noted (Hogan 1997), such representations have a demonstrable and profound effect on the kind of treatment we may be offered or forced into having against our will (e.g. electroconvulsive therapy (ECT) or psychotherapy, drugs rather than counselling, inpatient or outpatient care) and the diagnostic category into which we are placed. There is nothing abstract about the notion of 'discourse', as Jo Spence revealed (1996, p.92):

> I think it was when I was ill that I understood for the first time what it was to be a victim... I was in a discourse, a medical discourse, and I hadn't understood what a discourse was before. Here I was on a production line, as the kind of fodder passing along between doctors and consultants. That was the beginning of it. I began to see how they constructed a world view through the way they worked and what I wanted was irrelevant really...

Literature on gender and art therapy

Two texts on art therapy, *Feminist Approaches to Art Therapy* edited by Hogan (1997) and *Art Therapy, Race and Culture* edited by Campbell *et al.* (1999), are the most detailed attempts to date within British art therapy literature to examine the social construction of distress, especially with reference to race and gender. *Feminist Approaches to Art Therapy* is a varied collection of essays illustrating a range of opinion. Collectively the essays represent a broad cross-section of views; however, a uniting factor is that all of the contributors are keen to avoid the use of reductive and universally applied dogmatic psychological models which do not sufficiently address the socially constructed nature of individual distress. *Feminist Approaches* constitutes a challenge, therefore, to an over-reliance on reductive theory; it emphasises complexity in how femininity is constructed, experienced, institutionalised and linked to notions of madness. Another art therapy text which is relevant is *Tapestry of Cultural Issues in Art Therapy* edited by Hiscox and Calisch (1998), which looks at the experience of different cultural groups. *Gender Issues in Art Therapy* is an attempt to extend the debate further. The collection of essays reflects the varied facets of this theme, comprising a mixture of personal (and introspective), case study and theoretical material. The uniting theme of the essays is the emphasis on gender as an important principle of social regulation and social identity, and the importance of acknowledging this within art therapy practice.

Theorising sexual difference and gender

> ...the notion of 'sex' made it possible to group together, in an artificial unity, anatomical elements, biological functions, conducts, sensations and pleasures, and it enabled one to make use of this fictitious unity as a casual principle, an omnipresent meaning; sex was thus able to function as a unique signifier and as a universal signified. (Foucault 1978, p.154)

My interest, as an art therapist, is to develop a critical practice: a space for critical reflection and personal action. However, having decided to use the difficult term 'gender' in the title of this book, I now feel obliged to interrogate this problematic term. Readers not particularly interested in

theory will not be greatly disadvantaged in passing over this section as contributors explain their interest in the term gender.

The historically and culturally contingent nature of embodiment has been highlighted by many authors (Fox 1999; Lupton 1994; Scott and Morgan 1993; Shilling 1993; Turner 1984, 1992). The *meanings* ascribed to sexual differences are culturally determined in complex ways.

Cornwall and Lindisfarne (1994, pp.9–10) suggest that terms such as 'gender role', 'sexual orientation', and 'biological sex' have little explanatory value since they imply a false dichotomy between the sexed body and the gendered body:

> Though this biological social opposition has been the basis of most studies of gender, we insist that both the sexed body and the gendered individual are culturally constructed and that biology is no more primary or 'real' than any other aspect of lived experience.

None of us can step completely outside of our culture; all we can hope to do is comprehend it more critically. Our bodies are 'encultured' – subject to gender norms, and institutional practices, or 'gender culture', as Ramet (1996) puts it. It is surprisingly difficult to distinguish between what is innate and what is culturally determined (hence the problem with any essentialist argument and with the emerging discipline of evolutionary psychology). Indeed, I would argue that it is almost impossible to distinguish between what is innate and what is culturally determined. Can physical pain, for example, which we would suppose to be a brute fact, be said to be experienced in the same way across cultures? Surely pain is pain and we all experience it in the same way? However, having watched protagonists, supposedly in a state of bliss, their flesh pierced through with metal rods, processing through the streets of Singapore during religious festivals, I have been left believing that *basic physical experiences are in fact culturally mediated in the way that they are individually experienced* (see my chapter for more on this topic).

The constructed nature of gender difference has been highlighted and consequently the naturalness of some of our most important social institutions has been brought into question. Andrea Dworkin (1974), for example, was one of the first feminists to have described heterosexuality as a 'ritualised behaviour' supported by a myriad of social institutions,

though frequently viewed as 'human nature' (Dworkin 1974, p.112). Judith Butler (1990), drawing on the work of Linda Nochlin amongst others, goes further to suggest that the very notions of 'men' and 'women' act as oppressive binaries and should be viewed as 'regulative ideas which produce inequalities'. She argues that gender should not be viewed as stable or the locus of agency from which acts follow; rather, she suggests that gender be viewed as tenuous and established through 'a stylised repetition of acts' (Butler 1990, p.140).

Echoing Dworkin's work, Butler (1993) emphasises the 'performidity' [sic] of gender. Sex not only functions as a norm, 'but is part of a regulatory practice that produces the bodies it governs'. Her notion of 'performidity' is not a singular deliberate act but a 'reiterative practice'. Her notion of 'inequalities' (in the above quotation) is not just the usual one associated with gender difference (such as overt discrimination); rather, she is referring to symbolic legitimacy and intelligibility. Her point is to do with what it is possible to enact and conceptualise (Butler 1993, p.xi–xii). My experience on the Edinburgh bus with my baby being identified as a girl was 'at once the setting of a boundary, and also the [beginning of a] repeated inculcation of a norm' (Butler 1993, p.7).

Penelope Deutscher (1997) argues that the significance of Judith Butler's work is to allow a cultural construction of gender which no longer sees 'biological sex' as a *tabula rasa* to be inscribed by culture. While sex appeared to be the cause and gender behaviour the effect, she was to suggest that the very priorness or pre-cultural (or pre-discursive) nature of the body was the effect of the cultural conventions of gender.

Regulating gender: Sexuality and the institutionalisation of heterosexuality
Many writers on gender are interested in exploring the subject of desire in relation to the idea of 'discourses', in the Foucauldian sense, which are 'orders of knowledge' and 'regimes of power'. These are constitutive elements in the formation of different forms of subjectivity and social practices. Some writers on gender concentrate on desire in relation to the institutionalisation of heterosexuality, pointing out that sex is often defined in phallocentric terms, which position men as sexual subjects and women as sexual objects.

Attempts in the literature on gender to problematise heterosexuality, or to 'denaturalise heterosexual society' (to use Diane Richardson's 1996 phrase), have stemmed both from the gay and lesbian 'lobby', in their attempt to challenge a sense of cultural and spatial exclusion, and also from those interested in women's rights who have observed that hetero-sexuality as an institution is founded upon gender hierarchy: 'men's appropriation of women's bodies and labour underpins the marriage contract' (Delphy and Leonard 1992, cited Jackson 1996, p.30). This is obvious when one remembers that the idea of 'marital rape', under British law, is a very recent concept.

The idea of sexual harassment (promoted by Catharine MacKinnon and others) has not proved effective as an instrument for achieving equality and freedom from unequal opportunity. However, it has proved useful in highlighting the way in which gender norms are regulated by gendered institutional practices which include a range of intimidatory male behaviours. MacKinnon has described her work as concerned with 'seeing violence against women as an issue of sex equality, seeing women's rights as human rights' (MacKinnon in interview with Hodges 1996, p.150). Guillaumin (1981) has pointed out that women not visibly under the protection of a man are at risk. As Stevi Jackson (1996), sum-marising the work of Bartky (1990), puts it:

> Fear of sexual violence and harassment is also one means by which women are policed and police themselves through a range of disci-plinary practices: for example, restricting their own access to public space, where they choose to sit on a bus or train, how they sit and who they avoid eye contact with. (Jackson 1996, p.30)

Compelling support for Dworkin's position on the subject of penetration can be found in the ethnographic work of Peter Loizos (1994) who, in an essay on masculinity in Greece, found that the idea of penetration was linked quite explicitly to an assumption of obedience which could apply to men or women. However, Loizos concentrates on penetration by force as a means of degrading and humiliating, so his argument cannot be generalised to penetration *per se*. He concludes:

> In the context of interpersonal relations, to be dominant man can imply the use of force to subdue or discipline someone else, and

neither the other person's gender, nor the physical weapon (a penis, a fist) need to be distinguished. (Loizos 1994, p.73)

In the light of Loizos's research, Sheila Jeffreys' (1990) definition of heterosexuality is therefore a very interesting one. She defines heterosexuality as all practices which eroticise power, whatever the sex of those engaged in them! Stevi Jackson (1996) concurs with this point insofar as she perceives within lesbian and gay cultures a tendency to duplicate heterosexual norms: 'Even those who do not practice sado-masochism or take on butch and femme identities may find the cultural opposition between active/dominant and passive/subordinate sexuality intruding into their fantasies' (Jackson 1996, p.24). (This subject has been explored in detail in relation to art therapy by Hogan 1997, pp.21–37.)

Regarding the institutionalisation of heterosexuality, Stevi Jackson (1996), drawing on the work of Holland *et al.* (1994), suggests that women embrace a model of sexuality which prioritises male desires and the giving of pleasure. While suggesting that penetrative sex can be seen as more than 'merely eroticised submission', Jackson is nevertheless very negative: 'Whatever discourses we produce, whatever fantasies we have, they offer us no protection against the coercive power of the penis enacted as rape' (Jackson 1996, p.35). There is undoubtedly an '*institutionalization* of penile penetration under heteropatriarchy' (to use Kitzinger and Wilkinson's 1993 phrase), and penalties for transgressing gender norms can be very real.

Of course, as I illustrated earlier in the introduction, it is not just fear and intimidation which regulate gender; we are inculcated with knowledge about gender expectations. Gender is at the heart of our self-understanding.

So where does this leave us on the topic of desire? Certainly some people have sought to define their personalities in terms of their sexuality. This has been described by Richard Sennett (1981) as the 'idea of having an identity composed of one's sexuality', a view Sennett finds disturbing in its determinism (Foucault and Sennett 1981, p.167). However, David Forrest's (1994) idea of the homosexual community having a 'community status' provides a plausible explanation for such self-identification.

As noted above, the constitutive effects of power in creating desire is a topic addressed by many writers on gender. If we accept the idea that the

gendered body is both individual and a social symbol (it functions as a metaphor for society), then practices which construct gender, such as pornography as a vast industry, must be relevant. I am here using Catharine MacKinnon's definition of pornography as the 'graphic sexually explicit subordination of women through pictures and/or words' (MacKinnon 1993, p.22). Indeed, the forces shaping gender are exceedingly complex, as complex as the societies we inhabit; I am reluctant to lapse into what might be interpreted as a reductive deterministic stance here. However, as MacKinnon has suggested in *Only Words* (1993), the fact that certain acts are played out in pornography not only degrades women and reinforces a certain set of power relations in which women are subjugated, and this subjugation is erotic, it also provides men with models of violent sexual activity which they can live out (MacKinnon in interview with Hodges 1996, p.150). We must remember that there are massive commercial interests intent upon denying the persuasive amounts of anecdotal evidence which link pornography with violence against women (such as rapists admitting that they used pornography to arouse themselves prior to committing rape). MacKinnon's point that *pornography creates a certain consciousness which is then carried into other spheres, including non-pornographic sexual relations* is very persuasive.

The key point here is that pornography provides images of subjugation which are eroticised. This 'objectification' of women, as it has been referred to by MacKinnon and others, has therefore received considerable attention in writing on gender and the construction and maintenance of gender differences.

An extremist view on the question of objectification is put forward by Dworkin (1987), who wrote:

> ...who needs to be needed as an object; who needs to be entered; who needs to be occupied; who needs to be wanted more than she needs integrity?... The brilliance of objectification as a strategy of dominance is that it gets the woman to take the initiative in her own degradation... It is the best system of colonisation on earth. (Dworkin 1987, p.142)

As I have pointed out in previous work (Hogan 1997), the body is a hotly contested site of meaning, so it is hardly surprising that many women, in particular, experience ambivalence about their bodies, or in more extreme

cases act upon their body (through starvation, acts of mutilation etc.). As therapists we must be keenly aware of the complexity of discourses surrounding the body and view our clients' actions in the light of these and not merely as individual pathology.

Disruption to gender expectations can be extremely disturbing. To take the example of homosexuality, we must remember that homosexual practices carry the death penalty in some regimes. In Britain homosexuality was regarded as a mental illness by some psychiatrists until very recently. Homosexuality was only declassified as a mental illness in the International Classification of Diseases (ICD) in the 1992 edition. As Davies and Neal (1996, p.16) point out, some analytic associations still regard homosexuality as a sickness. The example of homosexuality illustrates how the disruption to gender categories can provoke extreme reactions.

Your body is a battleground

Regarding the subject of race in relation to gender, Avtar Brah (1996, p.156) complains that many studies of racism remain oblivious to the centrality of gender and sexuality in the construction of racism. She writes: '... racism is always a gendered and sexualised [sic] phenomenon'. The idea of 'race', she argues, is 'an *essentialist narrative of sexualised difference*'.

The notion of the body as the point for the interplay of ideological fields has been described by Deleuze and Guattari (1988, 1994) as a 'body without organs' (BwO). The body is seen as a philosophical surface upon which ideological determinants are realized. The BwO is the site of potential domination as well as a site of resistance.

Nick Fox is at pains to emphasise that in Deleuze and Guattari's work the subject is not viewed as passive: 'the process of inscribing subjectivity is not a passive process, but a dynamic "reading" of the social by an active sense making being' (Fox 1999, p.145). Using these ideas, 'I' can be understood as a 'complicated field of competing subjectivities and competing identities' (Moore 1994, p.26).

The lure of an existence without limits

The notion of fragmented, unstable, fractured identities which are in a constant state of flux and reconstruction means that we can no longer assume that other lesbians, homosexuals, men or women are experiencing the same thing. Deutscher (1997), summarising the work of Sedgwick (1990), makes the point that some transsexuals, for example, might identify themselves in the space 'between genders'. Or, alternatively, that 'queer' could refer to a woman who has sexual relations with a man 'as' a gay man. Furthermore, it is possible that a gay, sadomasochistically-orientated man might have 'more in common' with a sadomasochistically-orientated heterosexual woman than with a non-sadomasochistically-orientated gay man, lesbian-identified man or lesbians who sleep with men (Deutscher 1997, p.12).

Martin (1993) points to the 'greater mobility' of our desires identified in some 'queer theory'. In his view gender can become 'voluntary and fictional in the strongest sense' (Martin 1993, p.122). Whilst it is obvious that some people are playing with gender in their lifestyles (for example, the macho, leather-clad hunk sporting the 'keep your hands off my uterus – faggots' T-shirt), the people we are likely to meet in the therapeutic encounter may feel less at ease about such experimentation.

Whilst I would strongly encourage therapists not to lapse into an impotent nihilism in which the power of discourse cannot be challenged, one must also be aware of the difficulties involved. As Sedgwick (1990) has noted of dominant discourses: 'A deconstructive analysis of such definitional knots, however necessary, [is not] at all sufficient to disable them.'

Lupton (1997) is more optimistic about it: 'The emergence of critical cultural representations that highlight the discrimination inherent in dominant discourses and images around certain bodies is evidence of the spaces available to redefine discourse and practice' (Lupton 1997, pp.5–6). Judith Butler (1993) argues that there is always an opportunity for disruption to dominant discourses. She sees gender (or 'sex', to use her term) as a reiterative or ritual practice through which it acquires its natural effect. However, she argues that it is by virtue of this reiteration 'that gaps and fissures are opened up in the constitutive instabilities in such constructions [e.g.] that which escapes or exceeds the norm, as that which

cannot be wholly defined or fixed by the repetitive labor of that norm'. This instability, Butler argues, is the 'deconstituting possibility' allowing for a potentially productive crisis in such norms (Butler 1993, p.10).

In this introduction I have argued that gender is at the heart of our self-understanding and self-definition and as such must have profound consequences for our mental health. It is essential that art therapists, counsellors and other types of psychotherapy professionals are conversant with ideas about the construction of gender to avoid the imposition of preconceived or universalised ideas about gender norms in therapy. We must be able to facilitate an exploration of this complex contested site of meaning.

The scope of this book

The opening chapter, entitled 'Feminist Art Therapy', by Nancy Viva Davis Halifax, explores what feminism has to offer the practice of art therapy. She suggests that the idea of feminism is often contentious because feminism is non-doctrinaire and ambiguous in form. She argues for an increased tolerance of ambiguity in art therapy practice and explores what is distinctive about a feminist approach: namely that power in the relationship is explored, that participants are seen as imbued with expertise, that the therapy is led by the client's expressed needs and goals, and that therapy is evaluated in a collaborative manner. Furthermore, Halifax explores how feminist art therapy is non-pathologising and recognises clients' strengths and skills.

Several chapters follow which examine lesbian, gay and transsexual issues in relation to art therapy, but in rather different ways. 'Just a Stage I'm Going Through' by Hilary Bichovsky explores the idea of deviance in relation to a system of psychiatric care. Drawing on her experience of being an art therapy student in a clinical training placement, she looks at her particular experience of an institutional orthodoxy in relation to her sexual orientation and particular physical characteristics. The chapter raises many difficult issues which are taken up and explored in detail by other contributors. It is a moving personal account.

It is ironic that the contributor who was to discuss the topic of transsexuality from a personal perspective (that of a practising art therapist who is a female to male transsexual) was unable to finish his

contribution due to the debilitating effects of surgical interventions and drug treatments.

For some feminists, and others, acts of surgical mutilation, leading to 'sex change', may be utterly abhorrent if they are precipitated by the female subject having internalised misogynistic discourses about women's bodies resulting in them experiencing feelings of self-disgust. However, opposition to sex change surgery comes from other quarters too, from those who wish to assert ways of being which are other than the binary male/female divide. From this perspective, operatively achieved sex change can be viewed as positively conservative and reactionary, especially when it is accompanied by the assimilation and acting out of the most clichéd and stereotypical aspects of masculine or feminine behaviour; the pre-operative requirement that the would-be transsexual live as a member of the sex they wish to become whilst receiving hormone treatments perhaps reinforces this tendency. For example, a male to female transsexual acquaintance of mine saw himself as a would-be lesbian but was afraid to make this disclosure to his psychiatrist in case Medicare funding for the sex change was refused. He also felt obliged to assume very feminine attire during this period of transition. Conversely, some post-operative artists, such as Loren Cameron, are using photographs to challenge the enduring (Aristotelian) concept of men and women as opposites.

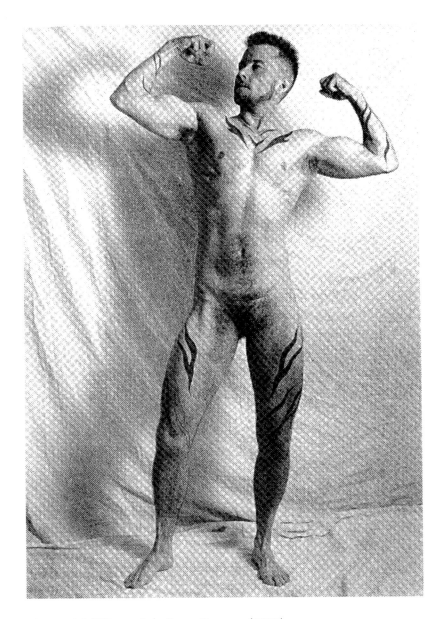

*Figure I.1 **Self Portrait** by Loren Cameron (1993)*
© Loren Cameron 2002. Reproduced with kind permission of Loren Cameron

Donna Addison explores how art therapists can be more responsive to the needs of gay, lesbian, bisexual and transgendered clients (GLBT). She also notes that even in large cities GLBT art therapists are likely to encounter their clients in social situations. Negotiation of how to handle such encounters can be addressed. For example, do clients wish their therapist to acknowledge them in public? The therapist's attitude regarding therapeutic 'boundaries' can be shared in the therapeutic situation as art therapists have different views of how social exchanges may affect ongoing therapy. How it feels to have met in a social situation can be openly discussed too in therapy, so that tensions do not arise or are minimised. Addison also raises the topic of homophobia, including internalised homophobia in working with homosexual clients, in her chapter.

In 'Singing With Pleasure and Shouting With Anger' Jean Fraser and Judith Waldman seek to politicise the art therapy process, or rather reveal the political nature of therapy, and explore its potentially oppressive and subversive potential in working with gay and lesbian clients. Gender identity is explored through a number of short, but illuminating, case studies. The case studies highlight issues such as rejection by one's family, social isolation, the oppressiveness of stereotypical roles, loss of self-esteem and fear of being ostracised.

The final section deals with the highly contentious subjects of trans-ference and interpretation of the therapeutic encounter. Though many art therapists doubt the value of the therapist proffering interpretations (or sharing their countertransference reactions) in response to their client's actions or artworks, even though we may formulate hypotheses, some advantages and pitfalls are explored with particular reference to homo-sexual countertransference.

Maggie Jones, with a close analysis of the relationship between the self and one's sexuality, relates the 'mainland' of standard psychiatric practice to the 'peninsula' of homosexuality. Describing the isolation of gay and lesbian communities, where boundaries are perceived as physical and mental, Jones examines the significance of art therapy in the context of borderline personality disorder. The notion of shifting and changing boundaries in relation to both mental health and sexual orientation is explored with reference to case studies of clients whose representations

of boundaries are depicted in their art. Jones concludes that the ability to roam between the mainland and peninsula is essential.

Two chapters follow which explore the topic of masculinity from quite different perspectives. Marian Liebmann's chapter, 'Working With Men', investigates various issues regarding being a female art therapist working with male clients. Through a number of short case studies and vignettes she highlights some of the particular problems and challenges she has encountered during her professional career. Topics related to masculinity, such as patriarchy and misogyny, are also touched upon.

José Batista Loureiro de Oliveira explores the topic of the sexual orientation of the therapist in Mediterranean societies. In his chapter 'A Mediterranean Perspective on the Art Therapist's Sexual Orientation' he introduces some historical considerations concerning homosexuality, homophobia and Latin American machismo. Drawing on the work of Foucault and others, he explores gender performance in photography.

De Oliveira asserts that mental health practices often conform to traditional models of masculinity and femininity. The author specifically applies this theory to the Mediterranean areas which, he believes, are struggling to accept homosexual orientation as other than 'a conspiracy against nature'. De Oliveira illustrates his argument with a description of the typical Andalusian attitude towards 'machismo'. He also considers regional religious and political history, citing Foucault's alignment of the early development of gender construction with the confessional ritual of Catholicism.

The notion of 'gender' is interrogated as a social construction. The importance of the therapist's sexual orientation is covered in detail from both an ideological and practical viewpoint. The author argues that the conservative nature of the healing therapies, particularly in Mediterranean areas, has an oppressive effect. Cultural differences in the acceptance of sexual orientation are discussed and illustrated with examples of the historical background to stereotypical classifications. The author challenges the institutional practices which he perceives as gendered, claiming that institutional power in general dominates and influences social behaviour at the expense of the individual.

With the lack of detailed research into therapists' sexual orientation, the author concludes that there is little interest in what he perceives as an

area of importance; it is easier to discuss the client, he claims, than to consider one's own experience and pressures. The mental health practitioners of Western cultures, who treat sexuality and gender as taboo subjects, should reappraise their understanding of sexual orientation and treat it as a crucial component of life.

In my own chapter, 'A Discussion of the Use of Art Therapy With Women Who Are Pregnant or Who Have Recently Given Birth', I examine women's experience of pregnancy and childbirth and the value of therapeutic intervention with pregnant women and new mothers. Research cited in the text suggests that therapeutic support for pregnant women can have long-term benefits, including health gains which should not be overlooked with regard to the cost analysis of such provision in antenatal care packages. My particular focus of interest, apart from the perceived benefits of the group, is a narrative analysis of women's experience of changes to self-identity as a result of motherhood.

Nancy Slater makes a short, impassioned plea to those working with sexually abused women to consider social context as crucially important: poverty and lack of access to institutional resources should not be overlooked when considering the ongoing nature of problems faced by women, particularly by those women who have experienced multiple abuses. She urges art therapists not to lapse into a reductive stance, but rather to be receptive to the complexities generated by ethnicity and context.

Savneet Talwar, in a polemical chapter entitled 'Decolonisation: Third World Women and Conflicts in Feminist Perspectives and Art Therapy', explores tensions between black and white conceptions of feminist practice. In particular, she takes up the topic of race in relation to art therapy and introduces the concept of therapeutic decolonization.

In 'Challenging Invisibility – Outrageous Agers' Rosy Martin seeks to confront and subvert stereotypical representations of ageing women. Using photography and video Martin interrogates discourses surrounding the ageing female body. The body itself is used to explore, challenge, toy with and refute ideas put forward by a number of influential twentieth-century theorists including Sigmund Freud, Judith Butler, Mikhail Bakhtin and Luce Irigaray.

Acknowledgements

Thanks to Robert Kapadia and Teresa Barnard for their constructive criticism of this introduction.

Bibliography

Bartky, S. (1996) Femininity and Dominations. London and New York: Routledge.

Brah, A. (1996) *Cartographies of Diaspora*. London: Routledge.

Butler, J. (1990) *Gender Trouble: Feminism and the Subversion of Identity*. London: Routledge.

Butler, J. (1993) *Bodies That Matter: On the Discursive Limits of 'Sex'*. London: Routledge.

Campbell, J., Liebmann, M., Brooks, F., Jones, J. and Ward, C. (1999) *Art Therapy, Race and Culture*. London: Jessica Kingsley Publishers.

Caplan, P. (ed) (1987) *The Cultural Construction of Sexuality*. London: Routledge.

Cornwall, A. and Lindisfarne, N. (1994) *Dislocating Masculinity. Comparative Ethnographies*. London: Routledge.

Davies, D. and Neal, C. (1996) *Pink Therapy*. Buckingham: Open University Press.

Deleuze, G. (1988) *Foucault*. Minneapolis: University of Minnesota Press.

Deleuze, G. and Guatteri, F. (1984) *Anti-Oedipus: Capitalism and Schizophrenia*. London: Athlone.

Deleuze, G. and Guatteri, F. (1994) *What is Philosophy?* New York: Columbia University.

Deutscher, P. (1997) *Yielding Gender: Feminism, Deconstruction and the History of Philosophy*. London: Routledge.

Douglas, M. (1996) *Thought Styles*. London: Sage.

Dworkin, A. (1974) *Woman Hating*. New York: EP Dutton Publishing.

Forrest, D. (1994) 'We're Here, We're Queer and We're Not Going Shopping.' In A. Cornwall and N. Lindisfarne *Dislocating Masculinity. Comparative Ethnolographies*. London: Routledge.

Foucault, M. (1978) *The History of Sexuality. Volume 1*. Harmondsworth: Penguin.

Foucault, M. and Sennett, R. (1981) 'Sexuality and Solitude.' In *Anthology 1*. London: Junction Books.

Fox, N. (1999) *Beyond Health: Postmodernism and Embodiment*. London: Free Association Books.

Griffiths, S. (ed) (1996) *Beyond The Glass Ceiling. Forty Women Whose Ideas Shape The Modern World.* Manchester: Manchester University Press.

Guillaumin, C. (1991) 'The Practice of Power and Belief in Nature. Part 1: The Appropriation of Women.' *Feminist Issues 1, 2, 3–28.*

Hiscox, A.R. and Calish, A.C. (1998) *Tapestry of Cultural Issues in Art Therapy.* London: Jessica Kingsley Publishers.

Hodges, L. (1996) 'Catherine MacKinnon.' In S. Griffiths (ed) *Beyond The Glass Ceiling. Forty Women Whose Ideas Shape The Modern World.* Manchester: Manchester University Press.

Hogan, S. (ed) (1997) *Feminist Approaches to Art Therapy.* London: Routledge.

Holland, J. Ramazanoglu, C. and Scott, S. and Thompson, R. (1994) 'Desire, Risk and Control: The Body as a Site of Contestation.' In L. Doyal, J. Naidoo and T. Wilton (eds) *AIDS: Setting a Feminist Agenda.* London: Taylor and Francis.

Howell, E. and Bayes, M. (eds) (1981) *Women and Mental Health.* New York: Basic Books.

Jackson, M. (1987) 'Facts of Life.' In P. Caplan (ed) *The Cultural Construction of Sexuality.* London: Routledge.

Jackson, S. (1996) 'Heterosexuality and Feminist Theory.' In D. Richardson (ed) *Theorising Heterosexuality.* Buckingham: Open University Press.

Jeffreys, S. *Anticlimax: A Feminist Persective on the Sexual Revolution.* London: The Women's Press.

Kitzinger, C. and Wilkinson, S. (1993) 'Virgins and queers: Rehabilitating homosexuality.' *Gender and Society 8, 3, 444–630.*

Lewin, M. (1997) 'Liberation and the Art of Embodiment.' In S. Hogan (ed) *Feminist Approaches to Art Therapy.* London: Routledge.

Loizos, P. (1994) 'A Broken Mirror: Masculine Sexuality in Greek Ethnography.' In A. Cornwall and N. Lindisfarne *Dislocating Masculinity. Comparative Ethnolographies.* London: Routledge.

Lupton, D. (1994) *Medicine as Culture: Illness, Disease and the Body in Western Societies.* London: Sage.

Lupton, D. (1997) Foreword in S. Hogan (ed) *Feminist Approaches to Art Therapy.* London: Routledge.

MacKinnon, C. (1993) *Only Words.* Cambridge, MA: Harvard University Press.

MacKinnon, C. and Dworkin, A. (1997) *In Harm's Way: The Pornography Civil Rights Hearings.* Cambridge, MA: Harvard University Press.

Martin, B. (1993) 'Extraordinary homosexuals and the fear of being ordinary.' *Differences: A Journal of Feminist Cultural Studies 6,* vols 2 and 3, 100–25.

Moore, H. (1994) *A Passion for Difference.* Cambridge: Polity.

Ramet, P. (1996) *Gender Reversals and Gender Cultures.* London: Routledge.

Richardson, D. (1996) 'Heterosexuality and Social Theory.' In D. Richardson (ed) *Theorising Heterosexuality*. Buckingham: Open University Press.

Russell, D. (1995) *Women, Madness and Medicine*. Cambridge: Polity Press.

Scott, S. and Morgan, D. (1993) *Body Matters: Essays on the Sociology of the Body*. London: Falmer.

Sedgwick, E. K. (1990) *Epistemology of the Closet*. Berkeley: University of California Press.

Seidler, V. (1987) 'Reason, Desire, and Male Sexuality.' In P. Caplan (ed) *The Cultural Construction of Sexuality*. London: Routledge.

Shilling, C. (1993) *The Body and Social Theory*. London: Sage.

Showalter, E. (1985) *The Female Malady: Women, Madness and English Culture, 1830–1980*. London: Virago.

Smart, C. (1996) 'Collusion, Collaboration and Confession.' In D. Richardson (ed) *Theorising Heterosexuality*. Buckingham: Open University Press.

Spence, J. (1986) *Putting Myself in the Picture: A Political, Personal and Photographic Autobiography*. London: Camden Press.

Turner, B. (1984) *The Body and Society: Explorations in Social Theory*. Oxford: Basil Blackwell.

Turner, B. (1992) *Regulating Bodies: Essays in Medical Sociology*. London: Routledge.

Ussher, J. (1991) *Women's Madness: Misogyny or Mental Illness*. Brighton: Harvester Wheatsheaf.

Ussher, J. (1997) *Fantasies of Femininity: Reframing the Boundaries of Sex*. Rutgers: Rutgers University Press.

Feminist Art Therapy: Contributions from Feminist Theory and Contemporary Art Practice[1]

Nancy Viva Davis Halifax

Theory and criticism arising from contemporary feminist art discourse can be a significant influence in the development of a feminist art therapy. The dominant cultural paradigm of modernity, with its emphasis on originality and timelessness, and its erasure of gender, has influenced contemporary art therapy practice. This paradigm has influenced our perceptions of ourselves as artists as well as our clients' self-perceptions. Our beliefs about art are as influential as our beliefs about psychotherapy, and will affect our approach to the practice of feminist art therapy.

The ideas in this paper were first presented at the 1996 American Art Therapy Association conference in Philadelphia, and they were accompanied by slides of artists' work. Although not often directly referred to, their work was an important presence, and served to extend as well as query my words. I showed their work because of my concern that we

[1] Originally published in the *American Journal of Art Therapy*, Volume 36, No.2, pages 49–55. Reprinted here with the kind permission of Gladys Agell and Vermont College of Norwich University.

often fail to look at art in a deliberate way. Art therapy is a hybrid profession, the progeny of art and psychotherapy, and we practitioners should know as much as we can about both fields. We must especially bring the world of art into our practice since, without it, the clinical practice is in danger of losing credibility.

As my time in this profession lengthens, I am increasingly concerned lest art therapists fail to remain connected to their art, to sustain their development as artists, and to maintain their passion. It is vital that we continue to practise the quiet language that art speaks. The practice of looking at pictures arises from art training and has been a valuable means of learning. We must search out ideas and bodies of knowledge that are being developed in the related fields of art history, contemporary art practice and feminist art criticism, where people are attending to the making of art.

Like art, feminism is a culturally and historically situated practice and, therefore, its shape (like the shape of art) varies. To illustrate this, consider your response elicited by the use of the term 'feminism'. This observation can lead to awareness of any predisposition towards constructing particular types of meaning. We may glimpse part of our history reconstructed through our response. As an idea, a theory, an evolving epistemology, feminism elicits complex, involved responses. Notions of feminism are often contentious because feminism is non-doctrinaire and ambiguous in form, and people do not tolerate ambiguity easily. Some would like to pin feminism down, but I would argue against that procrustean approach and encourage, instead, increased tolerance of ambiguity.

I am ambivalent in claiming 'feminist' as part of my identity. Some women don't identify themselves as feminists because they have misconstrued feminism as a monolithic and prescriptive system. Others refuse to call themselves feminists, recognising no advantage in that. Indeed, because we live in a patriarchal society, there are distinct disadvantages. Women who become feminists do so gradually, through their own experiences, which repeatedly reveal how little credence is assigned to their knowledge and narratives. Feminist knowledge is situated on the threshold of the personal and the political. It is at this threshold that my ambivalence to this part of my identity begins to diminish.

My first art therapy internship was in a large Canadian psychiatric facility, where the treatment model was conventionally psychiatric and biological. Drawings and related episodes which I presented were seen in a flat manner, used as diagnostic information. I began to feel anxious and self-conscious in presenting my perceptions of what was occurring in therapeutic relationships. A unified single-point perspective was encouraged, which allowed the professionals to stand objectively apart from the people with whom they were interacting. There was no allowance for multiple points of view. Over time, I came to realise that my experiences within this institution were resonant with my experience of the women clients. In looking at the suffering and pain that these women endured, the doctors did not make connections to the conditions of all of our engendered lives; never did they bring in an analysis beyond that of medical psychiatry. The inattention to the larger life aspects of the 'patient' was disturbing. As decisions were made regarding treatment, the 'patient' was neither kept informed, nor seen to be competent. An empathic treatment stance was seldom observed. I came to feel undervalued, my professional discourse ignored by the patriarchal hierarchy that existed within psychiatry. That first training fostered my capacity to doubt my own relationships with my clients and, again, I believe that in some way the institution also decreased my clients' ability to value themselves. The experience caused me to think deeply about my commitment to the healing professions. I came to understand how the institution and its practices limited and fostered the depth of my knowledge and my therapeutic relationships. I learned that, as art therapists, we risk devaluing our knowledge and our profession. We feel not 'good enough'; we disparage our work and we remain quiet in team meetings, as our ideas about our clients and their art suddenly recede. We repress aspects of our own experience, unconsciously mimicking the response of team members who do not comprehend the therapeutic work of art therapy.

A feminist understanding is useful, particularly because we live in a culture, society and time when the experience of so many has been marginalised by the dominant discourse. As I understand it, feminism recognises that our experience of the world passes through an autobiographical prism that includes facets of gender, class, race, sexual orientation, ability, and so forth. Feminists have worked hard to bring these

aspects of self back into the visible range where they can be influential. Women's realities (feminist or not) have, across time and culture, been ignored, buried, or otherwise obscured. Feminists have brought into the foreground many difficult truths about women's lives. They have worked to challenge a social system based on male values, a system where the qualities and experiences of men are seen as universal, objectively present and visible, and woman's experience and her relationship to knowledge are occluded. Feminism asks to include the experiences of those who have been excluded, not privilege those experiences. It would like to dethrone patriarchal discourse. The diversity of contemporary feminisms have in common their desire to address the hegemony of the patriarchy, to bring into view all of our gendered realities.

Both patriarchal and feminist thought can ensnare us in an uncon-scious epistemology. Feminists have learned the importance of entering a conscious and participatory relationship with a way of thinking, discov-ering how it can hinder, confuse, transform and change us (Bohm 1994). When we bring an experience or thought into the foreground, then other thoughts and experiences recede. We may out of habit pick up a particu-lar way of, for example, approaching a drawing, and through this we end up being less able to recognise alternate approaches, or we may end up in an approach where we are not sensitive to context. Ideally, most of us have experienced the limits of theoretical understanding so we can perceive and acknowledge the times when theory does not correspond to what is perceived, and thus we can act accordingly.

The theoretical substructure of feminist therapy can be historically located in the feminist movement of the late nineteenth-century and latter third of the twentieth-century. Through the contributions of accomplished women from diverse communities, we have gained a broader understanding of feminist theory and feminist therapy practice. Over the past thirty years, feminist thought has further contributed to the recognition that the inner life of the individual cannot be treated without the understanding that she developed in an oppressive culture; one which views her as inferior and deficient.

Feminist researchers began to focus on notions of healthy develop-ment and how developmental outcome was related to gender (Broverman et al. 1970; Kaschak 1992; Miller 1976). Feminist psychotherapists

began to transpose models of psychological health which were based on masculine assumptions. They looked beyond the theories of personality that consider intra-psychic development and the past as determinants of health; feminist psychotherapy sees our lives lived in culture and acknowledges the influence of race, gender, class, ability and so forth, on the way problems are developed and expressed. Gender and the socio-political context within which women are raised were acknowledged as being developmentally important.

In feminist psychotherapy, power in the relationship is explored. Both participants are imbued with expertise, so that from the very beginning the client is an active participant. Feminist psychotherapy clearly follows the client's expressed needs and goals, and therapy is evaluated in a collaborative and ongoing process. Feminist psychotherapy is non-pathologising and recognises strengths and competencies. A feminist and rational model of therapy is able to value what each participant brings to the relationship. At its best, it is capable of containing and tolerating the confusion that may arise with the admission of difference and multiple points of view. This kind of therapy suggests that people entering a supportive, collaborative, empowered, therapeutic relationship will carry that experience with them into the outside world. The relationship of self-to-self and self-to-other will undoubtedly be affected. Yet we must still acknowledge all that exists in our culture that works against our newly acquired knowledge of self and of our capacity to do and act.

The choice of theory is critical, and one must carefully consider how a particular body of knowledge will facilitate the client's relationship to the self and to her art. Our therapeutic position is influenced by our choice of theory. Theory may filter the world through into a different perspective. Each position, each theory, has its attendant risks and benefits. At times, theory can provide me with a clear and reassuring point of view.

Feminist theory provides me with a body of knowledge through which I can construct the intent of my practice; it offers a set of ideas against which I can evaluate my theorizing and my practice. Having chosen this body of knowledge, I have, over time, become familiar with its limitations and biases. As a result, I expect less of the theory, and have developed an increased tolerance towards its limits.

A theory must serve and honour what it perceives, being conscious of any paternal tendency. Perceptions can be dulled by over-reliance on theory, particularly if it is allowed to construct our perceptions according to predetermined patterns, so it is necessary to practise seeing both through and beyond the frame of theory. Wittgenstein wrote that 'the constraints imposed by any theoretical orientation may serve to impair our actual view, such that our understanding of the world is rather a mis-understanding' (Brill 1995, p.11).

The best attitude concerning theory is when it can be seen and used as a medium. As we play with it, theory becomes less monolithic, and we may see clearly how it shapes our perceptions. We can observe its influence, how it makes its own marks on us. Theory that arises from feminism and feminist therapy helps to keep perceptions visible. Theory can help us perceive our practice, providing a lens through which to view our work.

A practice of feminist art therapy must be able to recognize itself as the daughter of feminist psychotherapy theory and feminist art practice, criticism and history. An understanding of feminist and contemporary art can support the development of a feminist and relational art therapy practice.

My understanding of art is rooted in my history as an art student, and is based on what my mentors in art and art therapy inspired in me. As professionals, we must know from whence our theories of art and therapy arise, since these shape our interactions with those who seek our help. Art and art practice are notoriously difficult to define, and while this makes that aspect of our profession difficult to talk about, it also gives us a great deal of freedom to engage each other in dialogue. To make art an integral aspect of our identities as art therapists, we must articulate, with all of our doubts and uncertainties, our beliefs about art, and make visible our history as practising artists, as well as art psychotherapists. Our beliefs about art will influence our approach to the practice of art therapy. Those beliefs are as influential as our beliefs and theories about psychotherapy. Our identities as artists are at least partially constructed in relationship to our cultural and social realm; we cannot help but to have introduced cultural norms as part of our self-construction. We must, therefore, be

familiar with the dominant theoretical paradigms in the discourse of art and art history.

In art school, my first text in art history did not include art by women. This lack of representation gave me little to hold on to when I imagined what it might be like to be an artist. The paradigm which dominated the art world when my teachers were being taught was that of modernism; hence, their legacy to me was heavily influenced by modernity, and with it the notion that gender in art was not important. Modernity had eyes only for the radically new. It valued art that was original, timeless, monumental and universal (Gablik 1993, 1995). It perpetuated the myth that art and artist were not accountable. The myth of modernity acted to obscure our view of art as socially responsible; like science, art was morally neutral. We now know that neither is morally neutral nor objective.

In the West, under the influence of modernism, we have become accustomed to art that dominates its space, is upright, alone and heroic. Art that reflects a modernist sensibility displays social independence, a radically separate self, and a lack of connection to others (Gablik 1991). The modernist conception of art made my relationship to art practice full of difficulty and conflict. With its erasure of gender and its conception of art as universal, some women experienced modernity as liberating, but Griselda Pollock (1994) notes, as she describes the modernist lie:

> Women were caught in [a] deadly paradox. To gain access to more of their humanity, they would be permitted none of their femininity. Any traces of a gendered perspective or aesthetic sensibility would immediately suspend their claims to being considered serious artists, while, of course, any art that cannot call upon the full range of the producer's material and social experience will feel incomplete, unauthentic, like a masquerade...[A]rt by men was seen as unmarked, ungendered, universal in its revelations about the human condition while art made by women was always deemed to lack breadth, remaining partial, local, gender based, and impossible to consider as art pure and simple; it was still, and always, women's art. That meant not really art at all. Flowers by Georgia O'Keefe were sexual, feminine, by Van Gogh or Manet they were pure colour, triumphant responses to nature. (p.69)

Women artists came to understand that the notion of universality was exclusionary, and that it actually meant art by men, who were usually white and economically advantaged (Langer 1988; Parker and Pollock 1981; Vogel 1988). Women and other artists, who toiled on the periphery of a patriarchal world, were largely invisible as cultural producers. I discovered that the modernist art world, like that of medicine and psychology, was patriarchal and gender insensitive. I have had to reconceptualise art and art practice, the role of the artist. I have struggled with the definition of art and with internalised cultural definitions of who the artist is and how she practises.

Suzi Gablik's socially aware contemporary art criticism has placed herself as a subject in relation to another subject, that is the art, and its maker. Gablik (1991) states that:

> Our present models [of art], which until recently have been focused on notions of autonomy and mastery, have been notably unconge-nial to any aspect of the psyche that is receptive or connective, that emphasises the importance of relationship and harmonious social interaction. (p.128)

A connective aesthetic, as defined by Gablik (1995), is one that heals rather than confronts. It is shaped not by its relation to the collector and the market place, but by its commitment to social practice. It sees that our identity is:

> ...deeply embedded in the world. It makes art into a model for connectedness and healing by opening up being to its full dimensionality...the old specialisations of artist and audience, creative and uncreative, professional and unprofessional distinctions between who is and who is not an artist – begin to blur. (p.86)

Some artists are moving away from a model of practice which is isolated, disengaged and pure to one that is engaged, responsible and connected. There are artists who work independently of the traditional gallery or museum system. Their media and methods of working challenge our conceptions of what art is, who does it and where it exists. Both therapy and art can sensitively connect us to a greater whole and point us towards relationship and reciprocity. A feminist art therapy practice is built on interconnectedness and empathy.

In feminist therapy, being in a relationship is an intricate labour. It suggests also that finding meaning is an involved process because '[w]e are not on a quest for the right meaning' (Kaschak 1992, p.213). We are attempting to bring into view the areas of commonality, variety and difference. We need to hold 'the tension of the complex perspective, continuing to look for what or who is being kept invisible. Feminist therapy is an exercise in peripheral vision, double vision, inner vision' (Kaschak 1992, p.215). These exercises in vision resonate within the body of my work as an art therapist where my acts as a perceiver and my active sensory participation in the art reveal the multiple levels and contexts within which meaning is embedded.

In my practice, I want to have the client hear, smell, taste, really perceive herself and her history, in all of its intricate patternings; to encourage her to keep her questions and curiosity alive; to keep alive all that will aid her in navigating a less-than-hospitable world, where her perceptions are so easily placed in the background.

If our perception is limited, we must know it, and must know when and by what. We must know that we may tend to perceive and then interpret, or 'see as', in certain set ways. We must be observant of our history as 'lookers'. If we have only ever looked at the art of the European masters of the sixteenth century, or at contemporary Canadian landscape painting, then our seeing and 'seeing as' will be affected. We will always have a difficult time seeing beyond the familiar, yet I believe it is necessary to participate critically with our habitual responses. We need to open our senses to art forms we are less familiar with and to read about cultural relationships to art, historically and contemporarily. How important it is to look as closely and thoroughly as possible. Problems are often created by faulty perceptions, imagined confusions due to faulty investigations and oblique interpretations (Brill 1995).

Art which includes personal and social change as part of its agenda is viewed as culturally unreliable. Art which claims to achieve something is not seen as art (Lacy 1995). Art therapists make a lot of qualifying statements concerning the art created in their practice. We tend to be apologetic to both the artistic and therapeutic communities about what we do. We tend to devalue what is done in therapy as not being art. That is a

problem, because it means that our vision is restricted, heavily influenced by cultural views about what art is and isn't.

But art therapy can challenge current definitions of art practice and 'the nature of art as we know it, [seeing] art not primarily as a product but as a process of value finding, a set of philosophies, an ethical action and an aspect of a large sociocultural agenda' (Lacy 1995, p.46). Lucy Lippard (1970) has stated that:

> The goal of feminism is to change the character of art. To change the character of art is not to retreat from either art or society. [A feminist model of art does] not shrink from social reality no matter how painful, nor does it shrink from the role that art must play as fantasy, dream, imagination. (Lippard in Pollock 1994, p.86)

My goal is to change the character of art therapy, and to encourage the radical revision of art therapy as a connective art practice. We have much to learn from contemporary models of art practice, where art is conceived as a connective and responsible practice:

> Listening to others – getting beyond merely expressing ourselves – is the distinguishing feature of art in the empathic mode. When we attend to other people's plight, enter into their emotions, make their conditions our own, identification occurs. Then we cannot remain neutral or detached observers; responsibility is felt and we are summoned to action. (Gablik 1991, p.112)

Our model of practice is built on our capacity to perceive that the world exists in our therapeutic environment, and that we and our clients are not separate from what occurs in the world outside. Culture, and images from our culture, permeate our existence; they are bound to make an appearance in our lives, consciously or unconsciously.

In therapeutic practice, I work with clients as they use art to represent themselves to themselves. We use art as an autobiographical and embodying act, through which clients are conscious of, and empathic to, themselves. Developing a feminist reading of art within the practice of art therapy engages the therapist in the ongoing perceptual exercise of empathically extending perceptions:

> For centuries women have been the object of art. Here the author of the self-portrait is both subject and object. For women, this interac-

tion is particularly critical. 'Woman' has been the object of art for centuries, while women have remained marginalised as producers. To act in both roles, simultaneously, is to stage a crucial intervention. (Meskimmon 1996, p.14)

Here we have a description of a critical intervention we can make with our clients by encouraging them to depict themselves as subjects, thereby engaging in art as an autobiographical and empowered act.

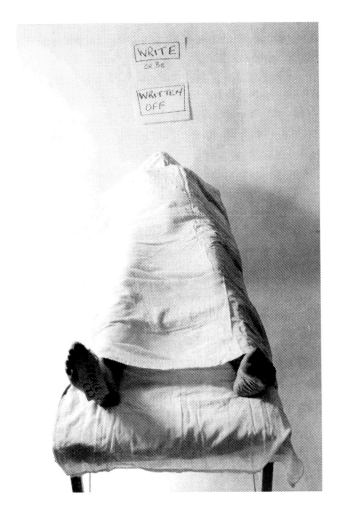

Figure 1.1 **Write or Be Written Off** *by Jo Spence in collaboration with David Roberts (1989)*
© Terry Dennett. Reproduced with the kind permission of the Jo Spence Archive

The work of Louise Nogouchi is profoundly empathic and takes the above intervention across the threshold. In Compilation Portrait #2, she examines her own identity, as she photographs herself in the same position as a convicted criminal, and then weaves the portraits together. Her intervention questions the formation of identity, and its boundaries. This empathic and attuned work provides an entrance into a profoundly valuable conflation of identity.

In our therapeutic work, it is vital to be attuned to how each person represents herself to us, to herself, and to others. We must be conscious of perspective, voice, and listening capacity, and ask through whose senses are the stories constructed and the pictures rendered. We encourage our clients to draw their own lines, narrate their own stories, to perceive themselves. The photographic work of Jo Spence (Figure 1.1) encourages us to take control of the methods of representation and to represent ourselves. In *Write or Be Written Off*, the foreshortened figure, shrouded, tagged, lets us ponder our mortality and our life narrative. The figure is protected from the gaze of the viewer, and simultaneously requests our attention; it is a strong call for us to voice our experience. The personal and the political are aligned in Jo Spence's work on identity. Jeanne Randolph (1991), a Canadian psychiatrist and cultural theorist, challenges us to examine our position as we listen to art:

> The meaning or the purpose of the objects is co-authored by the viewer while interacting with that object... The art object is reorganised as an amenable object with which the viewer interacts to experience the world. (pp.14–15)

As art therapists, how do we view the work and lives of our clients? How do we present their art? How do we talk about it with them? What do we transmit to them about art practice? How do we develop a feminist art therapy practice that we can carry into our relationships with clients, ourselves and the world?

I wonder how the art we are used to viewing has shaped our relationship to the art of our clients. Is it difficult for us to be with art with which we have less familiarity? With certain kinds of art, do we feel more uncertain, do we wish to close down our experience of it, and of the artist? We must be sensitive to the beliefs of our clients. Their histories as

artists may influence the nature of involvement they will have with various media. We can ask questions about their creative history and their first experiences with art, and know more of how a particular familial experience, culture or religion may have influenced their engagement.

In feminist art therapy, we begin the relational process between drawer and drawing with the meaning that the drawer inscribes on her work, and her description of the work's structure. Our perceptions are bounded by hers. Yet there are times when we gently work with our clients toward their increased understanding of their own work and themselves. We may sit with the person and share our perceptions with her, calling attention to areas she ignored, encouraging her to reflect on and observe her gaze. There are times in therapy that, with the consent of the client, I will sit beside her as she draws, looking at her drawings. This shared view is relevant because it embodies the attempt to join in looking and imagining together. It illustrates the essentially collaborative nature of our work. Our task is to encourage the client to forge an alliance with her own creativity, to the aspect of self that knows and can experience her work. There are many ways to understand a work, and some will be more useful than others. The divergent and ambiguous readings of the work that may arise in therapy can aid us as we reflect with our clients on how and when a certain way of perceiving might be useful.

We are not experts telling clients what their work means. There can be great pressure, from clients and colleagues, for interpretations of art. Historically, there has been a notion that a cure can be generated by the application of a correct interpretation. When the therapist is involved in interpretive moves with the art, it may be experienced by the client as a kind of disempowerment, as though she were deemed incapable of creating her own representation and body of meaning. Interpreting art through an objective, distanced and dualistic perspective needs to be resisted.

A feminist practice of art therapy remains largely undescribed, and what I have presented here is only a part of that collaborative and participatory process. As this practice is described, I can only hope that it remains true to its nature, encompassing complexity, tolerating ambiguity, and resisting the temptation of becoming prescriptive.

As art therapists, we often deal with issues that are not readily manifest in society or culture, issues which have no audience, no

community. We are dealing with the common and profound problems of chronic illness, poverty, malnutrition, racism, abuse, trauma, despair, depression, isolation and disconnection. My work tries to make conscious the internalized aspects of culture which obscure my view, limit my perceptions and cause my defences to rise. This consciousness serves to reflect back to me where I have internalised my culture's biases.

The myth of the artist that is held up to us by our culture will influence our practice and our identities. It will have already influenced our clients' relationship to themselves as artists. The modernist paradigm, which has been active, and which was influential in my art school training, suggests that art is a solitary pursuit, that it is somehow pure, autonomous and isolated from the rest of culture. This idea of the artist as non-relational may well act to make it difficult for our clients to really experience themselves as artists, as creators. It may have made it difficult for us to experience ourselves legitimately as artists. Set aside the idea that art is a specialised practice involving the production of discrete, self-referential objects by the solitary, heroic male genius. Art, along with its practice and process, can be engaged, collaborative and connected. Grappling with these ideas about art as a relational practice, and a recognition of internalised cultural conditioning, will support the development of a feminist art therapy.

Acknowledgements

This paper is gratefully dedicated to these artists, and others unnamed, for their contributions to our deepening understanding of culture and of each other. They are: Artemesia Gentileschi, Judith Leyster, Emily Mary Osborne, Berthe Morisot, Mary Cassatt, Gwen John, Betty Goodwin, Nancy Spero, Claude Cahun, Lygia Clark, Rosy Martin, Jo Spence, Judy Chicago, Carolee Schneeman, Susan Hiller, Suzanne Lacy, Ana Mendieta, Louise Bourgeoise, Roshini Kempadoo, Chila Kumari Burman, Mary Duffy, Jenny Holzer, Martha Rosler, Helene Aylon, Coco Fusco, Dominique Mazeaud, Estella Conwill Majozo, Louise Nogouchi.

Bibliography

Allan, P. (1992) 'Artist in residence: An alternative to "clinification" for art therapists.' *Art Therapy: Journal of the American Art Therapy Association 9*, 1, 22–9.

Bohm, D. (1994) *Thought as a System.* London and New York: Routledge. (Transcription of a seminar given in November 1990 and edited by David Bohm.)

Brill, S. (1995) *Wittgenstein and Critical Theory: Beyond Post Modern Criticism and Toward Descriptive Investigations.* Ohio: Ohio University Press.

Broverman, I.K., Broverman, D.M., Clarkson, F.E., Rosenkrantz, P.S. and Vogel, S. R. (1970) 'Sex-role stereotypes and clinical judgments of mental health.' *Journal of Consulting and Clinical Psychology 34*, 1, 1–7.

Felshin, N. (1995) *But is it Art? The Spirit of Art as Activism.* Seattle: Bay Press.

Gablik, S. (1991) *The Re-enchantment of Art.* New York: Thames and Hudson.

Gablik, S. (1993) 'Toward an ecological self.' In R. Hertz (ed) *Theories of Contemporary Art.* New Jersey: Prentice Hall.

Gablik, S. (1995) 'Connective aesthetics: Art after individualism.' In S. Lacy (ed) *Mapping the Terrain: New Genre Public Art.* Seattle: Bay Press.

Hekman, S.J. (1990) *Gender and knowledge: Elements of a post modern feminism.* Boston: Northeastern University Press.

Kaschak, E. (1992) *Engendered Lives: A New Psychology of Women's Experience.* New York: Basic Books.

Lacy, S. (1995) *Mapping the Terrain: New Genre Public Art.* Seattle: Bay Press.

Langer, C. (1988) 'Against the grain: A working gynergenic art criticism.' In A. Raven, C. Langer and J. Frueh (eds) *Feminist Art Criticism: An Anthology.* New York: HarperCollins.

Meskimmon, M. (1996) *The Art of Reflection: Women Artists' Self-Portraiture in the Twentieth Century.* London: Scarlett Press.

Miller, J.B. (1976) *Toward a New Psychology of Women.* Boston: Beacon Press.

Parker, R. and Pollock, G. (1981) *Old Mistresses: Women, Art and Ideology.* London: Routledge and Kegan Paul.

Pollock, G. (1994) 'Inscriptions in the feminine.' In M. Catherine de Zegher (curator & ed) *Inside the Visible: An Elliptical Traverse of 20th Century Art in of and From the Feminine.* Cambridge, MA: MIT Press.

Randolph, J. (1991) *Psychoanalysis and Synchronised Swimming.* Toronto: YYZ.

Vogel, L. (1988) 'Fine arts and feminism: The awakening consciousness.' In A. Raven, C. Langer and J. Frueh (eds) *Feminist Art Criticism: An anthology.* New York: HarperCollins.

Wix, L. (1996) 'The art in art therapy education: Where is it?' *Art Therapy: Journal of the American Art Therapy Association 3*, 3, 174–80.

Just a Stage I'm Going Through: Reflections on a Placement in an Adolescent Unit

Hilary Bichovsky

This chapter is about my experiences as an art therapy trainee at an adolescent unit. Although I did not complete my placement and training, the experience made a deep impression on me. It focused my thoughts sharply on psychiatry's attitude to non-conformism.

Like many people who choose to become art therapists, I went to art school – a place which feted, more than tolerated, non-conformity. We fed ourselves on notions of 'genius' and 'oddness' and ideas of the artist as a wild, eccentric spirit. It wasn't much like a psychiatric institution at all. Outside art school the rewards for odd behaviour diminished but I retained nourishing memories of a place where eccentricity was prized – romantic nonsense to some; to me a cornerstone of psychological survival.

Between art school and art therapy training came a decade of dropping out, when, amongst other things, I was a performance artist. My best, most thoughtful piece, which was selected for the National Platform of Live Art at the Institute of Contemporary Art (ICA) in 1993, was a monologue against transsexualism. The performance began with me holding up a series of placards which spelled out 'THE ONLY ONES

WHO SAY I'M WOMAN THROUGH AND THROUGH ARE MEN'. After this I sat down at a little table with a bowl of water, a razor, a shaving mirror and a towel and, while shaving my beard off, I recounted a dream, but in the persona of a male to female transsexual. Once the dream was described, I retook the stage as myself, recited some poetry against transsexualism – *Don't take a knife to the body of the contradiction* – and finally set fire, on a metal tray, an image of the pattern of hairs on my own arm. Vintage performance art. But not only do I count all this as sane, I count it as among the most sane things I have ever done. Whenever I performed this piece I felt fully alive.

The piece was titled *It's a Drag.* I already knew, from my own medical diagnosis, that 'excess' hair in women was considered an illness, but I didn't want to be a medical case. So I chose not only not to shave and not to conform, but also to make a song and dance about it. I hoped I was making a space, in an increasingly plastic public world, for a sample of unapologetic, unrevised femaleness. As an act of rebellion, my performance had roots (!) in common with the disability rights movement. It seemed to me, since body hair inspired such powerful taboos and prohibitions, that it might be important. As the saying goes: 'Where there's fear, there's power'.

The placement

During my art therapy course, well into my second and final year of training, I was placed at a fourth tier adolescent service, which served about thirty adolescents, aged between twelve and seventeen, who were resident there. (The system grades psychological distress in schoolchildren into four tiers, according to the severity and difficulty of the case, and allocates a type of provision to each numbered tier. Number four is the most severe. The institution where I did my placement was therefore called a fourth tier adolescent unit.) The building was prefabricated; ditto mores and atmosphere. There was a school on site and a multi-disciplinary team intended to support the young people who were well outnumbered by the professionals. This was at least partly due to the continual influx of trainees like myself, from various disciplines, taking placements. As is the case with all professions, the staff were dependent on their clients not only for income (indirectly) but also for self-image. As trainees,

our parasitic nature was highlighted. Not yet authorised to carry out our roles, we drifted around the building trying to look busy.

Notwithstanding this there was a lot of idleness among the staff – plenty of unnecessarily prolonged meetings in which the professionals clustered and from which the subjects of our discussions were scrupulously excluded. The daily review meeting lasted at least an hour, included thirty or so staff and was presided over by an autocratic and seemingly entirely unsympathetic consultant, who as it happened was neither male nor white. It resembled nothing so much as a royal court. There were favourites, most didn't speak, and all had to placate and humour the 'king' and make her look intelligent. It lacked a jester.

The analogy of the court is accurate in one other vital respect – within the National Health Service psychiatric consultants often appear to be subject to no-one and have absolute power. Lest I malign the whole team, however, I would like to speak up for the individuals there who had remained basically kind and hopeful in their work roles. I had originally intended to try to become one of these, but I didn't make it.

The social culture for the staff of the adolescent unit was allied to that of 'office life'. For instance, in the staff room it was normal to talk about TV, money (nobody had 'enough'), DIY, diets, your boyfriend-/husband/family/pets and where you were going for your holiday. It was like a prolonged visit to the hairdresser. I found it hard at the time to fit in with this – too many years spent as an outsider. Lucky me, with my colourful past. This, and a personal acquaintance with depression, meant I identified more with the clients than the therapeutic regime. I also found 'mental health', as modelled by most of the staff including me, unconvincing.

The theoretical model of mental health proposed by the consultant who led the unit was basically biological, although ironically the food at the centre was awful. There was no interest in individual psychotherapy, but family therapy was sometimes offered. In the reviews – the only place where I could gauge the stated intentions of the unit – when treatment was discussed, it was almost entirely in terms of dosages. No-one opposed the use of drugs. Some staff did make other, more psychological reflections, which on the whole had all the impact of raindrops falling into puddles. The consultant knew she was surrounded by inferiors who

had no authority to challenge her. From this position she dispensed the opportunity to 'discuss' to everyone. But when a young boy was admitted for severely disturbed behaviour, she referred him for a brain scan, confident that he had some sort of organic brain abnormality. This was despite his publicly discussed notes, which said he had come from a family where he had seen his mother and sisters routinely brutalised by his father. A subsequent meeting to report on the brain scan recorded that the boy had been unhappy and agitated after his hospital visit, which had 'involved having metal plates strapped to his head'. I hope somebody found the results of this scan useful.

None of the adolescents escaped medication – which was logical in a clinical atmosphere that posited the root of abnormal behaviour as abnormal physiology. Psychoactive drugs, and not the sort you might want to take at the weekend, prevailed. Not only clients' but parents' wishes were overridden to establish these drug treatments. Parents, where they were doubtful, handed trust to these psychological experts in what was, by definition, an unmanageable family crisis for them. I was inexperienced enough to be shocked by the ubiquitous use of drugs. The girl who was to be my first client had her dosage increased – explicitly against her wishes and those of her mother – because she had become violent after discovering that she was not to be let home for a weekend as she had been promised.

Over the next few weeks, she became sleepier and more remote, although people with more experience than I told me she was calmer and easier to approach. At our first session, however, she had seemed contactable, albeit in pain. Now the drug drew a veil between us, making her so sleepy she simply put her head down on her arms and slept. Possibly these were rich pickings for a psychodynamic interpretation; I don't know.

What I do know is that because her medication was being increased against her wishes and my principles, I myself felt defeated and despondent in her presence, and was scared by the visible effects of her medication.

Meanwhile the art therapist, who was, like me, a bit 'eccentric', was supervising me. To some extent an outsider within the unit's structure,

she understood how alienated I felt, although experience had led her to consider my total opposition to medication naive.

Some of the issues of non-conformity were uniquely mine, apparently: I was a lesbian and I was a woman who grew (and did not remove) a beard.

Vis-à-vis the lesbianism, my supervisor advised me one day that 'the kids' had been questioning her about me. Was I gay? She knew the answer to this was yes, but she said, 'I didn't tell them anything about your private life', as though I should be grateful. I felt insulted. She was of the opinion that sexuality was private and that discussion of it with regard to specific individuals was out of place (in an adolescent unit?), even when the young people themselves had raised the issue. When I asked her directly if I could tell them I was gay, since they had asked, she said no, pointing out, not unkindly, that a previous worker who had been gay and had discussed it openly had been asked to leave.

I felt distinctly uncomfortable that it was being assumed I would undertake to lie about my sexuality as part of taking on my professional mantle. I had never made that agreement, either to the course, the unit, or myself. For one thing I felt that here was a group of people who more than almost anyone else needed truths, and indeed could smell a lie a mile off. For another, I felt I was being manipulated into the position of yet another dissembling adult, as though I was ashamed of my lesbianism, which I wasn't.

Of my beard, however, I am occasionally ashamed, self-pride in this being harder to maintain in the face of lifelong, relentless media hammering and contempt. Perhaps this matter too should be private – but at what cost to me? I saw and see my beard as simply at the extreme end of a range of failures in femininity to which, paradoxically, the average female body is prey. Whereas my particular unfemininity may be unusual, that's a problem of degree, not type. The problem of feeling 'unfeminine' is shared by many women, I think, since current notions of femininity are artificial. My thinking about femininity is this: if women exhibit it, then it's feminine by definition, including a beard. And that is the way the definition works. It proceeds from the reality of women to a generalised notion of what womanhood is, not the other way round.

At the time, however, I was in no doubt when I sat in the reviews as to how abnormal, for a helping professional, was a woman with a beard. Recalling my moment of glory at the ICA, I had time to wonder what sort of diagnosis *It's a Drag* – even as a fantasy, let alone enacted – would earn me in this place. I kept feeling like I was on the other team – a response which I later learned had a name: 'over-identification'. In my placement journal I noted an educational psychologist as saying of one of the boys at the unit, 'I think he's definitely schizophrenic; he's got this lifelong feeling of never having fitted in'. 'Really?' I had written in response. 'What's pathological about that? What is there here to want to fit in with?'

Of course, being a woman with a beard courts a wide variety of curious responses, from pity to contempt to admiration. Whenever I am growing my beard a predictable proportion of my consciousness leaks away, squandered in the effort of monitoring other people's reactions and my response to them. Since adherence to the prescribed norms of femininity was one of the safe areas of chit-chat among the majority of female staff, however, I found I had distanced myself from them. Of course it was not only at the adolescent unit that I experienced self-consciousness – but in the context of the unit, I felt that my beard made me look like a mental patient.

So, I had been instructed explicitly not to say I was a lesbian – and that by probably the most liberal member of staff there – and I felt like a freak. Based on her handling of other human phenomena, I don't think the consultant would have hesitated to define me thus. She was draconian but not an anomaly. The policing of normality is apparently part of the role of psychiatry. The parameters of recommended, as opposed to proscribed, behaviour are narrow, however. The vision is dull. In terms of gender and sexuality it is about as reality-based, intelligent and flexible as are advertising stereotypes. Meanwhile, as befitted an adolescent service, the unit was full of young people testing out, sometimes in antisocial ways, the roles available to them in life.

And what liberty to reject the prescribed norms of adulthood did the 'kids' have? What would it have done for them to be removed from the grinding, underfunded institutionalisation of this place and be transported for a day to the privileged corridors of my old art school to see

how much paint they could use up, how much self-involved rubbish they could talk, to be fed by the images and ideas from the whole history of art and cosseted persistently by the suggestion that they were special, that oddness was attractive, that rebellion was the order of the day and that all the best modern artists had dreamed of overthrowing society? Finally, that personal suffering could be a rich source of images, of an 'oeuvre'? Had I been born working class, it could have been me in this unit and I couldn't forget it.

My reflection on my placement now is that the best that was in me was silenced by the culture of the place. My personal life was very difficult at this time, and subsequently I left not only my placement but the whole course. I have since worked in the acute ward of a local psychi-atric department (not as an art therapist, obviously) but that also fright-ened me. The two psychiatric institutions in which I have worked had a heavily depressing effect on me. That this is an irony, for places suppos-edly set up to heal the mentally ill, cannot be overstated.

My non-conformity, what's left of it, put down deep roots in the experience of being an artist, an experience art therapy purports to draw on. My training course encouraged applications from people who were working artists, people in whom the spark of 'creativity' still winked. But, in my experience, the NHS places such sparks under hopeless constraints, not to say bucketfuls of water, and extinguishes them. I have written this up, however, as someone who left, which is an indication of my mettle. I take my hat off to art therapists working within current NHS psychiatric provision as I have experienced it.

Acknowledgements

Thanks to Chris Wood for her support and to Jenny and John for the reviving conversations that wound along the Snake Pass.

Art Therapy with Gay, Lesbian, Bisexual and Transgendered Clients

Donna Addison

Art therapists are ethically opposed to discrimination based on sexual orientation. Since many art therapy resources (i.e. text books, journal articles, educational programmes) do not often address art therapy for gay, lesbian, bisexual and transgendered (GLBT) clients, art therapists must rely on information available from related professions. A focus in this chapter on sexual orientation and gender identity, ethical obligations, symbols usually associated with the gay community/culture and the 'special needs' of GLBT clients will be explored in an effort to increase art therapist competency when working with non-heterosexual clients. The scope of this chapter is not to teach art therapists how to 'cure' homosexuality, since homosexuality is not an illness – nor is it to persuade art therapists to 'accept' homosexuality. Rather, the scope of this chapter is to educate art therapists regarding appropriate and successful art therapy for GLBT clients.

Introduction

Art therapists in the twenty-first century have ample opportunity to provide art therapy to GLBT clients. Since sexual orientation is not always visibly identifiable, art therapists may or may not know whether they are providing service to GLBT clients. While North American

society has made great strides in accepting (or at least tolerating) homo-
sexuality, many barriers and questions remain. Why do helping profes-
sionals assume clients are heterosexual until 'proved' otherwise? Does art
therapy for GLBT clients differ from art therapy offered to heterosexual
clients? Is the artwork different? If so, what are the discernible differ-
ences? Does sexual orientation even matter during art therapy? Are the
lives of GLBT clients so different from their heterosexual counterparts
that it warrants special attention from the art therapist? Are art therapists
aware of the subtle and not-so-subtle (and often legal) discrimination
against members of the GLBT community? Can GLBT clients be 'trans-
formed' into heterosexuals? Is it ethical to help GLBT clients 'change'
sexual orientation?

These questions illustrate how art therapists face a wide spectrum of
potential confusion within this targeted population. The umbrella of the
term 'homosexuality' covers the gay man parenting his biological
children, the transgendered male who is now surgically a female, the
married heterosexual male who wears clothing usually associated with
females, a lesbian who dresses as a male but does not desire sex reassign-
ment therapy, and the bisexual married woman, for example. Just as there
is no single way to describe the 'typical' heterosexual, there is no way to
describe a 'typical' GLBT person. Indeed, it can be a very complicated
world for the art therapist!

Art therapists sceptical of the need for this chapter are assured that
discrimination is quite prominent for the GLBT community in the
twenty-first century. It is perfectly legal in 38 (out of 50) United States to
fire a worker because of sexual orientation (HRC 2000). (HRC is the
Human Rights Campaign, America's largest gay and lesbian organisation
with over 400,000 members. It is a bipartisan organisation focused on
mobilizing grass roots action, increasing public understanding of gay and
lesbian issues and working towards equality based on sexual orientation.
HRC was founded in 1980.) While hate crimes due to sexual orientation
are not uncommon, federal hate crimes legislation does not address
sexual orientation. The HRC (2000) reports that hate crimes committed
against GLBT people, 'make up the third largest category of hate crimes
reported to the FBI. 11.6% of all hate crimes reported'. Heflin (2000,
p.11) illustrates the GLBT perspective:

Millions of GLBT people around the world cannot even imagine the possibility of coming out, fearful that the revelation of their true identity will result in scorn and prosecution. Their fear is warranted. Not only are those suspected of being gay, lesbian, bisexual or transgendered subjected to regular harassment, harsh discrimination and violence from other citizens; in many countries, people may be beaten, imprisoned, sometimes even killed by their own government for engaging in homosexual acts.

Those working in the helping professions continue to use 'reparative' or 'conversion' therapy, even though such therapy has been found to be damaging and unethical. (Reparative therapy is a method used by a minority of clinicians who believe that sexual orientation is not 'fixed' and thus can be repaired. Such clinicians believe homosexuality to be unacceptable, a choice, and in need of being fixed. Reparative therapy is also referred to as 'conversion therapy'.) Such therapy has now been denounced by most American practitioners, as homosexuality is not defined as an illness or as something that needs correction (American Psychological Association (APA) 1995; Markowitz 1999). 'In 1990, the American Psychological Association stated scientific evidence does not show that conversion therapy works and that it can do more harm than good' (APA 1995).

Collages presented later in this chapter (Figures 3.1 and 3.2) attest to discrimination faced on a daily basis. One only has to go to the Internet to find a vast number of web sites advertising conversion therapy, hatred, and bigotry aimed toward 'non-heterosexuals'. In the United States, a strong movement against tolerance of GLBT persons continues and Matthew Shepard's death reminds the world of continuing ignorance and hatred. (Matthew Shepard, 1976–1998, a University of Wyoming college student, was brutally beaten, tortured and left to die in Laramie, Wyoming, by his fellow students. Matthew was left tied to a wooden fence for over 18 hours and murdered because of his sexual orientation.) As Falco (1991, p.3) notes, homosexuality is still largely considered immoral by religious standards, criminal by many state and civil standards and sick or merely tolerated by many members of the psychology and medical professions. Finally, one only has to read White (1994)

to understand the horror and pain faced by too many members of the GLBT community.

Although art therapists are ethically obliged not to discriminate against clients on the basis of many things, including sexual orientation, a review of existing art therapy literature reveals little specific information on ethical obligations and approaches in art therapy for GLBT clients.

Many art therapists remain unaware of symbols often utilised by GLBT persons. They may lack understanding of particular issues affecting this population, such as homophobia, coming out and discrimination. While information on the use of art therapy with GLBT clients has become available via the American Art Therapy Association (AATA) national and regional conferences, current art therapy literature and resources are significantly limited. Thus, art therapists often have to rely on literature available in related fields instead of relying on information from their own field.

In this chapter, I shall present material related to sexual orientation, with a particular focus on transgenderism, as this is commonly the most misunderstood orientation in my view. Ethical obligations of art therapists to GLBT clients will be considered. Symbols traditionally employed by the GLBT community and the 'special needs' of GLBT (focusing on internalised homophobia) will be explored. The goals of this chapter are to increase art therapists' competency when working with GLBT clients, regardless of the sexual orientation of the art therapist and to provide a resource for art therapists working with GLBT clients. Finally, I hope that art therapists, both gay and straight, will come to recognise that while they may have considerable experience in providing high quality, effective treatment to a variety of clients, there is no reason for any professional to assume that he or she is automatically competent to work with gay people. Education for art therapists is paramount not only so that GLBT clients can receive appropriate art therapy services, but also so that art therapists themselves can understand their GLBT clients in an appropriate, non-discriminatory manner.

Definitions: Who are gay, lesbian, bisexual and transgendered clients?

Understanding the different terms used to identify sexual orientation and gender identity is integral to providing adequate art therapy services to

GLBT clients. Artwork created by a transgendered client may make 'sense' only through understanding transgenderism. Just as cultural sensitivity is vital when serving clients of varied ethnic and cultural backgrounds, without an understanding of sexual orientation, art therapists cannot truly serve GLBT clients in a efficient, effective, ethical manner.

Sexual orientation is defined as emotional, romantic or sexual attraction to persons of a particular sex. Thus, gay men and lesbians are attracted to persons of the same sex, while bisexuals are attracted to both sexes. The terms 'homosexual' and 'gay' refer both to men and women who are attracted to the same sex. Although many persons in the United States might argue otherwise, sexual orientation is not thought to be a choice by the APA (1995), which clearly states that it is not helpful and is indeed harmful to attempt to 'change' a person's sexual orientation. It is estimated that 10 per cent of North American society is comprised of GLBT persons (Bass and Kaufman 1996; Berzon 1992; Human Rights Campaign 2000; Marcus 1993).

Gender identity and transgenderists

Gender identity differs from sexual orientation, as gender identity is a person's internal conception of themself as male or female. Gender identity for transgendered clients is complicated by the complex and rather confusing terminology used to describe the various categories of transgendered persons.

A transgendered person is someone who 'bends' or challenges traditional gender roles or whose gender identity differs from conventional norms associated with cultural constructions of masculinity and femininity (AEGIS 1998; PFLAG 1998). Transgendered persons may be gay, straight, asexual or bisexual. Transgendered persons may grow up questioning their gender identity which, for them, differs from their physical sex. In essence, a transsexual is defined as a person whose sex is opposite to the sex he or she was assigned before birth; such persons may live life as a person of the 'opposite' sex or may elect to have surgery to change sexual organs. Transgendered is thus an umbrella term for (1) cross-dressers/transvestites, (2) transsexuals, (3) androgynous persons, (4) intersexed/hermaphrodites, (5) transgenderists and (6) post-operative transsexuals. A transvestite is a cross-dresser – someone who wears

clothes usually associated with the sex opposite to that assigned at birth. Cross-dressers/transvestites do not desire to change their sex and, more often than not, identify themselves as heterosexual. Androgynous people dress or appear in a manner which does not identify gender identity in a visual manner. Hermaphrodites are born with genitals of both sexes or with ambiguous sex genitalia. Often, the doctor in the delivery room will assign a sex to the newborn. Transgenderists are defined as those living full-time as the 'other' gender and may or may not pursue genital surgery. Post-operative transgendered persons have completed sex change surgery and now live as the 'opposite' sex.

Discrimination

Art therapists must recognize discrimination against GLBT peers and clients. The transgendered, as well as gay, lesbian and bisexual persons, are not often covered by existing laws in the United States; discrimination can include, but is not limited to, eviction from homes, loss of employment, denial of service at public facilities and harassment. GLBT clients or their property are often subject to hate crimes, vandalism, physical, sexual and emotional violence, lack of respect, stigmatization and refusal of treatment by healthcare providers. The mere existence of 'conversion therapy' compounds that shame felt by GLBT persons, especially when 'unsuccessful' in their conversion to heterosexuality.

In today's society, it is important for art therapists to understand that transgendered persons are often exposed to extreme discrimination, even more so than their gay, lesbian and bisexual counterparts. It is difficult for transgendered clients to obtain legal documentation with new names or genders. It is easy to see why such people are often ashamed of their 'differences', as society tends to reinforce stereotypes regarding sexual orientation and gender identity.

Ethical obligations of the art therapist

Using conversion or reparative therapy as a basis for treating GLBT clients is an unethical mode of treatment. That stated, what approach should art therapists use when serving GLBT clients in an ethical manner? AATA's (1995) recommended ethical standards specifically

prohibit discrimination on the basis of sexual orientation, although such discrimination can be blatant: diagnosing a GLBT client with mental illness because of sexual orientation or viewing GLBT clients as needing to be 'cured' are extreme but common examples. Sexual orientation discrimination can also be quite subtle and seemingly innocent; the fact that graduate programmes fail to address GLBT issues, or even the personal belief that sexual orientation is never relevant to any art therapy situation, is almost as dangerous as blatant discrimination. Any situation where GLBT clients or peers are treated differently than 'non-GLBT' clients or peers, as based on art therapist preferences or prejudices, qualifies as discrimination. Weinrich and Thomas (1996) indicate that not designating minority groups, such as the GLBT community, worthy of a professional's attention is profoundly demeaning to minorities not included, is a gross distortion of realities faced by many GLBT persons, is incompatible with the essence of the helping professions and is antithetical to why many professionals enter the helping professions in the first place. Treating GLBT clients when inadequately trained or when viewing such clients as a 'non-minority' is unethical. Examples of unethical treatment include assuming that GLBT clients are seeking art therapy because of sexual orientation, automatically assuming sexual orientation is the 'problem', perpetuating myths regarding homosexuality, subscribing to heterosexism (the belief that heterosexuality is the 'better' or more acceptable sexual orientation), or refusing to refer GLBT clients due to personal beliefs incompatible with providing art therapy to GLBT consumers. Of course, it is not necessary for all art therapists to work with GLBT clients nor is it reasonable to expect all art therapists to be tolerant of GLBT 'lifestyles'. Art therapists who cannot or will not work with GLBT clients are ethically obliged to refer such clients elsewhere for treatment.

It is important for art therapists to address their own possible homophobia when working with GLBT clients. Art therapists struggling with their own GLBT impulses or beliefs must admit they may not be in a position to provide high quality services to GLBT clients. Since art therapists cannot avoid personal and societal attitudes regarding sexual orientation, it is imperative that art therapists be aware of any prejudices of their own.

An additional ethical concern arises when GLBT art therapists work with GLBT clients, as they may find themselves in this peculiar predicament: it is often almost impossible to avoid dual relationships within the GLBT community, especially those who work in smaller communities. Care must be taken to respect boundaries between personal and professional life; for the GLBT art therapist, this may mean curtailing attendance at or even avoiding GLBT social activities if they wish to avoid seeing their clients in social situations.

'Overlap' is problematic, as GLBT clients tend to refer each other and may frequent the same activities/establishments/events. The art therapist can end up seeing several GLBT clients from a particular (and small) social circle or when participating in GLBT community events. Even in a large American city such as Rockford, Illinois (the second largest city in Illinois, with a population of 140,000), GLBT professionals experience overlapping of personal and professional life on a frequent basis. The chances are quite high that an openly GLBT art therapist will at least be acquainted with potential GLBT clients due to overlapping in the art therapist's personal life. An example of overlapping within the GLBT community was demonstrated when this writer offered an experiential art therapy course at the local GLBT community centre; the writer knew each and every participant in a social context. Since GLBT art therapists may be seen as role models and a resource for GLBT clients, they are encouraged to participate in gay-orientated activities, as long as ethical obligations regarding dual relationships are considered. As an openly gay therapist who is active in the GLBT community, it is often impossible to avoid 'running into' clients when attending GLBT community events (concerts, festivals, dinners, etc.); thus, it is important to personally address this ethical concern before contact in the community happens.

Finally, and of the utmost importance, art therapists must consider and respect the status of GLBT clients: are they openly gay ('out') or 'closeted'? To 'out' a client is a horrific breach of confidentiality and ethics.

Symbols of GLBT culture

Clients in art therapy often give 'clues' regarding sexual orientation in their artwork. As they show what they cannot 'tell', it is important that art therapists are familiar with the symbols of GLBT culture. The

six-coloured rainbow flag (purple, blue, green, yellow, orange, red), the lambda, labrys and pink triangle are currently the most visible signs of GLBT culture/support. 'Freedom rings', six metallic rings coloured like the rainbow, are a variation of the rainbow flag and are popular to wear as jewellery. The Greek letter 'lambda' is an internationally recognized symbol, chosen in the 1970s to represent the 'gay movement'; it looks like an inverted Y. A labrys is a double-headed axe from ancient Greece, usually associated with the Amazons and often worn or depicted by lesbians. The inverted pink triangle is used as a sign of homosexuality, a concept taken from the Nazis' requirement that homosexual males wear pink triangles on their clothing. The triangle itself, whatever colour, seems to have been adopted by the gay community as a symbol of sexual orientation. Bisexual persons often use a blue triangle overlapping a pink triangle (creating a purple triangle in the middle of the overlapping, larger triangles) as a sign of bisexuality. The yellow equal sign (=) on a blue background is used by the Human Rights Campaign, a GLBT political organisation in the United States. It should be noted that displaying or wearing such symbols may not represent the person's sexuality, but rather may represent a person's support for GLBT persons. (As the popular bumper sticker says: it's possible to be 'straight' and not narrow!)

Many subtle symbols of sexual orientation may be used by GLBT clients in art therapy. Symbols can include the depiction of famous/popular persons such as Melissa Etheridge (singer), Ellen DeGeneres (comedian), Elton John (singer), George Michael (singer), Martina Navratilova (athlete), k.d. lang (singer), The Indigo Girls (musicians), and Chastity Bono (activist). Entertainers such as Barbra Streisand, Judy Garland, Marlene Dietrich, Doris Day, Rock Hudson and Bette Midler serve as icons for many in the GLBT community. Locations can often symbolise homosexuality: Provincetown (MA), San Francisco (California) and Key West (Florida) are only a few examples of gay US 'destinations' that might be depicted in artwork; Amsterdam is an international destination.

Words alone are often symbolic of GLBT culture; for instance, 'barebacking' is a term describing gay men who consciously choose to have unprotected sex with other men. There are countless phrases that

represent homosexuality and are recognized within various segments of the GLBT community, from 'a friend of Dorothy's' to 'singing in the choir'. The word 'queer' is often used to depict anyone of a non-heterosexual orientation. In addition, there are myriad movies, books, music and television shows focusing on GLBT themes which might be depicted in art therapy; art therapists are encouraged to learn more about such multimedia options.

What can the art therapist do?

Familiarity and use of 'gay-friendly' publications (for making collages and for learning more about the GLBT community) is highly recommended. Creating and conveying a 'gay-friendly' atmosphere in the art therapy room speaks loudly to GLBT clients, no matter what the art therapist's sexual orientation. Access to a pile of gay magazines within a pile of other magazines when making a collage or displaying one gay-themed magazine in the waiting room will not go unnoticed or unappreciated!

An example of subtle use of a symbol representative of gay culture is illustrated in a self-portrait (Figure 3.1) by Marc, a thirty-five-year-old gay professional who is in art therapy for issues unrelated to his sexual orientation. The client created an 18" x 24" collage using a popular gay magazine which he found in a pile of 'conventional' magazines. Marc included the Rainbow credit card in the artwork, clearly representing the gay community (the card, used almost exclusively by the GLBT community, depicts the 1997 'March on Washington' and is represented by Martina Navratilova, an openly gay athlete). During the session, the recognition of the Rainbow card by the art therapist conveyed knowledge of the GLBT community in a casual manner and allowed for open dialogue during the remainder of the session.

Meeting the 'special needs' of GLBT clients

A positive approach when working with GLBT clients in art therapy can be the catalyst for great change in both the client and art therapist, yet a lack of practical knowledge about GLBT 'lifestyle' can act as a major obstacle to satisfactory, successful therapy. While a client's sexual orientation may have little or nothing to do with the reason for seeking therapy,

Figure 3.1 **Untitled**

sexual orientation is never an non-issue (Addison 1996). GLBT persons do have special needs due to their different life experiences. (This does not suggest that GLBT persons should receive special rights in the heterosexual community!) Art therapists might mistakenly believe that GLBT clients are no different from non-GLBT clients; others might

believe that gay issues are unimportant in the twenty-first century as homosexuality has gained more acceptance in the general population. Some art therapists might subscribe to the tenet that they do not need to know about working with GLBT clients because, by choice, they refuse to work with GLBT clients (even though such therapists might not realize they have GLBT clients until well into therapy). As I have pointed out (Addison 1996), art therapists might be surprised how truly heterosexist they are: a quick look at the waiting room will often convey a very heterosexist attitude. Are there any gay-orientated magazines in the waiting room? Do application forms present gay-friendly wording? Is heterosexism conveyed through the language of the art therapist? Is discussion of 'alternative' sexual orientations discussed in a casual and open manner? Does the art therapist apologise to heterosexual clients for the inclusion of gay-oriented materials during art therapy? Art therapists must remember that the art room may be the only place GLBT clients may feel comfortable enough to be themselves; it may be the only place they feel accepted for who they truly are. As a profession, we must be sensitive to the needs of all clients.

As noted, 'special' needs does not imply special rights. Instead, it conveys that there are certain aspects of being GLBT that warrant closer attention. Special concerns for many GLBT clients are in housing or employment discrimination. GLBT clients find their way into therapy for many of the same reasons as heterosexual clients, but they may have additional needs when compared to heterosexual clients. Special concerns of GLBT clients in therapy may include gender confusion, relationship difficulties related to their GLBT status, religious conflicts, stigmatization and discrimination. 'Coming out' issues, gay parenting and loss of family support can also be major concerns. Prejudice, scapegoating, rejection and actual physical danger are all special needs issues.

Therapist and client homophobia

Homophobia and 'internalised homophobia' are special concerns. Heterosexual clients are not typically hated or disowned for sexual orientation nor do most heterosexuals have to worry about responses to their relationships. Most people in the United States are conditioned to believe that they will be heterosexual. Few can truly say that as a child they were

told about a life other than heterosexual. Can any GLBT person say they were delighted when struggling with their non-heterosexuality? Society sends a strong message which can understandably lead to conflicting feelings regarding sexual orientation. Internalised homophobia is the result of being brought up in a heterosexist environment. It is simply believing society's negative attitudes towards homosexuality that can result in guilt, low self-esteem, fear and even self-hatred. Internalised homophobia is the internalisation of anti-gay stereotypes and myths (Berzon 1996; Brody 1994). Homophobia feeds the hatred, ignorance and prejudice of society at large. Gay men have continually (and unfairly) been linked with AIDS, even though they do not represent the fastest growing population with HIV. Self-disclosure of the art therapist's own sexual orientation may lead to being ostracised within the profession, or result in the suspicion regarding that professional's motives. Internalised homophobia can be complex, as evidenced by the GLBT person discriminating against another GLBT person. People of any sexual orientation can experience internalised homophobia. As Loulan (1987) writes, 'I think that inside every single one of us is a place in which we believe that being a lesbian is just sort of gross. No matter how much fun we have, no matter how proud we feel, no matter how in love or loved we may be, we all internalise the homophobia that surrounds us'. Unconscious or conscious, the combination of negative attitudes and an individual's fear of homosexuality add fuel to the fire of internalised homophobia. Is it any wonder that depression, fear, shame, guilt and self-loathing can be major stumbling blocks for GLBT persons (or even for those perceived as being GLBT). Internalised homophobia can lead to misdiagnosis and mistreatment. In an effort to address this problem, it is suggested that the art therapist work to establish positive therapeutic rapport and a change of attitude.

Artwork produced by a thirty-year-old 'closeted' professional female depicts her struggle with internalised homophobia (Figure 3.2). Jamie was very fearful that she would lose her job as a teacher if her sexual orientation were to be exposed. The client utilised words and symbols of the gay community to create her self-portrait. The collage, a work created of symbols ambiguous enough to express self without increasing the already overwhelmingly low self-esteem due to internalised homopho-

bia, was a breakthrough for the client. Jamie was able to safely express her pride in her sexual orientation through art materials; her safety was supported in the group setting by the art therapist. Her work served as a 'springboard' to discuss and convey her deep conflict regarding her sexual orientation and allowed her an opportunity to talk about society's discrimination and hatred.

Figure 3.2 **Untitled**
© Donna Addision

The challenge of providing art therapy to GLBT clients

Art therapists should recognise that GLBT clients are a diverse group and include people of all ages, races, religions, nationalities, socioeconomic backgrounds within a variety of occupations and contexts. As indicated, art therapists are ethically bound to serve GLBT clients in an non-discriminatory manner, yet little information on serving this population exists within art therapy literature. Education during art therapy training could be very important in alleviating prejudice, dispelling myths and preparing art therapists. Art therapists would be wise to become familiar with literature from counselling, social work and psychology until more art therapy resources can be developed. Art therapy training institutions should include the topic of art therapy with GLBT clients as part of the curriculum. Credentialing boards should work to ensure that ethical obligations are met by registered and certified art therapists. Art therapists should be encouraged to help people of all sexual orientations to accept and integrate their feelings and to overcome others' homophobia and false beliefs. GLBT people will seek out art therapy for the same reasons as heterosexuals. It is vital that art therapists are prepared to serve these clients with a strong fund of knowledge and an open mind. The challenge for art therapists is to provide a setting of acceptance for all clients.

Bibliography

Addison, D. (1996) 'Message of acceptance: Gay friendly art therapy for homosexual clients.' *Art Therapy; Journal Of The American Art Therapy Association 13*, 1, 54–56.

American Educational Gender Information Service (AEGIS) (1998) *Transgender: What is it?* Decatur, GA: AEGIS.

American Art Therapy Association Inc. (AATA) (1995) *Ethical Standards for Art Therapists.* Mundelein, IL: AATA, Inc.

American Psychological Association (APA) (1995) *Psychology and You: Answers to Your Questions about Sexual Orientation and Homosexuality.* Washington, DC: APA.

Bass, E. and Kaufman, K. (1996) *Free Your Mind: The Book for Gay, Lesbian and Bisexual Youth and Their Allies.* New York: Harper Perennial.

Berzon, B. (1992) *Positively Gay: New Approaches to Gay and Lesbian Life.* Berkeley, CA: Celestial Arts.

Berzon, B. (1996) *Setting Them Straight. You Can Do Something About Bigotry And Homophobia In Your Life.* NY: Plume.

Brody, R. (1994) 'Ambiguity and integration: A meeting ground for art therapy and lesbian and gay identity development.' *Pratt Institute Creative Therapy Review 15,* 35–43.

Falco, K. (1991) *Psychotherapy with Lesbian Clients.* New York: Brunner/Mazel.

Helfin, M. (2000) 'My perspective: Beyond our borders.' *The Advocate,* November 7, 2000.

Human Rights Campaign (2000) *The Law and LGBT Workplace.* www.hrc.org/worknet.

Human Rights Campaign (undated) *Human Rights Campaign Foundation Resource Guide to Coming Out.* Washington, DC: Human Rights Campaign Foundation.

Loulan, J. (1987) *Lesbian Passion: Loving Ourselves and Each Other.* San Fransisco: Spinster/Aunt Lute Press.

Marcus, E. (1993) *Is it Choice? Answers to 300 of the Most Frequently Asked Questions About Gays and Lesbians.* New York: HarperCollins.

Markowitz, L. (1999) 'Dangerous practice: Inside the conversion therapy controversy.' *The Family 4,* 3. 10–25.

Parents and Friends of Lesbians and Gays (PFLAG) (1998) *Our Trans Children.* Washington, DC: PFLAG.

Weinrich, S. and Thomas, K. (1996) 'The Counseling profession's commitment to diversity sensitive counseling: A critical reassessment.' *Journal of Counseling and Development 74,* 3, 472–477.

White, M. (1994) *Stranger at the Gate: The be Gay and Christian in America.* New York: Simon and Schuster.

Singing With Pleasure and Shouting with Anger: Working with Gay and Lesbian Clients in Art Therapy

Jean Fraser and Judith Waldman

Introduction

In 1998, the Psychoanalysis and Homosexuality Conference took place at Addenbrooke's Hospital in Cambridge. Several art therapists, including the authors, attended and together we recognised the need for a forum to discuss omissions and silences we had experienced around sexuality within our profession. Out of this day emerged the Lesbian Gay Bisexual and Transgender Art Therapists' Network (currently relaunching as the Sexual Identity and Gender in Art Therapy British Association of Art Therapists sub-group). Our early discussions with colleagues at Network meetings identified a range of issues not currently addressed: the pathologising of homosexuality within traditional psychoanalytic literature; the inappropriateness of certain key psychoanalytic concepts for working with gay clients; the complex issues relating to disclosure of lesbian or gay sexuality both for clients and for practising and training art therapists; and the massive silence around homoerotic transference and countertransference.

In this chapter we will begin to explore these questions in the hope that the debate will widen. We write, not as outsiders, but from within the

profession, where there are many voices to be heard including, of course, the others in this book. We ourselves bring different voices and influences to this collaboration. Judith's interest in social art therapy (Hogan 1997) and narrative therapy (White 1991) has informed her long-term therapeutic relationships with lesbian clients, together with her conviction that the daily subversive acts of identifying as lesbian, gay, bisexual or transgendered challenge the status quo of social relationships. Jean has a long-held interest in post-structuralist theories which deconstruct meaning and foreground the ideological underpinnings of what we perceive as 'truth'. Her brief (twelve-week) psychodynamic art therapy interventions with a large number of gay men and lesbians, together with her experience in group supervision with lesbian and gay therapists utilising a range of different models, has convinced her of the limitations of an unquestioning adherence to any single therapeutic model.

The process of this collaboration has been stimulating, but it has also sometimes felt painful. While we both share a psychodynamic baseline, we have struggled to find ways in which our sometimes very different views could be woven together. There is a tension between the position of victim in relation to discrimination and marginalisation, and that of queer political activist – 'We're here, we're queer, get used to it' – whose uncompromising attitude does not seek heterosexual society's tolerance or approval. We have felt ourselves located at different positions at different times in relation to these polarities. However, having a shared understanding of what it feels like to experience oneself as an outsider is an important part of what we bring to our art therapy work. What we are emphatically agreed upon is the importance of the social context in our art therapy work and that it is homophobia, not homosexuality, which is pathological and which can contribute directly or indirectly to depression, anxiety and other mental health problems for lesbians and gay men. We have both been sustained by Sally Skaife's perception about the radical and empowering basis of art therapy, the function of art as a mirror of society, and art therapy's consequent potential as a subversive activity (1995, p.2).

Art therapy and sexuality

Art and sex, they're the same thing

<div align="right">

(Picasso in Jeffries 2001)

</div>

The 'postmodern' emphasis on a plurality of voices and truths has begun to infiltrate our profession, enabling concerns around, for example, race and culture (Campbell *et al.* 1999) and race and feminist concerns (Hogan 1997) to be explored. However, with the recent welcome exception of Jane Dudley's article in Inscape (2001) on the effects of heterosexual bias on art therapeutic practice, few art therapy publications have so far addressed sexual orientation, the identities produced by same sex object choice, and how either of these might manifest within the art therapeutic work. The many psychotherapy texts which have explored what it means to identify as a lesbian or gay person within a heterosexual mainstream (for example O'Connor and Ryan 1993, Shelley 1998) tend not to be included within our training institutions' reading lists. This virtual erasure of sexual orientation or identity within the art therapy profession impacts on art therapists in several ways. First, there is a lack of awareness of how homosexuality is pathologised within traditional psychoanalytic theory. Second, there is a limited understanding of the effects of prejudice and stereotyping on lesbian and gay clients. Third and most important, there is the issue of our own potential to remain emotionally available when becoming the subject of homoerotic transference.

Art therapy training institutions have equal opportunities policies and the overt discrimination that has until recently prohibited lesbians' and gay men's entry into many psychotherapy training institutions does not appear to have happened in our profession. However, having equal opportunities policies may mask the need for our training institutions to confront the social and psychic realities of those groups whose rights they aim to protect. Our conversations with lesbian and gay art therapists indicate that many have experienced a sense that their sexual identities could not easily be expressed in training. Sexuality seldom seems to be discussed, let alone homoerotic transference and countertransference; many lesbian and gay art therapists have told us that this absence only hit them after qualifying. Perhaps the taboo of sexual impropriety within the

therapeutic relationship looms so large in the background that a form of censorship and emotional inhibition prevails.

If, as Merleau-Ponty states, 'there is an interfusion of sexuality and existence' (1986, p.169), surely it is important for training art therapists to have encouragement to examine their own cultural awareness and sexual biases. It is not realistic to assume that this will automatically happen in personal therapy. It is particularly hard to see how, as art therapists, we can provide a safe space for lesbian and gay clients if our own sexuality and sexual anxieties have not been adequately worked through, or the complexity of lesbian and gay object choice and lifestyles is insufficiently understood.

Cultural definitions of diversity

I would like to believe in the multiplicity of sexually marked voices...this mobile of non-identified sexual marks whose choreography can carry, divide, multiply the body of each individual, whether he be classified as 'man' or 'woman'.

(Derrida, in McDonald 1982)

We use the terms 'lesbian' and 'gay' to encompass self-identified gay men and women, bisexuals and transgendered individuals and those who relate to the more recent 'queer' identity. Also included is anyone who may be questioning their sexuality, or engaging in any way in same sex behaviour or desire. All these definitions will have a multiplicity of meanings for those who embrace them. While necessarily transitory, these terms of identity can enable individuals to recognize themselves and each other, to form cultures and communities and to have a social, political and sexual engagement within a mainstream culture in which they might otherwise feel marginalised and isolated.

Attitudes to homosexuality have not been constant but have varied across cultures and across time. Homosexuality has been sanctioned in some cultures, for example the Berdache in Native American society or the Hijras in India, and reviled in others, such as countries operating Sharia law. Foucault (1981) has pointed out that in Europe the category 'homosexual' only emerged at the end of the nineteenth century through a range of discourses – sexological, religious, legal, psychoanalytic –

which established same sex behaviour as an object for investigation and regulation. We agree with Foucault's rejection of fixed definitions of homosexuality and his emphasis on the role of discourse in constructing sexual meanings and definitions. As he notes, what is crucial is to discover what voices and viewpoints are involved in these constructions. Most relevant to our work as art therapists is an understanding that the meanings we ascribe to homosexuality are not 'natural' but rather historical and ideological, as are the normative values Western culture attributes to heterosexuality.

There is, of course, a tension between the assertion of a fluid sexuality and our use of definitions that can, and have been, taken to imply fixed identities. In using these terms we do not see sexual identity as fixed but rather in continual negotiation at both conscious and unconscious levels, not only in relation to sexual practice, but also with respect to gender, race, class, age and an infinite number of other social or psychic possibilities.

It is important to remember that many lesbians and gay men will come to art therapy bringing issues which have little to do with their sexuality, for our identities encompass far more than our sexuality alone. Some people who practise same sex behaviour may not wish to identify as lesbian and gay. Others, for a variety of reasons, may never have felt able to enact their sexual desires, as in the following case study of art therapy work carried out with an older client who was able to 'come out' as bisexual during the course of the therapy. This case study will also attempt to illustrate the complex overlap of different group identities. The client's reflections on the impact of oppression on her life are explored, as well as the meaning for her of self-recognition and change. In this example the therapist is one of the authors who saw the client for six months on a one-to-one basis.

Pat

Pat, a sixty-eight-year-old client at a day hospital for the elderly, presented as an articulate and softly spoken widow who suffered from depression and anxiety attacks. She was enthusiastic about art therapy

and the process of mixing her own watercolours, which expressed her feelings 'better than words'.

Pat said she was not 'the frilly type', and had joined the army in her twenties, where she loved wearing a uniform and high boots. When she exclaimed, 'Maybe I'm a cross-dresser?', I was initially surprised and then wondered if a 'closeted' part of me had subconsciously colluded with the day hospital's assumption of a heterosexual norm. Pat then poured out details of her unlived-out feelings for women, making it unmistakably clear that the suppression of her gender identity and choice of love-object had been a lifelong dilemma for her, and a major cause of her depression. We discussed how the exploration of her potential to be bisexual had been censored by a thirty-year-long, unhappy and emotionally abusive marriage. After describing her previously hidden pleasures in reading lesbian novels, she exclaimed, 'I've come out!'

Pat's relief after her disclosure was palpable as she played flirtatiously with erotic transference. When a nurse unexpectedly popped her head into the art studio, Pat grinned mischievously, and said, 'We could have been up to anything!'

However, Pat was beginning to understand how complex her identity was and experienced this complexity as both liberating and bewildering. A set of four pictures from a single session depict this process. Pat gave names to the pictures, the first being entitled *In the Depths*, where she felt trapped, locked-up and depressed. In *Trying* she saw light at the end of the tunnel, indicating many choices, many tunnels; in *Almost There* she had hope and finally came through to *Free at Last*, where she had found her way through the maze to a less encumbered self. Her hope in the future was expanded in a further series of paintings of herself in rainbow colours, which expressed 'the right to be bisexual, the right to be me', embodying a more integrated vision of herself as independent and androgynous. Interestingly, in the bottom right-hand corner of this picture there is a couple standing side by side, maybe about to enter into the semicircle of a community of colourful figures. I wondered if this was an expression of her fantasy enacting her newly acknowledged desires.

Although Pat felt frustrated that a different, self-defined life could have been possible, she described feeling *reborn* through the creation of her imagery. The multi-layered symbolism of the rainbow colours in her pictures reflected a much richer view of her own personality, as well as a sexually diverse community with which she could now identify. However, after having her hair cut short, Pat worried that she looked 'masculine', and 'too much like a lesbian'. At this point she began to have persecutory fears that if her dead husband knew about her disclosures he would have 'more ammunition' with which to torment her. Her joy at her self-discovery was painfully undermined by fears of people 'out to get me'. She agreed when I tentatively suggested that this anxiety might be connected to internalised homophobia, the same negative cultural attitudes to same sex object choice which could have suppressed the exploration of her sexuality earlier in her life.

Discussion

My work with Pat made me aware of the possibility of stereotyping specific client groups; in this case there was an expectation that issues would arise relating to bereavement, physical decline and approaching death to the exclusion of issues such as gender and sexuality. However, Pat had other ideas, and having come out it then became crucial to her that both the day hospital team and myself acknowledged this new aspect of her identity. As a result of this work, discussions within the multi-disciplinary team began to include awareness of unfulfilled sexual identity as part of their clients' 'life reassessments' (Jung 1960).

Pat's former desexualisation in this setting for the elderly has much in common with the experience of clients with physical or learning disabilities. A similar issue also surfaced with a thirty-year-old woman with multiple sclerosis living in a Catholic nursing home, who disclosed in art therapy that she had a lesbian lifestyle before being incapacitated by illness. She felt that her physical disability overshadowed her lesbian identity in an institution she found desexualising.

This case study embodies a wide range of concerns which we believe are frequently present when working in therapy around sexual identity, sexual object choice and lifestyle. These concerns include the importance

of coming out; the effects of traditional cultural attitudes to gender which often 'conceal an underworld of (sometimes desperate) improvisation' (Phillips 1994, p.127); the stereotyping of the needs and issues of particular client groups; the importance of cultural symbols of identity; and the importance of acknowledging and grieving the psychic and social consequences of internalising society's homophobia.

Homophobia, social context and a sense of self

[Homophobia is] the fear of feelings of love for members of one's sex and therefore the hatred of those feelings in others. The belief in the inherent superiority of one pattern of loving and thereby its right to dominance.

(Audre Lorde in Golding 1996)

'Filthy poofs…you should all be bombed.'

(Phone call to Stonewall lobby group following the bombing of the Admiral Duncan gay pub in 1999)

Lesbians and gay men are defined and categorised as 'other' by a dominantly heterosexual society and this sense of 'outsidership' is likely, to some degree at least, to be embodied in the issues which are brought to art therapy. Society's lack of acknowledgement may cause immense difficulties in relation to self-esteem, the establishment of sexual identity and mental health. An example of how this societal invisibility was internalised by a lesbian client working with one of the authors was expressed in a picture of a blank mirror (see Figure 4.1). The client described the sense that her sexual identity was unacceptable, and this perception was reinforced by her experience of the under-representation of lesbians in the outside world.

Figure 4.1 **The Blank Mirror**

For lesbians and gay men, homophobia means the attack on the self embodied by day-to-day experience of prejudice and discrimination. This can take the form of stereotypes which have the effect of reducing gay men and women to what they do in bed. Or it may be institutionalised through legal and moral discourses which reflect social anxiety about the robustness of heterosexuality and the family, such as Section 28 of the Local Government Act, 1988 (HMSO 1988). This forbade the discussion of homosexuality in schools, denying the validity of what it termed 'pretended family relationships'. Furthermore, the act legitimised censorship and functioned to reduce support for gay young people and enable bullying to go unchallenged. This invidious piece of legislation is still in force.

We both became aware during our training that there was often little understanding of how homophobia (or indeed other prejudices) can exist

unconsciously within us all, however well-intentioned we may be. There often seemed to be little knowledge of the consequences of homophobia for lesbians and gay men. These can mean loss of home, children, job, inheritance rights, bullying at school, relationship difficulties, and family and parenting problems, sometimes including outright rejection.

Vignette

> The despair of family rejection was expressed vividly by 'Alan', a young gay man whose mother had become very cold towards him when he came out to her. He painted a figure on a raft floating in the middle of an empty sea, in front of a huge setting sun. The figure was the only part left unpainted, a featureless gap in the middle of the picture. As he finished he said, 'I just want to be in the sun again'; a poignant double meaning. In the following session he painted the blank-figure-shaped area black. He then began to connect to depressed feelings, and to explore his need for his mother's acceptance.

Research indicates the raised level of suicide and suicide attempts amongst lesbian and gay teenagers in comparison with heterosexual young people (Bridget 1995; D'Augelli and Hershberger 1993; Trenchard and Warren 1984). Sickness and death due to HIV and AIDS has also had a massive impact on the gay communities. Coming to terms with an HIV diagnosis and mourning for multiple bereavements due to the virus is clearly more difficult when HIV is seen by society as self-inflicted.

Less tangible but more insidious is how homophobia can become internalised as shame, as the result of inhabiting a context where prejudice is part of the social fabric. One of the authors was present at a training workshop held in 1998 at a lesbian and gay-run counselling organisation, where counsellors were asked to name some of the problematic perceptions they had encountered. An hour later ten A1 sheets of paper were covered in writing: *predatory, narcissistic, immature, child molesters, diseased, unnatural, unreliable, lonely, deviant, promiscuous, can't make stable relationships, sick, perverted, should be killed, need a good fuck, can't get a man/woman, just a phase, barren, must have been abused.* Although the degree

of wounding caused by these societal projections will vary, many lesbians and gay men do not escape without some degree of self-hatred or doubt, regardless of how clear they may feel about their sexual identity (O'Connor and Ryan 1993, p.249). Art therapists may become the object of negative societal transference so it is important that this can be tolerated as part of the therapeutic work.

Vignette

One of the authors was struck by repeated comments made by a lesbian client. 'My family is really a mess. We've got everything, a child molester, a prostitute, a murderer, a drug addict and a lesbian.' It was important for the therapist to maintain her own role as a 'stand-in' for societal homophobia (Ryan 1998), which enabled her to tolerate the equating of lesbian sexuality with categories of which the client was ashamed. Her temptation to counter these comments with gay affirmative remarks had to be resisted, as she was aware that this would have denied her client the therapeutic space to express and be with her pain.

Psychoanalytic explanations, psychiatric struggles

Then I caught myself foolishly imagining that gays might some day constitute a community rather than a diagnosis.

(White 1988, p.183)

Psychoanalytic discourse has concerned itself more with why a client may be lesbian or gay, and has ignored how homosexuality is experienced by the client in his or her life, a causal investigation which is not paralleled in relation to heterosexuality.

This search for explanations has been a major contributor to the naming of homosexuality as deviance from the heterosexual 'norm'. We are indebted to the increasing number of psychotherapy publications (e.g. Hopke 1989; Lewes 1989; O'Connor and Ryan 1993; Shelley 1998) for a wealth of research on this subject. We have had to restrict our discussion to highlighting just some of the theories which have contributed many

contemporary assumptions and stereotypes of homosexuality described in the previous section.

Beginning with Freud, we can find a surprising, if confusing, range of ambiguities. Freud shocked contemporary Viennese society by declaring that homosexuality was not a sickness and signed a statement opposing its criminalisation. He was also clear that being homosexual should not be a bar to training as an analyst, an understanding so far ahead of its time that we are only recently catching up with it over the last few years. Freud's enlightenment is echoed in his famous assertion in 'Three Essays on the Theory of Sexuality' (1905, p.145) which asserted that: 'all human beings are capable of making a homosexual object-choice and have in fact made one in their unconscious'. This belief in what Freud coined 'polymorphous perversity' – an innate bisexuality in everyone – offers the possibility of viewing sexuality in a mobile and fluid way (Izzard 2000, p.109). Heterosexuality did not seem to be taken for granted by Freud, for Izzard continues, 'Thus from the point of view of psychoanalysis the exclusive sexual interest felt by men for women is also a problem that needs elucidating and is not a self-evident fact'. So far, so good.

However, Freud's answer to elucidating the problem of heterosexuality was to conceptualise the Oedipus complex, where the child takes the parent of the opposite gender as its love object. And, crucially for homosexuals, this theory set the scene for psychoanalysis seeing same sex object-choice as developmental failure: immature, narcissistic, arrested development and as the outcome of failed heterosexuality. We can see this position present in Freud's case study *The Psychogenesis of a Case of Female Homosexuality* (1920) in which he links his client's lesbianism with her supposed 'masculinity'. Her sexuality is reduced to a discussion of her disappointment in her father and her consequent repudiation of men. As O'Connor and Ryan have noted, viewed from this perspective female homosexuality can only be seen as a negative and reactive choice (1993, p.42).

Like many others before and after her, Melanie Klein also saw homosexuality as caused by unsatisfactory negotiation of the Oedipal complex. In abandoning Freud's theory of bisexuality, she reinforced the equation of homosexuality with pathology (Maguire 1995, p.205). In addition, O'Connor and Ryan note that Klein's object relations perspective led her

to further pathologise homosexuality as a destructive and oral sadistic relationship of part objects resulting from unresolved difficulties at the paranoid schizoid position. In other words, Klein saw same sex object choice as a defence against psychosis (O'Connor and Ryan 1993, p.77). Throughout Klein's writing she assumes a *natural* causality connecting biological sex, gender and desire, so it is hardly surprising that she saw heterosexuality as the only successful outcome to an analysis (Klein 1984, p.45). No room is left in this perspective for the positive adoption of a lesbian or gay identity or as a viable sexual orientation in a predominantly heterosexual world.

Although Jung avoids Oedipal reductionist explanations of homosexuality, he nevertheless replicates many of the normative conclusions of Freudian thinking. Despite his attempt to understand the individual psyche through a wealth of cross-cultural myths and stories, the centrality of 'archetypes' in Jung's perspective cannot allow for any real acceptance of fluidity of object choice. Contemporary Jungian analyst Robert Hopcke, for instance, noted that in 1921 homosexuality was seen by Jung as an identification with the contrasexual archetype; the animus for women and the anima for men. This is suspiciously similar to the familiar narcissistic stereotype of homosexuality.

O'Connor and Ryan note that Jung 'retains a dualistic metaphysics, an assumption of an oppositional universal notion of "the masculine" and "the feminine"' (1993, p.160). In their view this position fails to take account of the diverse understanding of masculinity and femininity which exists between individuals and across different cultures, historical moments and social contexts.

Unfriendly persuasion

I went from talking about not wanting to be with men and choosing celibacy to talking about wanting to be with women and foregoing celibacy, then she said that I was not struggling hard enough for my heterosexuality.

(Brenda in PACE 1998, p.66)

In recent years, the status of homosexuality has been fiercely contested both within psychoanalytic theory and institutions, and within mental health discourse. Although homosexuality was declassified as a disease

by the World Health Organisation in 1992 and no longer appears as a pathology in the *Diagnostic and Statistical Manual*, there are still contemporary psychoanalysts who advocate use of the profession to 'cure' individuals of their homosexuality. One of the most notorious and emphatic of these homophobes is Charles Socarides who maintains that all homosexuals are in need of treatment. An extraordinary degree of generalisation and stereotyping prevails in his writing such as his explanation as to why homosexual clients have left analysis: 'Because of their *pathological narcissism*, they seem unable to maintain a continuity of analysable [sic] transference relationships…they often suffer from poor object relationships and/or lack of object constancy' (1979, p.263, authors' italics). For us, it is precisely this kind of thinking which is pathological!

In 1995, a vociferous campaign was organised by institutions and individual members of the psychotherapy community to prevent Socarides from taking up the NHS Association of Psychoanalytic Psychotherapy's invitation to give their annual keynote address. So began a counter discourse whereby some psychotherapy training institutions began to reassess their long-standing block on the entry of lesbians and gay men into training, and to instigate equal opportunities policies.

The work of Socarides and others like him is echoed by psychiatry's history of heavy-handed and cruel attempts at cure. As recently as the 1970s, shock therapy was still being used in South Africa, while in Canada a gay man who endured three-times-a-week shock and aversion therapy has written a comic but understandably angry and bitter article about encountering his ex-psychiatrist four years later at a gay club (Riordon 1982). Currently, the most insidious attempts at 'curing' homosexuality, however, are through the ministrations of the 'ex-gay movement', a more recent manifestation of the religious right, in which lesbians and gays are persuaded to adopt a heterosexual lifestyle in the name of religious duty, often with tragic consequences.

What theory?

> *Starting with two sexes, as we must – described as opposites or alternatives or complements – locks us into a logic, a limiting binary system, that often seems remote from lived, spoken experience, and is complicit with the other binary pairs – inside/outside, primary process/secondary process, sadism/*

masochism, patient/analyst, and so on – that are such a misleading part of psychoanalytic language. There is, as it were, always another alternative. We should be speaking of paradoxes and spectrums, not contradictions and mutual exclusion.

(Phillips 1995, p.84)

Binarism has been present as an organising principle within Western philosophical thought since Greek civilisation. Homosexuality and heterosexuality now tend to be constructed in an oppositional way, as are nature versus culture, genetics versus social construction, reason versus emotion and many other concepts. We have reproduced in full this somewhat lengthy quotation by post-Freudian psychoanalyst Adam Phillips because it sums up for us many of the difficulties embedded within many approaches to human sexuality and sexual identity. We have found it especially helpful in considering alternatives to orthodox theoretical formulations of homosexual desire or identity.

In the face of the pathologising of homosexuality by traditional psychoanalytic developmental explanations, and the cruelties of psychiatric and religious meddling, how can we construct a flexible theoretical framework to help contain our work with lesbians and gay men? It would clearly be silly to exclude the insights of object relations theory on the strength of Klein's prejudice towards homosexuals. In any case, theory can never be neutral – all theories have ideological underpinnings – and it is a mistake to imagine that any single approach could be self-sufficient and right and others irrelevant and wrong. It is hard, for instance, for psychodynamic theories, with their emphasis on the client's inner world and on the therapeutic relationship inside the art therapy space, to engage helpfully with the lesbian or gay client's external social context. However, gay affirmative therapy, a recent development in reaction to the pathologising of homosexuality in traditional psychoanalytic literature, does not easily enable the exploration of the shame connected with internalised homophobia. Aspects of both models may be useful.

Vignette

One of the authors worked in brief art therapy with 'Jane', a thrity-five-year-old woman who had been ashamed of the sexual

feelings for women which she had experienced for twenty years. She was scared to act on these feelings and had never previously told anyone about them. Jane was married with no children and she was involved with a fundamentalist Christian church which condemned homosexuality out of hand. In one session she began to look at lesbian magazines which the therapist had included as a 'message of acceptance' (Addison 1996) in the large pile which was available for collage. Jane appeared embarrassed, turning the pages rapidly, and when the therapist reflected this back to her, she began to spend longer looking at the photographs and said she would like to cut some of them out. As she did so, sticking them down in rows, she began to talk of which women she fancied, and which ones were 'like me'. She seemed very clear about who she identified with, and who she desired. However, after a silence, Jane expressed fears that she was too ugly to be fancied by anyone. She could not imagine going to a club on her own. The therapist was aware of her fear that she would never find anyone with whom she would be able to enact her desires. While engaging in this discussion, the therapist experienced a fantasy that both she and Jane were visiting clubs together. This fantasy felt protective and put her in touch with how terrifying meeting lesbians felt for Jane and what a risk she had taken in coming to therapy at all. Jane was able, through her collage, to begin to engage in issues of identity, identification and desire. Her artwork was able to hold her difficult, shameful feelings and to open up a space between herself and the therapist where for the first time they could be safely expressed.

The above intervention took place in a lesbian and gay-run counselling service. This raises the issue of disclosure of therapist's sexuality, and in this case the therapist was 'out' to the client by virtue of her presence within the setting. Many lesbian and gay people seek out this kind of organisation, looking for a sense of safety and understanding. Such a choice needs to be respected, and often arises following negative experiences of prejudice and insensitivity within mental health or therapeutic settings. It is especially important that issues of difference between client and therapist can be explored in their work together so that merging and collusion is avoided. Functioning within the NHS as both of us do, we would not ourselves usually consider disclosing our sexuality to clients.

However, the following vignette, where circumstances forced one of the authors to re-evaluate her position on disclosure, makes an interesting exception.

Vignette

The therapist was present at the annual Gay Pride march, a celebratory highlight of the lesbian and gay communities, where she unexpectedly ran into a lesbian client with whom she was currently working. When, at the next session, the client expressed her puzzlement about this, the therapist felt she had a choice; she could work with the client's fantasies, or she could disclose her lesbianism. The therapist felt that if she denied or withheld her personal reasons for identifying with the march she risked conveying a message of shame which could reinforce her client's negative self-image. As she felt that her own positive identification as a lesbian was likely to enhance her client's self-esteem, she decided to come out to her. This proved to have a beneficial effect on the therapy, as the therapist functioned as a positive, successful role model, which the client could hold up against her own internalised homophobic images of lesbianism. This was the client mentioned earlier who had drawn an image of a blank mirror (see Figure 4.1). The therapist felt her decision to disclose her sexual orientation counteracted 'the profound absence of mirroring of lesbian orientation' (Gair 1995, p.121) which can contribute to feelings of shame and social stigma about being gay.

The homoerotic therapeutic relationship

...the desire for closeness needs to take its particular shape in any therapeutic pairing. This may sometimes challenge the therapist to question her own sexual orientation: is it fixed or can we freely experience within ourselves the variety of possibilities.

(Schaverien 1998, p.187)

We were intrigued by Ryan's invention of a fictitious character, the 'liberally minded practitioner' (1998) who wishes to take up a more open position towards homosexuality but is affected by anxieties resulting

from the cultural silences which exist around homosexual eroticism. Besides fears of appearing homophobic and fears of ignorance about homosexual activity or lifestyle, many lesbian and gay clients have bemoaned the necessity of having to teach their therapist about their life-styles (Izzard 2000). Significant anxieties can arise for heterosexual therapists about being the object of homosexual transference.

David Mann has also pointed to anxieties associated with homoerotic transference, and the defences which can be mobilised against countertransference feelings by heterosexual therapists who have not come to terms with their own unconscious bisexuality (1997, p.104). Mann gives an example of his own anxiety. When complimented on his appearance by a gay client he found himself imagining his wife's breasts. These anxieties can also be linked to the taboo on acting out sexual desire within the therapeutic relationship (Mann 1997, pp.101, 104).

Unfortunately, therapeutic opportunities to work with lesbian and gay clients' feelings of longing, despair or shame can be lost because of the heterosexual therapist's feelings of discomfort.

In his groundbreaking paper of 1959, 'Oedipal Love in the Countertransference', Harold Searles was able to relate movingly his 'wholly delightful fantasy' of being married to a male homosexual patient (p.295). This experience opened up an understanding of how difficult the patient found it to experience such desires, an understanding which could have been lost without Searles' openness to his own countertransference.

A frequent defence against homoerotic countertransference anxiety that we have both encountered from colleagues is to interpret homoerotic transference (or indeed any erotic transference) solely in terms of infantile eroticism experienced between the baby and mother. It is, however, essential to consider whether such transference may also relate to current adult feelings. This is explored further in the case study discussion below. Interestingly, Schaverien has acknowledged how engaging with the adult aspect of the transference might have deepened the therapeutic relationship with a male client (Schaverien 1995, p.30). She has argued that '... there are times when interpretation of adult feelings in infantile terms is a defence for the female therapist against consciousness of sexual arousal'.

Another interesting clinical example is described by Ryan, in which a lesbian client brought to her therapist dreams of a sexually explorative nature involving a female lover's vagina (1998, p.49). The therapist linked these dreams to a child's curiosity towards her mother's body, which Ryan calls 'a developmental interpretation that the patient experienced as shifting the focus away from the mainly sensuous and erotic nature of her dreams'. This 'left her feeling angry and unhelped' and unable to continue to explore her own sexuality and her erotic transference towards the therapist. One of the authors faced major challenges relating to the homoerotic transference of her client in the following case study.

Sinead

Sinead was 24 when we began individual art therapy at an outpatient day hospital, after she had spent two years in a therapeutic community. Her history included early childhood sexual abuse by her mother, male relatives, and a carer at the children's home she was moved to by social services as a teenager. She had identified as gay since early adolescence, and had experienced a great deal of disapproval from both her biological and foster mothers. A great concern of hers was that people thought she was a lesbian because she had been abused. This incensed her. I was reminded of other lesbian clients in my clinical experience who had been abused and who were haunted by this assumption. Golding's research (1997) provides evidence of lesbian mental health users who have experienced similar difficulties.

When Sinead's transference spilled over into intense and prolonged erotic feelings, I felt that interpreting it in relation to a mother/child scenario missed acknowledging the rapport between two women, therapist and client, who shared a sexual desire in women (Ryan 1998). Sinead felt ashamed and embarrassed about her feelings, and wrote several confessional letters to me. She wrote that she was troubled by dreams in which she felt a 'very close bonding' between us, 'like there's a very powerful overwhelming feeling of love and strong sexual desire'. Her fantasy gave me the active role which she saw as 'masculine', as if she could

not be active and simultaneously be 'feminine'. My interpretations that these were feelings she might have felt for a mother figure were seen by her to be inaccurate, and therefore insisting on an incorrect interpretation would have done her a disservice.

It was very challenging to contain feelings such as embarrassment, shame and desire, and to deconstruct their sources. This meant that we had to disentangle unresolved childhood experiences from adult emotions, as well as guilt relating to being gay and to having feelings towards me which Sinead felt were inappropriate. Her honesty in addressing these feelings made it possible for me to follow her lead and explore my own feelings of discomfort. During the rawness of these discussions I felt as if we were treading on very taboo eggshells!

In my countertransference, I wondered if my emotional availability had been experienced by Sinead as seductive. Through careful supervision and self-analysis I realised that these thoughts were stimulated by feelings of guilt arising from internalised shame. As we continued to work through these issues, the erotic transference became a vehicle by which Sinead was able to explore the acceptability of her lesbian sexuality more openly than previously. It also enabled her to question what she saw as 'feminine' and 'masculine' behaviour with greater flexibility and to develop acceptance of her own desire. I was deeply moved by Sinead's courage in addressing these difficult issues, and hoped that by dealing with her feelings honestly, therapy would strengthen her confidence in her sexual object choice and gender identity.

Discussion

As stated above, homoerotic transference and countertransference does not have a comfortable seat in discussions about the therapeutic relationship but, as Izzard has argued: 'We have a commitment to allowing the patient to make an emotional impact on us at the deepest level, and to thinking about this in terms of a communication by the patient' (Izzard 2000). Gould (1995) points to a 'countertransference obscurity' in which the therapist may tolerate homosexual feelings but not engage personally with them. In the above case study I felt it was my responsibility to take

the exploration of difficult feelings in the erotic transference beyond orthodox psychoanalytic interpretation around a mother/child dyad. I was sustained by Mann's view that the erotic can be a crucial aspect of the therapeutic relationship, engendering interpretations which have 'transformational qualities' (1997). Acknowledging these feelings in my work with Sinead was a deep learning experience for both of us.

Conclusion

In this chapter we have explored how art therapy may be used to work with lesbian and gay clients. We have stressed the political nature of art therapy and its subversive potential to investigate the impact of the status quo on lesbian and gay clients. We have pointed out the need for therapists to address their own homophobia and sexual biases, and the importance of coming to terms with unconscious bisexuality in order to work more creatively with issues of sexual desire and identity.

The ability of artwork to make visible the invisible, hidden and secret, to bear witness to pain and to celebrate courage makes art therapy a highly effective means of working with lesbians and gay men and individuals who are questioning their sexuality. The lesbian, gay and queer communities have long used cultural production to interrogate the world. Art has been a key tool for dismantling pathologising definitions and creating new meanings. In art therapy, lesbian and gay clients may, in the words of gay art critic Emmanuel Cooper (1994, p.341) 'become artists, singing with pleasure and shouting with anger, explor[ing] the diversity and strength of lesbian and gay identities with vigour and insight'.

Bibliography

Addison, D. (1996) 'Message of acceptance: "Gay-friendly" art therapy for homosexual clients.' *Art Therapy 13*, 1, 54–6.

American Psychiatric Association (1994) *Diagnostic and Statistical Manual of Mental Disorders.* Washington DC: APA.

Bridget, J. (1995) 'Lesbian and gay youth and suicide.' Paper presented at a conference on *The needs of gay and lesbian young people,* 28 April (London, National Children's Bureau).

Campbell, J., Liebmann, M., Brooks, F., Jones, J. and Ward, C. (eds) (1999) *Art Therapy, Race and Culture.* London: Jessica Kingsley Publishers.

Cooper, E. (1994) *The Sexual Perspective: Homosexuality and Art in the Last 100 Years in the West.* London: Routledge.

D'Augelli, A.R. and Hershberger, S.L. (1993) 'Lesbian, gay and bisexual youth in community settings: Personal challenges and mental health problems.' *American Journal of Community Psychology 21,* 421–448.

Dudley, J. (2002) 'The co-therapist relationship – A married couple?' *Inscape 2001, 6,* 1, 12–22.

Foucault, M. (1981) *The History of Sexuality: Volume 1: An Introduction.* Harmondsworth: Penguin.

Freud, S. (1905) 'Three Essays on the Theory of Sexuality.' In J. Strachey (ed) *The Standard Edition of the Complete Psychological Works of Sigmond Freud.* Vol. 7. London: Hogarth.

Freud, S. (1920) *Psychogenesis of a Case of Female Homosexuality.* Standard Edition, Vol. 18. London: Hogarth.

Gair, S.R. (1995) 'The False Self, Shame and the Challenge of Self-cohesion.' In J.M. Glassgold and S. Iasenza (eds) *Lesbians and Psychoanalysis: Revolutions in Theory and Practice.* New York: The Free Press.

Golding, J. (1996) *Lesbians, Gay Men, Bisexuals and Mental Health.* London: MIND Information Unit.

Golding, J. (1997) *Without Prejudice, Lesbian, Gay and Bisexual Mental Health Awareness Research.* London: Mind.

Gould, D. (1995) 'A Critical Examination of the Notion of Pathology in Psychoanalysis.' In J.M. Glassgold and S. Iasenza (eds) *Lesbians and Psychoanalysis: Revolutions in Theory and Practice.* New York: The Free Press.

HMSO (1988) *Local Government Act.* London: HMSO.

Hogan, S. (1997) *Feminist Approaches to Art Therapy.* London: Routledge.

Hopcke, R. (1989) *Jung, Jungians, and Homosexuality.* Boston: Shambala Publications.

Izzard, S. (2000) 'Psychoanalytic Psychotherapy.' In D. Davies and C. Neal (eds) *Therapeutic Perspectives on Working with Lesbian, Gay and Bisexual Clients.* Buckingham and Philadelphia: Open University Press.

Jeffries, S. (2001) 'Picasso's Erotic Works Too Blue for British Eyes.' In *The Observer,* 25th February.

Jung, C. (1960) 'The Structure and Dynamics of the Psyche.' In *The Collected Works, Vol. 8.* London: Routledge & Kegan Paul.

Klein, M. (1984) 'On the Criteria for the Termination of a Psycho-analysis.' In *Envy and Gratitude and Other Works 1946–1963.* London: Hogarth.

Lewes, K. (1989) *The Psychoanalytic Theory of Male Homosexuality.* London: Quartet.

Maguire, M. (1995) *Men, Women, Passion and Power: Gender Issues in Psychotherapy.* London: Routledge.

Mann, D. (1997) *Psychotherapy – An Erotic Relationship: Transference and Countertransference Passions.* London: Routledge.

McDonald, C.V. (1982) 'Choreographies: Interview with J. Derrida.' *Diacritics 12,* 66–76.

Merleau-Ponty, M. (1986) *The Phenomenology of Perception* trans. Colin Smith. London: Routledge.

O'Connor, N. and Ryan, J. (1993) *Wild Desires and Mistaken Identities: Lesbianism and Psychoanalysis.* London: Virago.

PACE/McFarlane, L. (1998) *Diagnosis: Homophobic. The experiences of Lesbians, Gay Men and Bisexuals in Mental Health Services.* London: PACE.

Phillips, A. (1994) *On Flirtation.* London and Boston: Faber and Faber.

Phillips, A. (1995) *Terrors and Experts.* London: Faber and Faber.

Riordon, M. (1982) 'Blessed Are the Deviates: A Post-therapy Check-up on My Ex-psychiatrist.' In E. Jackson and S. Persky (eds) *Flaunting It: A Decade of Gay Journalism from the Body Politic.* Vancouver: New Star Books.

Ryan, J. (1998) 'Lesbianism and the Therapist's Subjectivity: A Psychoanalytic View.' In C. Shelley (ed) *Contemporary Perspectives on Psychotherapy and Homosexualities.* London, New York: Free Association Books.

Schaverien, J. (1995) *Desire and the Female Therapist: Engendered Gazes in Psychotherapy and Art Therapy.* London: Routledge.

Schaverien, J. (1998) 'Jung, the Transference and the Psychological Feminine.' In B. Seu and C. Keenan (eds) *Feminism and Psychotherapy.* London: Sage.

Searles, H. (1959) 'Oedipal Love in the Countertransference.' In *Collected Papers on Schizophrenia and Related Subjects.* London: Hogarth Press.

Shelley, C. (ed) (1998) *Contemporary Perspectives on Psychotherapy and Homosexualities.* London, New York: Free Association Books.

Skaife, S. (1995) 'The Dialectics of Art Therapy.' *Inscape 1995,* 1, 2–7.

Socarides, C.W. (1979) 'The Psychoanalytic Theory of Homosexuality with Special Reference to Therapy.' In I. Rosen (ed) *Sexual Deviation.* Oxford: Oxford University Press.

Trenchard, L. and Warren, H. (1984) *Something to Tell You.* London: London Gay Teenage Group.

White, E. (1988) *The Beautiful Room is Empty.* London: Picador.

White, M. (1991) *Deconstruction and Therapy.* Adelaide: Dulwich Centre Publications.

From the Peninsula: The Geography of Gender Issues in Art Therapy

Maggie Jones

For if the entire history of landscape in the West is indeed just a mindless race toward a masculine-driven universe, uncomplicated by myth, metaphor and allegory, where measurement, not memory, is the absolute arbiter of value, where our ingenuity is our tragedy, then we are indeed trapped in the engine of our self-destruction.

(Schama 1996, p.14)

Maps are useful guides. They supply us with information about location, topography and direction. They assist us in charting a course. The map for this chapter is to follow the contours of a metaphysical exploration of a landscape and inscape viewed from the position of lesbian/gay identity and the place of art therapy in relation to this position. Locating the self, the 'I', on the map is a starting point from which the scope broadens discursively within the perceived environment of experience.

Where in the world am I?

'Maggie's too cute for a woman! It's no mischief, much while she's a little 'un, but an over-cute woman's no better nor a long-tailed sheep – she'll fetch none the bigger price for that!' (Eliot 1978, p.15). Well – my mother was warned. A neighbour warned her when I was seven and running

around, inventing games and fighting injustice with the help of my bicycle (following the example of 'The Q Bikes' – a story in *The Beano*), and stereotypically climbing trees. She said: 'You'd better be careful letting her be like that – she'll grow up queer.'

In reality the growing up queerly took its course and I entered into a relationship with a man significantly older than myself before the outer movement from heterosexual to homosexual occurred as self-knowledge and 'being' allowed this to happen. During and enduring the emotional upheaval and readjustment at this time questions of 'I' were inescapable and demanding, I think in a way that can only be understood and fathomed by gay and lesbian people. This is because of the pressure identified by Adrienne Rich as 'compulsory heterosexuality' (1981), which forces us to position and reposition ourselves amidst a prevailing current of apparent opposition. Questions such as those raised by David Holbrook (1994, p.36) were and continue to be relevant: 'Is there a question of not only whether the "I" can find a meaning, but first of whether there is an "I" at all which everyone must solve? And how does this relate to a meaning of reality?' What was the relationship between my self and my sexuality? Did the acknowledgement of my sexuality change the 'me' in the world somehow?

The depths of self, which may be plumbed in the ensuing ontological pursuit, are of course variable, according to the forming experiences of personal identity in the concrete and perceived world of existence. How we may choose, or have chosen for us, what of ourselves we make explicit or complicit is a dilemma not easily resolved, and must be continuously addressed for lesbian and gay people within each new situation that we find ourselves. The assumption of heterosexuality is ubiquitous and invalidating. It echoes through the centuries and resonates still. Whilst it may be agreed that homosexuality is now neither necessarily bad or mad, indeed in some pockets of metropolitan life considered to be cool and avant-garde, the reality remains that for many people coming to terms with a homosexual orientation is neither easy nor often desirable. For some an internal sense of disquiet and misplacement is externally reinforced by the rejection of family, friends and colleagues. Outcast. Quiddity may be not merely challenged but fractured.

This may read as a scene in extremis to those of us whose profes-
sional, financial, physical or class positioning allows us to pass as accept-
able and included in the mainstream. Neither does it refer to the rather
patchy and privileged allowance of the glorification of difference as
suggested by Radclyffe Hall – 'the world would condemn but they would
rejoice; glorious, outcasts, unashamed, triumphant' – which, uplifting
though it might be in print, is undone somewhat by the imagery
contained in the book's title: *The Well of Loneliness* (Hall 1998, p.303).
Depths plumbed indeed.

Looking towards the mainland

Somehow the love that dares not speak its name has been awarded an
excrescence or eccentricity that often places it simultaneously within and
without the literary body. Now it is not uncommon to find in bookshops
a section headed 'Gay Literature' – both within and made separate. In
universities, Queer Studies and Queer Theory create a space for an intel-
lectual sectioning of human experience, in the wake of Women's Studies,
which had become a discrete academic subject sometime earlier.
Criticism has been levelled at the absorption of lesbian experience into
the Queer canon. Alison Murray (1995, p.70), commenting upon
academic writing, says: 'The academy has progressed from women's
studies to gender to sexuality, getting closer to the cunt of the matter
while continuing to marginalise class, race and alternative subject-voices'.

There is in this academic pursuit something of 'a looking in upon' the
experience of what it is, and means, to be lesbian or gay; of historical
reference and contemporary reality. For some this may exert a reassurance
of existence, of continuity and inclusion even in the complex sometime
struggle and sometime pleasure of otherness. It may make known that
which has hitherto been made unknown by silence and condemnation. It
may also signify nothing. The quality of the exercise and the multi-direc-
tional and perspective approaches to gay and lesbian lives as a study may
directly and indirectly raise consciousness and make a positive presence
of the subject, but may also condescend to a meretricious occlusion – a
form of closure.

I cannot speak for you. How may we speak of that which we do not
know? But nonetheless we interpret constantly from shards of informa-

tion, real and imagined, and make-believe our knowledge. We do this in order to include ourselves in the daily round and to separate ourselves from our differentness. 'I' – that identity that I claim for my known self – may claim knowledge and experience of being lesbian in a heterosexual society. I may claim knowledge and experience of writing as, painting as, being an art therapist as, a lesbian, and there may be some resonance for others in this. However encouraged we may be by the words of equal opportunities there is a disjunction that occurs between the politically correct intention or posture and the shop-floor, staff-room, office reality. This is, I suspect, in many cases less of a conscious dissembling than a largely apathetic or disregarding evasion of the tension that exists between inclusion and exclusion and the judgments that are implicated in the smooth running of the mill, whether it be the mill of trade or of pro-creation. A sense that, on both sides of the table, we may continue to work and eat together so long as we don't bring attention to the difference. Tim Davis (1995, p.287) writes: 'Michel Foucault's *Discipline and Punish* (1979) opened a door on Queer Nation actions, as Foucault's description of panoptica (a prison in which all parts are visible) seemed to be an appropriate metaphor for heterosexism. As Foucault states, the panoptica functions as "a machine in which everyone is caught, those who exercise power as much as those over whom it is exercised. It becomes a machine no one owns"' (Foucault 1979).

However, if one has the audacity to bring non-heterosexuality to attention, to make it seen, to rattle the chains, then one must bear the consequences. The (silent) majority of gay and lesbian people in employment remain hidden in the euphemistic closet, crossing daily the borderline between the private and public self. The manoeuvring involved in travelling thus from the peninsula to the mainland of this sociogeographical state is demanding and attention to the details of accoutrement and demeanour exacting. For those of us fortunate enough to not have to don the garb of such avid heterosexual presumption there still remains the intricate psychosexual journey between the not quite island of the peninsula that is homosexuality and the mainland assumption of heterosexuality. There is always a weighing up that has to be done before any disclosure of same-sexual orientation – the lay of the land must be assessed and the risk deemed worth taking. (Though I might romanti-

cally lean towards Katherine Mansfield's entreaty to 'risk everything', my inclination is tempered by a banal sense of preservation.) Looking towards the mainland in her 'discussion of feminist geography's futures' Louise Johnson 'comments on the continued squeamishness within the space of the university about sexual outsiders': 'I have agonised for years about the consequences – professional and otherwise – of "coming out" in print, declaring my sexuality and building a feminist geography upon my lesbianism. And basically I've seen the risks as too great, the stakes too high in a homophobic culture and discipline' (Johnson 1994, p.110, cited in Bell and Valentine 1995, pp.24–5).

The lay of the land

It would be misleading to infer, even by omission, that peninsula dwellers share a distinctive and self-accepting identity. The peninsula landscape is as varied and diverse as the people who inhabit it. 'Some of the first geographical works on homosexualities suggested that lesbians and gay men lead distinct lifestyles (defined to a greater or lesser extent by their sexuality and the reactions of others to that sexuality) which have a variety of spatial expressions creating distinct social, political and cultural landscapes' (Bell and Valentine 1995, p.4). What is meant here by lifestyles, I think, must incorporate the more obvious and visible expressions of same-sex socialising such as gay and lesbian bars, clubs, the showpiece Mardi Gras parades, together with the more subdued and sublingual seeking out of 'people like us' that occurs through knowing glances. What is visible and what is not?

> Linda Peake's (1993) study of lesbian neighbourhoods in Grand Rapids, Michigan, and Gill Valentine's (1995a) work on a town in the UK provide further evidence that lesbian spaces are there if you know what you are looking for. In both research areas there are "lesbian ghettos" but they are ghettos by name and not by nature. The lesbians in these towns leave no trace of their sexualities on the landscape. Rather there are clusters of lesbian households amongst the heterosexual homes, recognised only by those in the know... Despite the attention paid to visible gay communities like San Francisco, the reality is that most gay men and lesbians live and work not in these gay spaces but in the "straight" world where they face

prejudice, discrimination and queer-bashing. The hegemony of heterosexual social relations in everyday environments, from housing and workplaces to shopping centres and the street, is increasingly the subject of geographical research. (Bell and Valentine 1995, pp.6–7)

Certainly, having lived in many different locations from inner city to small village, and having entered into the complexities of each social and differently class-influenced place, my experience would suggest that, whilst I have fortunately encountered no difficulties in being accepted, this is not the case for others. I know too that it has never been long before I have come into contact with other lesbians whether through deliberate search or inadvertently.

In the course of daily existence lesbians and gay men make choices about disclosure, making ourselves as much of a fit as we can, or need to be, in collusion. We might, as I have suggested, successfully pass, even become so much of a natural that we no longer have to consciously, or self-consciously, act the part. 'No homosexual child, surrounded over-whelmingly by heterosexuals, will feel at home in his sexual and emotional world, even in the most tolerant of cultures. And every homo-sexual child will learn the rituals of deceit, impersonation and appear-ance' (Sullivan 1995, p.13). With this comes his awareness that: 'I would have to be an outlaw in order to be complete' (Sullivan 1995, p.8).

Whilst the sense of belonging to another, different land may have some resonance, even appeal, to both gay men and lesbians there are sig-nificant differences for men and for women, just as there are significant differences for black and white gays and lesbians and for homosexuals living in condemning or oppressive regimes. Racism and sexism further compound the sense of otherness and threat. It is neither necessarily germane nor gainful to suggest a homologous reality in the lives of homosexuals. Exploration and consideration of the historical and con-textual boundaries between homosociality and homosexuality and the effective reality of variation between men and women, between ethnic groups and classes, and between national cultures is a huge subject which requires more respect than I am able to give it here. My canvass here is to adumbrate the notion of separateness and of not quite belonging to the mainland that is being homosexual. In 'The Laws of God, the laws of

man' in his *Last Poems*, A.E. Housman speaks of this sense of alienation (Housman 1960, p.79). The sense given by Housman is one of a person out of place amongst a prevailing ethos. The correlation between the socially driven impetus of classification and control and the physicality of the land we inhabit is an interesting consideration. Munt says: 'The boundaries of physical geographies are rebuilt in mental images' (1995, p.118). Bell and Valentine in the introduction to *Mapping Desire* (1995, p.19) make the point that 'the straightness of our streets is an artifact, not a natural fact'. Jonathan Glancey (1999, p.38) develops this notion: 'Humankind's long crusade to batter Nature into a gridiron of straight lines, as if hammered into shape by an almighty blacksmith, is at the heart of our need to control our surroundings and beggar the devil. By the grid, we stamp order on our world, fence ourselves around with common sense... At its worst, the grid is not simply lifeless, but a symbol of repression'.

Drawing the lines

The lay of the psychotherapeutic land and the boundaries which define it are inscribed by a heterosexual taxonomy into which is encoded the route-markers of psychoanalytical straightness. It matters not which genus is adopted or which path is taken within the maze of psychotherapeutic endeavour – it arises from a heterosexual domination, which continues to be monitored and governed by hetero-normative privilege and control. These paths have been drawn by the consentient monocular vision that has mapped the geodesic line between heterosexuality and psychoanalysis. This is a straight line. It is a constructed determination to deny the bent.

Art therapy, within this straight-weighted pre-eminence, has the opportunity to incorporate the less-than-straight line. Art by its very nature has the deviant potential for ambiguity. It has the capacity for holding many notions, many angles, many colours and places, in a way that the written or spoken word rarely allows. Beyond the contour of the canvas or the sculpture there is both the specific physical space in which it exists and the sensory space in which the observer allows the image to exist. Its existence offers a verisimilitude of intention that must yet be observed and perceived with doubt. It can be unnerving, if it is allowed to

be, reflecting a direct but equivocal attitude. In therapy the interplay of many parts and the ability to hold belief and doubt in the same breath has a synchronicity with this image of art. When the act of making images in art therapy co-opts the psychotherapeutic process, with the principles of psychodynamic theory and its informing heterosexual, white, middle-class history, the essential quality and value of this possibility is attenuated.

It may be significant that there has been a steady movement towards psychotherapy within the development of art therapy over the past ten years. As a consequence of this inclination to reduce the anarchic quality of art into the mainstream and more acceptable accreditation of psycho-therapy, an opportunity to walk and encompass the borderline between art and therapy, to develop ambidextrously, appears to have been lost, with art therapy assuming the character of the psychotherapeutic partisan. The result of this is a rather dull homeostasis. In the context of this chapter art therapy has adopted the mainland as its home. As I think back to my excitement in discovering art therapy I remember a sense of rightness for me in following this course. As a child I had always drawn pictures and had been easily occupied so long as I had the means to do this. Art therapy consciously made sense as a process of drawing together my passion for art with my curiosity about human difference. However, I now consider the draw of a more subliminal momentum also to have been present, in that art therapy appeared to offer ambiguity within its make-up; an opportunity for other than the linear and unidirectional process. As dexterity is directly associated with right-handedness, without equivalent for left-handers, so the presumed rightness of hetero-normative therapeutic practice has elided the homo-normative voice. In this, ambiguity, with the creative tension that it secretes, has been compromised. Within the medical world from which psychodynamic theory is derived, ambiguity is suspect, a bent word, which testifies to the difficulty of diagnostic accuracy no more so than in the case of the borderline personality disorder. This, of course, is tautolo-gous. To be on the borderline is to be disordered if placed between the groundswell of a prevailing norm and the less known, less travelled and less desirable topography on the other side.

I wish to glance momentarily back to the genesis of art therapy in Britain and would like the following excerpt from Adrian Hill to be read with an air of ambiguity:

> Isolation from the community, no doubt, evokes a more contemplative attitude towards life, and while the patient's animal ego is quiescent, the spiritual or subliminal essence, hitherto cramped by a humdrum environment, is allowed free play in producing works of considerable imagination, both of an idealistic and necrotic nature.
>
> It would be a misconception, however, to place too much significance on the inevitable pictorial transformation which usually takes place, because as soon as a standard of cause and effect is established, the exception to the rule upsets any psychological calculations. (Hill 1945, p.41)

Although something of the patriarch (and man of his time) the gut and gusto of Hill's writing is as refreshing as his passion for art, and his encouragement of art appreciation is contagious. Describing his encouragement of two young women art students in the Sanatorium, he says: 'I soon spotted their complaint and resolved at once to restore the imaginative faculty which in both cases appeared to have been vigorously suppressed. I exhorted them to paint dangerously' (Hill 1945, pp.39–40). Viva the imagination – for in the imagination there lies the possibility of possibility.

Who determines the boundaries?

Within the lexicon of psychotherapy the use of the word boundary is much valued and well aired. It may refer to something that indicates the furthest limit, as of an area or border; something of which, in professional, personal, moral or physical terms, we must be aware and endeavour not to transgress. It may also refer to a need to distance oneself from another person by the means of an artificial and imposed barrier to exchange. There is surely a danger in assuming a language of interpretation in response to an evolving personal language of experience. Language differences and understandings must be carefully negotiated. Erecting formulaic boundaries in a psychotherapeutic transaction may correctly protect the client from overfamiliarity and simultaneously limit

the possibility of an openness of dialogue. There may be a correlation between the urgency to refer to and concretise the boundary with a need for control and fear of the other. If this is the case it does not allow for the awareness that 'margins and centres shift with subjectivities constantly in motion' (Munt 1995, p.118). In this sense the boundary may become a rigid and restrictive device wherein both parties are bound to the artifice and unable to move. Similarly the word 'fantasy' is often used transliteratively with a sense of esoteric therapeutic ownership. In using a word to claim a meaning for a specific purpose the range of interpretation becomes limited and the possibility of exploration reduced. Fantasy, as a vehicle indicating the faculty of inventing images, of daydreaming (or 'transferring' – my childhood term for daydreaming was 'day transfer'), may be reduced without doubt to a compliant obeisance to the gravitas of a psychopathological interpretation.

If it is true that we respond within the parameters of our consciously deciphered pathology, however good or bad the training, what we import from lived experiences infiltrates what we impart in part. As therapists we learn and lean in one direction or another. We have our own inclinations and cravings, physical, spiritual and psychological. It takes more to move beyond the 'willing suspension of disbelief' into the actual unknown and unchartered territory of another. To be able to withstand the impelling pull of what we think we know – and what we understand to be expected – is to hold oneself in suspension on all accounts. To keep the canvas open and free from doctrine (which does after all sound rather like a pharma-ceutical product) is both the challenge of the artist and the art therapist. The beauty of the idea of art therapy lies within the possibility of the blank page: of risking the first mark and allowing some form to emerge and from this to allow a separate life without prejudice – of a tolerance between life and the artful possibility. As the therapeutic industry configures itself, the possibility of such a suspension of self with image freedom seems to become more remote as positions are taken with regard to a notion of acquired process.

Some years ago I had a particularly testing time with an autistic young man, a refugee from eastern Europe referred for art therapy. He was unable to keep to the boundaries of the paper, however big, in his paintings, instead preferring to use the walls of the hospital corridor for

his images. The energy of his delivery was awesome; the demand to draw his marks beyond the confines of paper and room a powerful statement. I did not want to discourage him but was all too aware of the unacceptability of the placing of his markings. At this time his need to express himself was free-ranging and could not be contained even by the offer of a specific piece of wall. Before it was possible to pursue any other creative options his living situation changed and he stopped coming to the hospital. I was pleased to read an article in a local paper some years later that he was still painting and had found the ability to adapt to painting on large boards. I still wonder at the urgency of his desire to express himself in images without words and enjoy the memory of his somewhat iconoclastic rendering of the stark hospital walls.

I have, in my work as an art therapist, become aware of the significance of my own presentation, which without being explicitly lesbian has neither been explicitly heterosexual. A woman I was working with many years ago spoke of and drew herself as 'half and half'. This did not refer directly to her sexuality but was a reality of her experience of being in the world. Whilst this may reflect the pain of not feeling whole and an absence of integration, it also implies a personal knowledge and vision that could more easily be tolerated if the demand for a mainland sense of wholeness or completeness carried less weight and value. The confusion of self and not self and sense of not belonging that is felt and expressed by many women who have been abused, a sense of a disinherited self, is amplified and compounded by the external pressure of a fictitiously happy, whole and ideal state of being. (Dare I suggest that the 'nips and tucks' of cosmetic surgery may be seen as a physical counterpart to the psychological rearranging of anxiety, grief and anguish?)

A woman, in her late forties, whose life had been controlled and determined by early and prolonged abuse followed by considerable alcohol intake and abandoned sexual activity, psychiatric diagnoses and pharmacological interventions, painted herself into her world. In the process of doing this she was able to reveal to herself the reality of her experiences and to lay claim to an understanding of the experiences to which she had been reacting. After completing each painting the intensity of her dissociation was phenomenal but from each she knew how to begin the process of reparation and repatriation. It took a long

time for this client to accept me – her distrust was feral but she was totally in charge of the pace and content of the process. She commented frequently on my appearance, especially about my hair when it was cut shorter than usual. Once she had decided to trust me enough and begin the work, the ambiguity of my presentation continued to be vital. It allowed her, and freed her, to creatively and safely use me in the transference of her profound and painful story. Nina Mariette, in her book *Painting Myself In* (1997), describes her own process of engaging in an evolving visual documentary of self-revelation:

> I sort of had this vision when I started, sort of the reverse of that cartoon about painting yourself into a corner of the room. Slowly, I was going to paint myself out of the room, into what, I was never sure, some vision of life after abuse I guess, that so many survivors strive for.
>
> Nearly always just out of reach. You get used to the feeling of being not quite right with yourself and the world, like living in a different world, and of course being told that it's you who is out of step with the rest of the 'normal' world. (p.25)

Nina's book describes an archaeological (or maybe arteological) process of discovery through the surface of each revealing image.

Walking the borderline

Nina's book, together with the imagery of many people who have shared something of their personal experience, reminds me of the interplay between 'I' and 'we' in the writing of Virginia Woolf. 'The "we" must be gathered up by the "I" for the homeward journey: "Now we have got to collect ourselves; we have got to be one self"' (Marcus 1997, p.123). 'In cultural criticism, in psychosexual practice, Woolf stands simultaneously outside, beside and inside the borders of heterosexuality and of her sex. These borders are as fluid, as subject to redrawing, as those of counties and countries. Woolf's stance, then, occupies many places; her position many points' (Stimpson in Bowlby 1992, p.175). Woolf epitomises the state of between-ness, a neither/nor state; she stretches boundaries, transgresses social, sexual and psychological borderlines. 'Woolf's novels, even those that appear to be furthest from the urgencies of the

present time, are shown to be inseparable from what (Gillian) Beer describes as the politics of *The Waves*, "its dislimning of the boundaries of the self, the nation, the narrative'" (Bowlby 1992, p.15). Hers is an expression of being without country – of not belonging to the mainland. The perverse irony, of course, lies in the mainland public acceptance of Woolf as a great writer, although I suspect that there remains a reserve less confirming than that expressed by Vita Sackville-West when she wrote of Woolf: 'no less a critic than Coleridge, she reminds us that a great mind is androgynous' (1929). There is nothing of the anodyne in her writing. She is 'between the acts', subject to 'the waves' ('the barbaric vagueness and disorder out of which civilisation has emerged' – Auden 1985, p.17) and on 'the voyage out' from the beginning. The 'I' as a 'term for somebody who has no real being' (Woolf 1993, p.4) is the seminal and oblique heart of the borderline state. The apparent flux and chaos of the uninhabited 'I' immediately threatens and disembodies the person from 'their' self and simultaneously from a society hell-bent on imposing a mainland order of binary tolerance. 'In the either/or, and/or, and/and structures of Woolf's writings we find the refusal of stark or singalistic choices and resolutions and an insistence upon processes and open endings' (Marcus 1997, p.169).

For young lesbians diagnosed with borderline personality disorder the self in the world is indeed an alien and unwelcoming place to be. The inhospitable phallocentric psychiatric underwriting of the mainland context bedevils the acute sense of discordance of the self, of not being in harmony with internal or external worlds. This Sturm und Drang of the borderline experience is isolating and highly frictional, both close-up and in the wider social arena. The struggle for perceived mainland normality is intense and friable. For the person on the borderline the boundaries are less visible and identifiable and therefore more remote and scary. A struggle to engage and to sustain the self in relation to another may necessarily involve gerrymandering, which is indeed often inter-preted as manipulation and 'splitting'. The object of the 'other' (therapist?) in relation to the 'borderline' person must remain sufficiently intact but with a warm-blooded imagination and integrity. For a lesbian grappling with something like a felt sense of statelessness of self the holding image of the 'other' may have more relevance and be more con-

structive if the 'other' is also lesbian, with the necessary therapeutic attributes.

There has been much written from the mainland of psychiatry and psychodynamic theory about borderline personality disorder. This disorder has replaced hysteria as the young woman's complaint, spawning articles by the truckload on the subject, from aetiology to 'how to' work with this 'difficult' group (often regarded as obstructive). Is it perhaps a combination of the disturbing nature of the thwarted self (if I dare use such a term) and a desire of male order to control apparently wayward or troublesome young women that makes this disorder so fraught? Engaging with the person, however, is not the same as engaging with the description of the disorder. As and when the engagement is positive, the use of imagery becomes crucial as this allows for the introduction of a third 'I' (eye) in the therapeutic tableau vivant. The either/or is real, pausing between the diffusing polar positions that had previously been fixed and restrictive. Effectively this is far from a straight transaction. The ability to tolerate (allow the existence or occurrence of without authoritative interference) the borderline experience, and the ability to roam between the mainland and the peninsula of this experience, between the inner and outer realm of the self, is vital.

From one 'Is-land' to another

In the course of writing this chapter I have returned to live in England from New Zealand; island nations both. My movement across the world is not so unusual. People are moving and shifting, crossing borders all the time and for many reasons. There are forced and unforced, chosen and desperate reasons. The earth moves in every sense, microscopically and geologically. Movement is essential and borders can and do shift both within ourselves and geographically. Within and beyond our bodies movement is continuous motion. Therapy must move and shift not simply with the vagaries of trend but with the frisson and awareness of artful curiosity. Art movements are caught and held for consideration – perhaps a human need for categorising which thus creates an artificial ordering of that which defies ordering.

The borderline is a statement of control but defies the control as an artificial construct. It is essentially fluid and implicitly in flux. It is a

metaphor for tolerance and understanding. Between the mainland and the peninsula exists the creative, and destructive, tension that epitomises the skin-strain between the physical body of the self and the world within which it lives. The vitality of consciousness and the awareness of our absolute movement is perhaps somehow thus predicated upon our ability to tolerate and welcome the tension of the borderline. 'What he meant by "awareness" was perhaps a sense of the as yet unimagined wholeness of life; a recognition that one could live freely only on the frontiers of one's being where the known was still contained in the infinite unknown, and where there could be a continual crossing and re-crossing of tentative borders' (Van Der Post 1982, p.144).

I do though know that on whatever 'Is-land' (Frame 1999) it is that I am living the chart for this chapter remains the same. We must take our own bearings.

As Gertrude Stein stated:

Then we have insistence that in its emphasis can never be repeating because insistence is always alive and if it is alive it is never saying anything in the same way because emphasis can never be the same not even when it is most the same that is when it has been taught. (Stein 1988, p.171)

Bibliography

Auden, W.H. (1985) *The Enchafed Flood.* London and Boston: Faber and Faber.

Bell, D. and Valentine, G. (1995) *Mapping Desire.* London and New York: Routledge.

Bowlby, R. (1992) *Virginia Woolf (Longman Critical Readers).* Harlow: Longman.

Davis, T. (1995) 'The Diversity of Queer Politics and the Redefinitions of Sexual Identity and Community in Urban Spaces.' In D. Bell and G. Valentine (eds) *Mapping Desire.* London and New York: Routledge.

Eliot, G. (1978) *The Mill on the Floss.* London: The Zodiac Press.

Foucault, M. (1997) *Discipline and Punish.* London: Allen Cane.

Frame, J. (1999) *Janet Frame: The Complete Autobiography.* London: The Women's Press.

Glancey, J. (1999) 'True Grid.' *The Guardian Weekend* (February 13).

Hall, R. (1998) *The Well of Loneliness.* London: Virago Press.

Hill, A. (1945) *Art Versus Illness.* London: George Allen and Unwin Ltd.

Holbrook, D. (1994) *Creativity and Popular Culture*. London and Toronto: Associated University Press.

Housman, A.E. (1960) *The Collected Poems of A.E. Housman*. London: Jonathan Cape.

Hutton, A. (1963) 'The Q Bikes', *The Beano*. Dundee: D.C. Thomson & Co., Ltd.

Marcus, L. (1997) *Virginia Woolf*. Plymouth: Northcote House.

Mariette, N. (1997) *Painting Myself In*. Dunedin (New Zealand): University of Otago Press.

Munt, S. (1995) 'The Lesbian Flaneur.' In D. Bell and G. Valentine (eds) *Mapping Desire*. London and New York: Routledge.

Murray, A. (1995) 'Femme on the Streets, Butch in the Sheets.' In D. Bell and G. Valentine (eds) *Mapping Desire*. London and New York: Routledge.

Rich, A. (1981) *Compulsory Heterosexuality and Lesbian Existence*. London: Only Women Press.

Sackville-West, V. (1929) 'Review.' *The Listener* (November 6).

Schama, S. (1996) *Landscape and Memory*. London: Fontana.

Stein, G. (1988) *Lectures in America*. London: Virago Press.

Stimpson, C.R. (1992) 'Woolf's Room, Our Project: The Building of Feminist Criticism.' In R. Bowlby (ed) *Virginia Woolf (Longman Critical Readers)*. Harlow: Longman.

Sullivan, A. (1995) *Virtually Normal – An Argument About Sexuality*. London: Picador.

Van Der Post, L. (1982) *The Seed and the Sower*. London: Hogarth Press.

Woolf, V. (1993) *A Room of One's Own*. Harmondsworth: Penguin.

Working with Men

Marian Liebmann

Introduction

The starting point for this chapter is a contrast between two experiences of working with men in art therapy. The first was with men in the criminal justice system (on probation), where I experienced some initial resistance to engagement and then managed to build up good relationships, often leading to very productive art therapy work. The second is with men in the mental health system (in a community mental health team), where men are referred less frequently than women, do not engage as well and often seem reluctant to take responsibility for themselves – leading to a less satisfying art therapy experience.

I have become intrigued by these two different sets of experiences, separated by some years. In my current place of work (mental health) I have sometimes wondered – perhaps I don't work well with men? – but then remember my previous experience. Is it the difference in client groups? Is it the difference in the settings? Is it the way I work? Have I changed? In this chapter I hope to look at some of the factors involved in each setting, including the way I have worked in each of them; reflect on some elements of the growing literature on men; and then raise some questions concerning art therapy practice with male clients.

In this area of work, therapists' own assumptions are more important than in other areas as we are all affected by gender issues, so I begin by reflecting briefly on my own experience. I grew up in the 1950s in a time

when girls and women were supposed to conform to the stereotype of submissive behaviour and specified roles. I rebelled against these, but often kept this to myself lest it should be evidence of perceived 'maladjustment'. I was heartily relieved when the women's liberation movement came along ten years later and vindicated what I had felt all along. However, there have still been many times of frustration in my working life when I have been discriminated against or treated in a sexist way: there are still many battles to fight to gain true equality.

Nevertheless, I have never wished to engage in the wholesale denigration of men. It has been my good fortune not to have been abused or raped by men (I say good fortune because this has been the experience of very many women I know), and I have been happily married for many years. For reasons of personal inclination and work circumstances, it has suited us as a couple to divide the tasks in a 'reversed roles' way from the traditional one – but this is no longer unusual now. I have often thought that men needed a liberation movement too, and have been encouraged to see this beginning to happen – at least in some quarters.

Male socialisation

There has been much written about the nature/nurture debate, which is outside the scope of this chapter. But whatever the part in determining behaviour played by nature, it is clear from much writing and research that socialisation plays a large role in establishing male identity and masculine attributes.

Kim Etherington outlines three main areas of male socialisation (Etherington 1995):

1. *Gender and sex roles*
 Male children are socialised to be dominant, competitive, aggressive and tough. To be a normal male means to aspire to leadership, to be sexually active, knowledgeable, potent and a successful seducer. The burden inherent in these expectations is clear' (Etherington 1995, p.32). Parents often have different expectations of male children in these directions, and male children seem to be more dependent on these stereotypes to guide them.

2. *Patriarchy*
 This is the institutionalisation of male dominance over women
 and children in society in general. It involves the notion of
 'chattel property' as a norm, giving men the rights of
 ownership and therefore control of women and children, who
 in turn are encouraged to be passive and submissive. Although
 this view has been challenged vigorously, the continued
 existence of child abuse and domestic violence (mostly,
 though not all, committed by men) shows the persistence of
 this mode of thinking.

3. *Homophobia*
 This is the fear of homosexuality, and often lies behind the
 intolerance of deviation from stereotypical male behaviour or
 attitudes.

Other authors provide complementary points of view. In her book *You Just Don't Understand – Women and Men in Conversation*, Deborah Tannen (1992) describes her thesis that men respond in ways that reflect and establish a hierarchy between them and others, whereas women are socialized to concentrate on making connections and being part of a group. This results in many misunderstandings in terms of communication, which Tannen sees as a 'cross-cultural' matter between women and men.

Male therapists have described how men are taught to switch off their emotions and then find it hard to relate to others (Hodson 1984), and have described the damage to men's and women's lives caused by this. In addition, their verbal communication skills are often very lacking (Hodson 1984), and are not always encouraged (Miedzian 1992). They often look to women for emotional support (Lee 1991). Biddulph (1999) relates this and the male reliance on stereotyping to 'under-fathering', often carried on from generation to generation. Other authors (e.g. Miedzian 1992) chart the ways in which male violence is an outcome of the stereotypical attitudes described, and is learned through example, the media, toys and sport. These findings apply across all social classes, even if the manifestations differ in some respects.

All these authors seem to agree that, as there is a substantial component of learned and transmitted behaviour, there is also a hope that some of these attitudes and behaviours can be unlearned. There is also broad agreement on the elements that would help in this endeavour: teaching communication and conflict resolution skills, boys and fathers becoming more involved in child-rearing, and men valuing purported 'feminine' attributes such as gentleness.

Jungian psychology has also encouraged men to value their 'feminine' side (anima) and women their 'masculine' side (animus). Interestingly, recent research emphasises the malleability of behaviour with different socialisation, so there is less reason to assign specific characteristics irrevocably to one gender or the other (Clare 2000).

Counselling and therapy are clearly useful means of helping men achieve change, whether they approach these voluntarily, through private therapy or areas of the mental health system, or in a variety of more coercive ways, such as the criminal justice system.

Working as a female therapist with men

Working as a female therapist with men raises certain issues. There are a number of roles that can be projected on to me by male clients: mother, confidante, professional expert, adviser, partner, sex object. When I worked in the probation service, friends would ask me if I felt in danger from the men I was supervising and counselling. I reflected that many of them (mostly young men) treated me as a mother-figure, and, as their mother was often the person they felt closest to (and their father was frequently absent or violent), I was usually able to build up good relationships more easily than many of my male colleagues.

When the therapist is a woman and the client is a man, the counsellor or therapist role redresses the balance of traditional roles of men and women. In the probation service, for the most part, male clients accepted my authority, as I had the power to take them back to court. Just occasionally would some remind me that they were used to holding the power outside the probation office, for instance by quoting their beliefs that women were inferior, or occasionally by trying to get their way through sexually seductive manipulation by using a 'chat up' routine.

Working in the mental health system, the situation appears more complex. Men of approximately the same age or older than me may have depression, following a marriage break up. They may engage well with art therapy, discovering their creativity and the ability to express pent-up feelings. But they then seem unable to move on, believing their key to happiness to be continued dependence on the mental health system fulfilling the same role as their ex-wife.

These 'transference' issues may be played out in a number of ways. Joy Schaverien (1995) observed a movement from idealisation to denigration of women, and a confusion in some men between adult and infantile erotic transference. She noticed that when erotic dependency issues came up, men were likely to leave therapy prematurely (Schaverien 1995, 1997) to avoid discussing intimacy or to avoid awareness of these impulses.

Within groups the issues may be diluted or enhanced, depending on the circumstances. In groups where I have been assisted by a male member of staff (a community psychiatric nurse, for instance), we may be perceived as the 'parents' of the group. If I am the only woman present, then I am often treated with 'chivalry'; as someone who is especially delicate and who 'shouldn't have to listen to all that swearing'.

Probation

Traditionally probation orders have been used for offenders whose offences or personal lives dictated the need for counselling and help rather than straightforward punishment. The period I worked in the probation system covered 1987 to 1991, and there have been many changes of policy and emphasis since then. Although in theory offenders had to agree to a probation order, it was (and still is) a rather constrained choice, as other options (such as prison) are often seen as worse.

By far the largest majority of offenders are men, and the provisions in the criminal justice system reflect this, being framed around the needs of men – women find that they have to fit into that system and on the whole do not have their needs adequately met.

The basic requirements of probation at that time were to keep appointments with a probation officer over the period of probation (usually one or two years), and to notify any change of address or employ-

ment. Sometimes there were additional requirements to attend groups, such as anger management, alcohol education, driving skills, and so on, depending on the offence.

Most of the offenders I saw were happy enough to talk to me after an initial period of resistance. Some recognised the connection between their lives and their offences, and hence avoided further offending. But very few of them would have turned up on the doorstep asking for help or asked their GP to make a referral!

Many offenders had a poor education and were inarticulate, as has been mentioned above. As a qualified art therapist as well as a probation officer, I had access to non-verbal means of help in this area. I asked most of my clients if they were willing to make drawings and, if they were, these became the basis of our conversations. The drawings proved extremely useful in helping the clients learn how to communicate personal issues, especially their emotions. Often I felt my role was teaching them to talk about themselves, something completely new to many of them. This in turn helped them to assess situations more clearly and avoid future offending.

I have written elsewhere about the use of 'comic strips' to help offenders look at their offending behaviour in a non-threatening way (Liebmann 1990, 1991, 1994, 1998). This was particularly useful for male probation clients, who often seemed to have no understanding why they had committed the offence – their attitude was: 'It just happened'.

Probation case studies

The case studies below show ways in which art therapy helped in articulating feelings and illustrating gender issues.

Dave

The inability to register emotions was demonstrated particularly graphically when a sex offender drew a comic strip of his offence, an indecent assault. I learned more in this session about his offence than from all his previous verbal accounts. After we had looked at the drawing together, I tried to help him focus on his feelings, so that he could match them to his

actions. I asked, 'So what were you feeling when you were committing the offence?' 'Only her leg' was his reply.

Kevin

This inability to reflect on or articulate feelings led me to try to devise concrete ways of considering attitudes. Kevin, aged sixteen, had hit girls but did not know why. During his period on probation he did many drawings of his offences and of his suffering at the hands of his violent father. After six months, while telling me about a television programme, he remarked, 'Girls and women are like dirt on the ground you walk on'. On one hand, I felt a professional responsibility to let him know that he should not talk about women in those terms. On the other hand, I felt a greater responsibility to help him understand the connection between this attitude and his violence towards girls.

So I asked him who else in his family had said such things – his father, of course, who had called his mother 'Slut!', 'Whore!' and many similar names. I was also aware of the way Kevin placed his mother on a pedestal, and I was reminded of many men's polarised views of women as either 'madonnas' or, if they fall from grace, 'whores' (Schaverien 1997; Welldon 1988).

So I suggested he drew small pictures of all the girls and women he knew, and we arranged them on the table from 'most disliked' on the far left to 'most liked' on the far right (see Figure 6.1). He placed a young woman from his training scheme at the far left, and his mother (bottom) and me (top) on the far right. His victims were positioned in-between and he realized that one of them (whom he had hit at a bus stop) was completely unknown to him, so he placed her in the middle.

Figure 6.1 **Continuum of Girls and Women**

Through seeing the pictures in front of him, and participating actively in arranging them, he began to understand that girls and women were not 'all the same – dirt on the ground' but might be good, bad or in-between. He would never have reached this understanding through a lecture on the evils of sexism.

Mental health system

I currently work on an inner city community mental health team with people diagnosed as having serious mental illness. Although, in theory, treatment and therapy are voluntary, mental health clients can be 'sectioned' (that is, detained compulsorily in hospital under certain sections of the Mental Health Acts) if they are deemed a danger to others or themselves. This in turn provides an ever-present pressure on clients to accept most treatments suggested by psychiatrists, the main power holders in the mental health system.

Although approximately half of the mental health clients in the inner city are men, far fewer are referred to art therapy. It is interesting to speculate on the reasons for this: do staff see art as a 'feminine pursuit', or a 'middle-class hobby'? In the inner city multicultural milieu, is art therapy seen as a 'white activity' or is therapy generally considered to be

something 'men don't need'? Of those men who are referred, many do not engage.

Most of the men referred, although agreeing to the referral (often from a psychiatrist), simply never keep any appointments with me. So after two such attempts, I send the case back to the referrer. Clearly these clients' decisions are not based on personal knowledge of me, although it is clear from the appointment letter that I am a woman. I sometimes wonder what difference it would make if I were a man, but my experience in probation leads me to believe that talking to a male professional could be even more difficult for many men.

This section looks at some of the reasons why men find it difficult to engage in therapy.

Men as mental health clients

In her research on adult male survivors of childhood sexual abuse, Kim Etherington (1995) looks at the factors of male socialisation that make it difficult to admit vulnerability or to ask for therapy. Several of her research subjects saw themselves as failures as men for having allowed themselves (as they saw it) to be abused in the first place. This led them to minimise the harm done and to block off their feelings about the abuse and about themselves. Instead they often opted for alcohol and drugs to soothe the pain.

The hierarchical nature of the mental health system provides men with a forceful reminder of any perceived self-failure. They may want to avoid it completely or, if they have to be part of it, leave it as soon as possible.

Phil

Phil was referred by a trainee psychiatrist for art therapy to explore his history of sexual abuse as a child. He was keen to start and eager to please during the sessions, but found it hard to acknowledge the pain. He thought others laughed at him for being a 'sicko', taking medication and coming to art therapy. Sometimes he admitted to hiding in his flat and drinking to blot out his ever-present thoughts about the abuse. But mostly he related how things were going 'better now', keen to give the

impression that he could cope. Each session, Phil deferred discussing the abuse and his feelings. But he enjoyed using paints to express himself, working carefully on geometrical shapes of different kinds.

Phil started art therapy with a male trainee art therapist and continued with me. His attendance was erratic, and he missed as many sessions as he attended, usually from anxiety. The pattern of absences was not very different for either the trainee therapist or me, though it grew more erratic as time went on. After many discussions about this, I finally gave up trying, which made me feel quite guilty.

One of Phil's earlier paintings, *Dragonfly*, is shown in Figure 6.2. He used bright colours (red, yellow, green, blue and brown) and painted slowly and carefully. He started with the central radiating lines (which he saw as a dragonfly – himself – emerging) and moved on to paint carefully constructed boxes up the right-hand side of the paper. He saw the dragonfly as being able to knock down the barriers that he had put up. He tried to keep all the lines and boxes separate and 'under control' and became anxious if the colours ran into each other at the bottom of the painting.

Figure 6.2 **Dragonfly**

He also worried that the space in the picture looked 'mad' because it wasn't carefully constructed like the boxes. We discussed how he might work towards a happy medium between totally constructed (and walled in) and total chaos (too frightening).

A painting a few months later, *Reclaiming Childhood,* (Figure 6.3) was painted more quickly, as he had arrived late for his appointment. He had been using a little book to write down events and feelings that reminded him of the abuse in his life (something we had worked out as a useful way for him to contain his anxiety). I suggested he might focus on some of these feelings, and he chose an occasion when a friend's children had come round to borrow his dog and bounced all over his flat. He was amazed by their spirit of freedom, something that had been missing from his own childhood. For the painting, he chose bright colours and started with a pale pink circle, which he filled with red, in the centre (which he related to being a target for other people). He surrounded this with a solid purple triangle (pointing downwards), then a dark green square around it. Then he painted two 'wings' in blue, left and right, and solid red above and pale pink below. The squares in the four corners were bright yellow.

Figure 6.3 **Reclaiming Childhood**

Finally he painted red dots on the blue and purple dots on the yellow. He related the picture to never being allowed to express himself as a child, and said he enjoyed this opportunity to fill up the page with 'his stuff'.

I was sad that Phil was unable to keep the appointments, as I felt he was gaining great benefit from art therapy; it was a way of expressing himself when words were simply not available. I still wonder if there is anything else I could have done to help him keep going. In his own words (from the evaluation form I sent later and he returned), he said: 'What I found most helpful was the time and freedom to express my feelings with someone in a neutral situation. Also the fact that I wasn't made to feel different from other people or that I was "mentally unstable" which is what I assumed with all counselling.'

Although it seems difficult for men to engage in any kind of personal therapy, it is clear that art therapy has a particular role in helping them to express feelings. However, there is a further problem for some men – far from leaving too soon, they wish to stay for ever!

Paul

Paul (aged fifty-five) was referred by his GP at his own request: a friend had suggested art therapy would help with his depression and lack of motivation. He had been a college lecturer but had been made redundant. I offered him up to a year of individual art therapy and the opportunity to attend a group. Initially all went well. Paul found that art therapy unlocked his creativity and he enjoyed using the paints to express his feelings. He attended two groups, both gaining from them and contributing to them. But as the year came to an end, he seemed to sink back into depression at the thought of finishing. He seemed unable to carry out his commitments outside the session. He had had two long-term relationships; both partners had left him. I wondered if he related the ending of art therapy to me also leaving him – when I shared this question with him, he said art therapy was not like that. And yet I had a feeling that he, like many men, instinctively expected the woman in the relationship to do all the emotional work, while he chose to be passive and expected to be carried.

Gerry

To some extent the mental health system encourages this dependence. Gerry too wanted to stay in art therapy for ever. He was very creative, expressing himself well on paper, and art therapy appeared to be the most successful therapy for him. I 'inherited' him after his three years' attendance at a day hospital, group and individual art therapy. After two further years of art therapy, I began to realize that keeping him as a 'mental health patient' was not effective, as nothing had really changed for him. Gerry, his psychiatrist and I formulated a plan to help him progress. However, while the psychiatrist and I were away, Gerry had a small crisis, and another psychiatrist told him how ill he was and put him back on strong medication. He was encouraged by this psychiatrist to think of himself as long-term mentally ill and incurable. Fortunately he decided he did want to move on, and left the mental health system to do voluntary work in the community. His last pictures reflected the progress he had made, showing an integration of disparate elements into a new way of painting about himself.

Peter

There are men whom I have found straightforward to work with. Peter came with a history of depression and angry feelings, many connected with his background. But his most pressing problem concerned his turbulent relationship with his partner, the mother of their two young children, from whom he had recently separated. At first he used art materials to describe the hostile communication with his partner, and we discussed ways of communicating in a less hostile way – something he was keen to do, as he felt their arguments might damage the children. As he became more familiar with the art materials, the process absorbed him and he became calmer and more reflective. Starting with crayons, he progressed to paints and clay, gaining a great deal of satisfaction from the abstract shapes he produced. After two years, the arguments had diminished considerably. He finished art therapy when he found a job.

Group work

While some men have told me that they could not face group work –
often because they find issues of abuse too shameful to share – many men
seem to engage well in group art therapy. I have run several groups with
mixed membership and one men's group. After an initial period during
which membership fluctuated, all the groups ran well with an enthusias-
tic and stable membership, including the men's group. Perhaps the group
situation is less intimate and threatening for men than individual therapy,
especially as the art is an active means of expression, providing a bridge
to the more difficult verbal expression and acting as an 'equaliser' in com-
munication between women and men.

In the mixed groups, men often gained a good deal from the women
in the group, and were enabled to move forward in a way they had not
done in individual therapy. Sometimes this involved a challenge from the
women concerning rigid attitudes and apparently uncaring behaviour.
There is a danger, however, that mixed groups may exploit the way
women provide more for men than they gain themselves, continuing a
stereotypical and damaging pattern for both. This is reminiscent of views
about co-education, often seen as 'good for boys, not so good for girls'.

In one group, a man unthinkingly took over – occupying a large
amount of space, painting over others' contributions in group paintings,
dumping his pictures on top of others' wet paintings. When challenged
by the group members, he was very hurt and upset – and although he
seemed willing to look at the issues, this too took up a huge amount of
group time!

Sometimes men with many problems find solace in the activity of
painting. Andy attended a general art therapy group I ran. He was quite
psychotic most of the time, and often missed sessions because he mixed
up days and times. Often it was difficult for other members to understand
his thoughts and delusions. But on the days he made it to the group, he
gained peace of mind from the process of drawing and painting, and a
feeling of acceptance from other group members.

The men's group

The men's group emerged by accident. Originally, the group's membership had been equally balanced, but two women left for domestic reasons, whereupon the two remaining women felt outnumbered by the men and also left. The theme of the art therapy group, 'anger management', may also have contributed to the women dropping out – in our society anger is a more acceptable emotion for men to express than women. However, I was not the only woman in the room (as I had been in a number of probation groups – an uncomfortable experience), as a female student therapist was attending the group as a participant observer. With two women and six men (five clients and one co-therapist) the group did not feel too unbalanced. The art therapy activity also helped to equalise the atmosphere.

The 'anger management' art therapy group was set up in response to expressed client need. I had run such groups for violent men when in the probation service. I wanted to see if I could combine some of these strategies with art therapy, and to see if this could be helpful for a different client group with similar needs. The group ran for ten weeks (one session of two hours per week) with an interview before and after. The pre-group interview was designed to inform people about the group and to introduce ground rules such as the importance of weekly attendance. It was also to respond to clients' questions and to assess their suitability for the group. The post-group interview helped clients reflect on their experience and decide on their next step.

Each session included time for artwork, a time for sharing and a concluding relaxation. An early session introduced relaxation and guided imagery. A session on 'What is anger?' produced very colourful paintings and pictures. Another session, on 'Anger – good or bad?', included a look at the physical consequences of anger – tension, stomach problems, headaches and so on. Looking at family connections with anger was a crucial later session – three members of the group discussed their step-fathers, making significant connections with their current angry feelings.

One of the group members led a chaotic life, but nevertheless managed to attend regularly and produced graphic images of his anger. His guided imagery painting of a peaceful lake enabled him to find a way

out of his angry feelings. He commented at the end: 'I can relax if I make a conscious effort – sitting, listening to music, reading, painting at home ... I don't get so angry with people.'

Another group member painted a picture of his anger coming down the middle of the paper, then splitting in two directions – one going inward and turning into festering resentment inside him, the other going outward into productive energy. He realised after doing the picture that he had a choice about how he used his anger.

The group helped to make anger less frightening for themselves and more possible to deal with in a constructive way. Group members felt more able to deal with events in their life without losing control, and were able to cite specific instances where they were coping better. The creativity fostered by the art therapy process was a positive way forward from anger for several people.

Conclusion: an art therapy for men?

This chapter has been an interesting one for me to write, as it has been a genuine exploration of ways of working. At times I have found working with men frustrating, leaving me wondering if I have lost my professional skills – at other times, interesting and rewarding, when I have seen progress being made. The conclusions I have drawn have been surprising to me, and I have wondered if I was 'out on a limb' somewhere. My readers have reassured me on this point and confirmation came from an unexpected source, an audiotape from a professor of psychiatry (Briere 1995), who offered similar pointers to those I give below. The whole process has helped me to see new possibilities.

This exploration has looked at some of the differences between two client groups, settings and ways of working. It would seem that art therapy has much to offer men, but some have difficulties accessing it, because of factors connected with male socialisation. The norms of therapy – openness about feelings, communication, self-reflection, intimacy – are areas where many men have difficulties. And yet it is for this very reason that therapy has something to offer which they need.

Art therapy has a special role in providing a bridge to these skills, in giving time for an activity (and one with very visible boundaries), which may feel safer and more purposeful (in being active) than a verbal therapy.

Art therapy provides an active phase which can then lead more easily to reflection. There are many ways of practising art therapy, and the reflections above suggest the following pointers:

- There needs to be a recognition of the extra difficulties men may find in accessing therapy; perhaps some literature, in which men speak of the benefits, could help the cautious to be reassured about art therapy – in particular the vulnerability (and 'un-macho-ness') of being a client.

- The 'art part' of an art therapy session is likely to be the more important part for many men, especially at the beginning of therapy.

- Sessions comprising structured exercises may be helpful in containing men's anxiety about the unfamiliar world of feelings.

- Work around feelings may need to be divided into smaller, more manageable steps.

- Some men may find group work easier than individual work, because it is less intimate, and group solidarity compensates for their feelings of being 'deficient men' for needing therapy.

- Men's groups may help men to look at their specific needs without instinctively relying on women to 'do the emotional bit'.

Of course, there is a great overlap between men and women in their approaches – from the stereotypes at each end of the spectrum to men who are comfortable with feelings and women who experience similar difficulties to many men. So these reflections may also be relevant to some women.

In the same way that the criminal justice system makes very few provisions for the 'special needs' of women, perhaps the mental health system should pay more attention to the 'special needs' of men. This chapter is a tentative start.

Acknowledgements

I would like to acknowledge the help of the following colleagues who read and commented on the chapter in draft form: Jo Beedell, Mike Coldham, Karen Drucker, Kim Etherington, John Ford, Liz Lumley-Smith, Richard Manners, Damian Taylor, Fiona Williams.

Bibliography

Biddulph, S. (1999) *Manhood: An Action Plan for Changing Men's Lives.* Stroud: Hawthorn Press.

Briere, J. (1995) Audio transcript of 3rd Annual Conference on Advances in Treating Survivors of Sexual Abuse, San Francisco, Mar 2–6 1995.

Clare, A. (2000) 'A Question of Violence' 25.7.2000. Part of series Men in Crisis, Radio 4.

Etherington, K. (1995) *Adult Male Survivors of Childhood Sexual Abuse.* London: Pitman Publishing.

Hodson, P. (1984) *Men: An Investigation into the Emotional Male.* London: British Broadcasting Corporation (BBC).

Lee, J. (1991) *At My Father's Wedding.* New York: Bantam.

Liebmann, M. (1990) '"It Just Happened": Looking at Crime Events.' In M. Liebmann (ed) *Art Therapy in Practice.* London: Jessica Kingsley Publishers.

Liebmann, M. (1991) 'Letting go and getting framed.' *Probation Journal 38*, 1, March issue.

Liebmann, M. (1994) 'Art Therapy and Changing Probation Values.' In M. Liebmann (ed) *Art Therapy with Offenders.* London: Jessica Kingsley Publishers.

Liebmann, M. (1998) 'Art Therapy with Offenders on Probation.' In D. Sandle (ed) *Development and Diversity: New Applications in Art Therapy.* London: Free Association Books.

Miedzian, M. (1992) *Boys Will Be Boys: Breaking the Link Between Masculinity and Violence.* London: Virago Press. First published in 1991 in America by Doubleday.

Schaverien, J. (1995) *Desire and the Female Therapist: Engendered Gazes in Psychotherapy and Art Therapy.* London and New York: Routledge.

Schaverien, J. (1997) 'Men who leave too soon: Reflections on the erotic transference and countertransference.' *British Journal of Psychotherapy 14*, 1, 3–16.

Tannen, D. (1992) *You Just Don't Understand – Women and Men in Conversation.* London: Virago Press. First published in 1990.

Welldon, E. (1988) *Mother, Madonna, Whore: The Idealisation and Denigration of Motherhood.* London: Free Association Books.

A Mediterranean Perspective on the Art Therapist's Sexual Orientation

José Batista Loureiro De Oliveira

We learn gender performance early in childhood, and it remains with us virtually all our lives. When our gender identities are threatened, we will often retreat into exaggerated displays of hyper masculinity or exaggerated femininity. And when our sense of others' gender identity is disrupted or dislodged, we can become anxious, even violent. 'We're so invested in being a man or women that if you fall outside that easy definition of what a man or woman is, a lot of people see you as some kind of monster' commented Susan Stryker, who is a male-to-female transsexual.

(Kimmel 2000, p.104)

We hardly ever write about the therapist (it is easier to write and construct case studies) or when we do, we do so in a 'straight', respectful, powerful and conventional way. In essence, we perceive the therapist as neutral, invisible, untouchable, recalling the myth of a healer and authoritative figure. This myth might recall the psychoanalytic and medical model (of course I am mentioning the prevailing Western therapeutic models). Naturally, there is an infinite number of 'unofficial' therapists in both East and West.

In the West, for example, psychoanalysis sought to build a scientific account of masculinity and femininity. Freud located the high drama of male and female gender identity acquisition and consolidation in the Oedipal crisis, and he privileged the role of the father in this civilising process. This is the point at which the father threatens boys with castration if they do not give up the mother as a sexual love object; girls, by contrast, are forced to recognise their effective castration and presumably turn away from the mother in anger and disappointment. Psychoanalysis has had a huge cultural influence.

In the nineteenth and twentieth centuries, the 'healing sciences' have been impregnated by the psychopathologisation of sexual perversions, deviances and not socially adapted behaviours (Foucault 1978). The work of Foucault has clearly explored the construction of Victorian notions of sexuality and all its consequences for psychological and social practices. Terry S. Stein summarises Foucault's thought:

> The seminal work of the French philosopher Michel Foucault, beginning with the publication of *The History of Sexuality, Volume I: An Introduction* in 1978, significantly shaped the parameters of the social constructionist debate about sexuality throughout the next decade. Foucault argues that there is no intrinsic sexual drive but rather that the human potential for thinking and acting is shaped by social forces of regulation and categorisation into various forms of sexuality at different times in history. Thus, according to this view, sexuality is not simply influenced or moulded but is actually created by cultural forces. (Stein 1998, p.31)

Stein's words help us to clearly see the difference between essentialism and social constructionism. The former is committed to approach sexuality, gender and sexual orientation as something directly based on biological destinies of nature only, completely ignoring the socio-cultural interactions in the construction of gender and its attributes. It seems that social sciences and medical practices have more dividends in coining a human relationship on the biological destiny and conformist practices, whereas the social construction of gender is anchored in multiple diverse elements that construct the male and female gender. Then, gender and sexuality are not intrinsic innate drivers in which we

are trapped, but rather our gender and sexuality are socially and historically created, based on power, class and race.

There are huge similarities between the Mediterranean and South American cultures and similar gender issues relate to each:

> Latin America…the gender consequences involved a reshaping of local culture under the pressure of the colonizers… It is a familiar suggestion that Latin American machismo was a product of the interplay of cultures under colonialism. Spanish Catholicism provided the ideology of female abnegations. Spanish colonialism also involved a violent and sustained assault on the customary homosexuality of native cultures. (Connell 1995, p.198)

Gender and sexuality are embedded within cultural context and are reshaped by historical, societal, political and individual driving forces. Studies in sexual orientation should also be approached as not only psychological issues but within the broader mosaic of possibilities including history, sociology and cultural studies.

In this chapter I will be considering therapists and their sexual orientation and will also try to look at different concepts within the 'healing sciences' in the Mediterranean and South America such as psychology, art therapy, psychoanalysis and psychiatric conceptions of sexual orientation. I shall be arguing that the 'healing sciences' might be amongst the most conservative vehicles of the reproduction of heterosexism, sexual discrimination and gender dichotomy.

I will also argue that sexual orientation is still a contentious subject (even in academic circles) because it is inculcated with sex role theory and essentialism which have been dominating the social sciences in a negative way since the early twentieth century (Connell 1995). This analysis will approach sexual orientation according to the social construction of gender, identifying psychological practices still anchored in negative conceptions of gender and sexual orientation stereotypes.

Even at the beginning of the new millennium the conceptions of gender and sexual orientation are based on traditional values. These values are mainly manufactured and controlled by gender dominated institutional powers which dictate the male and female gender stereotypes. Gender traits are not predetermined by biological genotypes, but

they are rather part of a large and complex sociological structure. To be male or female is a mixture of elements where:

> the meaning of gender vary [sic] among different groups of women and men within any particular culture at any particular time. Simply put, not all American men and women are the same. Our experiences are structured by class, race, ethnicity, age, sexuality, region of the country. Each of these axes modifies the others. Just because we make gender visible doesn't mean that we make these other organising principles of social life invisible. Imagine, for example, an older black gay man in Chicago and a young white heterosexual farm boy in Iowa. Wouldn't they have different definitions of masculinity? Or imagine a twenty-two-year-old heterosexual poor Asian-American woman in San Francisco and a wealthy white Irish Catholic lesbian in Boston. Wouldn't their ideas about what it means to be a woman be somewhat different? (Kimmel 1999, p.3)

The theoretical background of this text is the social construction of gender and also it is inspired by the men's studies where I situate my psychotherapeutic work and research. There are still few men working on men's studies applied to art therapy or psychological treatment in general. That is why many issues regarding sexual orientation here are addressed to the male therapist.

Hormonally gendered: approaching sex role theory

A provocative, backward, narrow and sophisticated version of gender was imposed on the sciences in the 1930s; hormones, biological combinations, bodies and souls followed biological apparatus configurations. Worse, male and female gender profiles were shaped in a way that forced men and women to perform a theatrical gender role.

Sex role theory has outlined male and female biological traits in such a way that gender is compulsorily predicted by biological and anatomical fate. The ideology that our gender is only a biological heritage is hugely influential and disseminated as Kimmel explains:

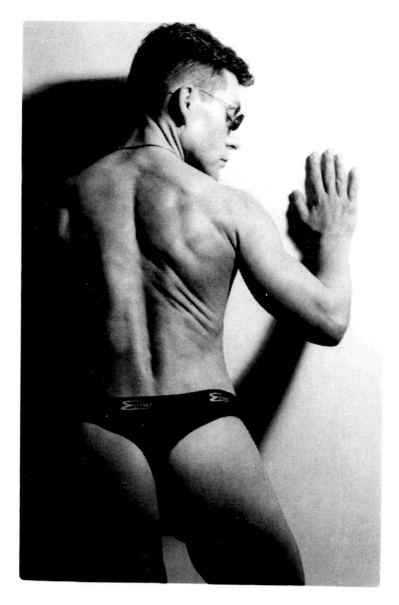

Figure 7.1 **Man's Bottom** *by José Batista Loureiro De Oliveira (2000)*
© José Batista Loureiro De Oliveira

Under a fascist and Catholic upbringing, sexual roles are fixed. All that does not fit into biological normality is seen as nature's aberrations. Abnegations, silence, blame, sin, within this background, generate victims of moral and sexual insanity. Identification and desire are anchored in the biology of the person. Homoerotic desire is denied, blasted and evil. Female bottoms are used for selling, lust and beauty but showing a male bottom is sinful, immoral and homophobic.

...anatomy, many of us believe, is destiny; the constitution of our
bodies determines our social and psychological disposition.
Biological sex decides our gendered experiences. Sex, is
temperament. Biological explanations offer perhaps the tidiest and
most coherent explanations for both gender difference and gender
inequality. (Kimmel 1999, p.2)

Biological determinism is not only present in sex role theory but also
permeates other realms of our lives and professional practices. Sex role
theory was not created by mental health practitioners, but it was taken up
by them. Connell describes the establishment of sex roles in the twentieth
century social sciences as follows:

Around the mid-century, sex difference research met up with a
concept that seemed to explain its subject matter in an up-to-date
way, the concept of 'social role'. The meeting gave birth to the term
'sex role', which in time passed into everyday speech. The idea of sex
role is now so common that it is worth emphasising its recent origin.
The metaphor of human life as a drama is of course an old one – it
was used by Shakespeare. But the use of 'role' as a technical concept
in the social sciences, as a serious way of explaining social behaviour
generally, dates only from the 1930s. It provided a handy way of
linking the idea of a place in a social structure with the idea of
cultural norms. Through the efforts of a galaxy of anthropologists,
sociologists and psychologists, the concept, by the end of the 1950s,
had joined the stock of conventional terms in the social sciences.
(Connell 1995, p.22)

Sex role theory is still dominating the social sciences and, therefore,
affecting our conceptions and practices such as sexual orientation. This
background constitutes a narrow approach to the subject of gender in
contrast with that of social constructionism. To reiterate, the critical
analysis of sex role theory has largely been developed in the writings of
social constructionists in their analysis of the way in which sexual
characteristics are viewed as inherent, objective, transcultural and
trans-historical.

There are updated examples of gender politics in Rio de Janeiro,
Brazil regarding the state Assembly voting on the recognition of gay

rights groups. Some politicians from Rio de Janeiro, Brazil, have stated the following regarding homosexuality:

> I am not against homosexuals, but against homosexuality.
> Mario Luiz (PFC)

> For years we have heard that there are ex-deputies, ex husbands and other exes. Never, however, in my whole life have I heard about the existence of one ex-gay, ex-homosexual.
> Wolney Trinidade (PDT)

> In the average masculinist mind, a person who holds an active sexual relation as a homosexual is not considered 'homosexual'. They consider homosexual the one who is 'eaten (penetrated)', the man that holds the passive role.
> Carlos Minc (PT)

> Sex is not an option, it is determinism. Nobody was born male or female because they have chosen so…what they wish indeed, is to admit as natural what is against nature for their human relationship.
> Carlos Dias (PFL)

> If God, whom I've questioned so much, accepted a gay, he would not have created Adam and Eve but Adam and Ivan. To conclude, I was told by the chairman of Arco-Ins (a gay group) that 10% of society is gay. We are 70 deputies; therefore there are 7 gays here. I wish to know who they are.
> Sivuca (PPB)

> (excerpted from *Jornal do Brasil*, Cidade-December 19, 1999 – Rio de Janeiro.)

Clearly institutional power is massive and decisive for collective fates. Sexual prejudices are all well-set against social deviance. The above voices are part of the country's colonial and religious background. Of course, daily sexual and gender practices and performances are not the same as those that institutions claim to be the universal and moral ones. In other words, there is a gap between what institutions' idealised behaviours are and what people do with their gender and sexuality on a daily basis.

The narrow and bigoted definitions of social stereotypes do not help the development of individual and institutional dynamics in any way. The sex role stigma preserves the fixed roles, the static and monotonous repetition of a list of behaviours, whereas the social construction of gender is open to follow the dynamic formation of gender, such as the notion that 'masculinity is not just an idea or a personal identity. It is also extended in the world, merged in organized social relations. To understand masculinity historically we must study changes in those social relations' (Connell 1995, p.29).

Many psychological practices have adopted the biological ideology of male and female traits from sex role theory. Psychology seems to have the ideological power to discern between conforming gender and deviant gender. Some healers 'know'.

Mental health practices are constructed within a historical timescale and take into account local politics and gender conceptions, therefore, they are not universal. Even if we work with clients using a particular theoretical model, we are always practising with locally constructed configurations.

As healing practice is not a neutral issue, there are still many healing practices turning clients' sexual orientation into a bizarre and hegemonic heterosexism. Sex role theory is a universal and biological prediction for males and females. One should struggle to adapt to universal gender. Kimmel clearly expresses the mandatory conformity of sex roles when he points out that:

> ...the sex role paradigm is based upon the traits associated with the role – *a kind of laundry list of behavioural characteristics – rather than their enactments.* This makes sex roles not only more static than they might otherwise be but posits an ideal configuration that bears little, if any, relation to the ways in which sex roles are enacted in everyday life. In addition, the sex role paradigm minimises the extent to which gender relations are based on power. Not only do men as a group exert power over women as a group, but the historically derived definitions of masculinity and femininity reproduce those power relations. (Kimmel 1987, pp.12–13, my italics)

Sexual orientation and gender are very fashionable issues within academic circles as well as in the media. In my opinion, Latin societies are

behind in gender and sexual political issues: these societies have been dominated by machismo, Marianism and a lack of understanding of women, gay and lesbian minorities, often abused by the church's ideologies and colonisation.

Gender and sexual orientation are not impartial issues; rather, they are locally and socially constructed and spread out under the creation and maintenance of institutional power. Gendered institutions impose a gender conforming identity (gendered family, gendered classroom and gendered workplace) (Kimmel 2000) on each individual. The problem does not arise from living in gendered societies, but from the construction of gender stigma in relation to gender conformity and sexual orientation.

According to sex role theory, gender is more of a performance than an identity (Butler 1990). Some things are exclusively designated for each gender, such as skirts for women and slacks for men, heels for women and moustaches for men. We 'do' gender in different settings of our lives, we do gender with clothes; television role models dictate regimes of gender construction. It is a 'regime' because it is imposed and some people under the spell of these models identify themselves with a public representation of sex roles.

The evidence of sex role theory limitations is clear especially when related to the plurality of gender requirements. Dividing sex and gender into fixed categories, with lists of attributes that men and women must acquire, does not help mental health practices to open up possibilities to rethink sexual politics in relation to gays and lesbians, women's oppression and sexual orientation. Connell expresses the limitations of the sex role theory approach when applied to gender and sexuality, stating:

> In sex role theory, action [the role enactment] is linked to a structure defined by biological difference, the dichotomy of male and female – not to a structure defined by social relations. This leads to categorisation, the reduction of gender to two homogenous categories, betrayed by the persistent blurring of sex differences with sex roles. Sex roles are defined as reciprocal; polarisation [sic] is a necessary part of the concept. This leads to a misperception of social reality, exaggerating differences between men and women, while obscuring the structures of race, class and sexuality. It is telling that discussions

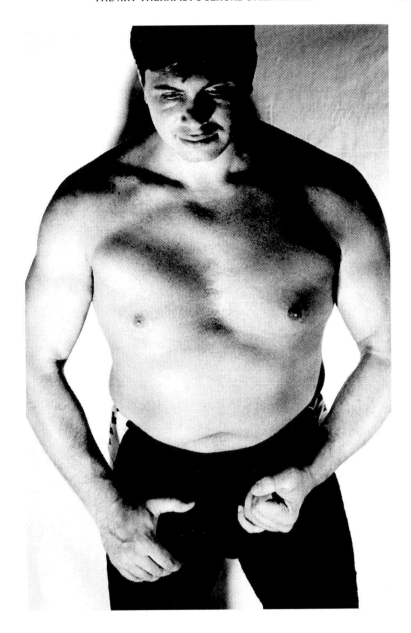

Figure 7.2 **Man's Balls** *by José Batista Loureiro De Oliveira (2000)*
© José Batista Loureiro De Oliveira

Gender and sexuality are socially constructed. Men are not only determined by biological factors. Obviously, having a penis is not enough to construct gender identity. Typical Latino men reassure their sexuality and gender based on machismo, then: 'a macho' (that is a real man) 'is a guy who thinks with his balls'. (Gilmore 1987, p.98)

of 'the male sex role' have mostly ignored gay men and have little to say about race and ethnicity. (Connell 1995, p.27)

Setting gender forms through biological traits only results in a tragic and conservative social construction: human beings live outside biological sexual stigmas. All prejudice against 'deviant' gender, such as that experienced by gays and lesbians, may well originate from the notion that the universal biological profile of male and female must correspond to universal models of masculinities and femininities with no consideration of local cultural constructions.

Few psychologists have criticised psychological literature regarding male gender sex role theory. Joseph Pleck, an American social psychologist, has explored the limitations, contradictions, uses and abuses in the sex role constructions of the male gender stereotype since the 1930s. His contribution to the psychology and sociology of gender is distinctive. In *The Myth of Masculinity* (1981) Pleck clearly rejected the construction of the male sex role identity (his name for the functionalist sex role theory) and proposed the notion of male sex 'role strain', reinforcing the idea that the male did not suffer from sex role identity construction, but rather from the strain caused by sex role expectations (Segal 1990). Attributing and judging people according to their innate biological male and female attributes brings to mind the most bigoted, backward and insane biological determinism still prevailing in the mental health professions. As cultural beings, our sexuality, gender and sexual orientation are beyond innate biological conformism and predictions. Gender conformity and inequality are more institutional appropriation of our bodies than a biological destiny. Conformity and inequality invites power, control and discrimination.

The plurality of voices: approaching the social construction of gender

Here, I discuss briefly the fundamentals of the social construction of gender and its movement towards a sound approach to sexual orientation. The social construction approach was a breakthrough for the social sciences in the twentieth century and has brought about many new ways of approaching gender and sexuality.

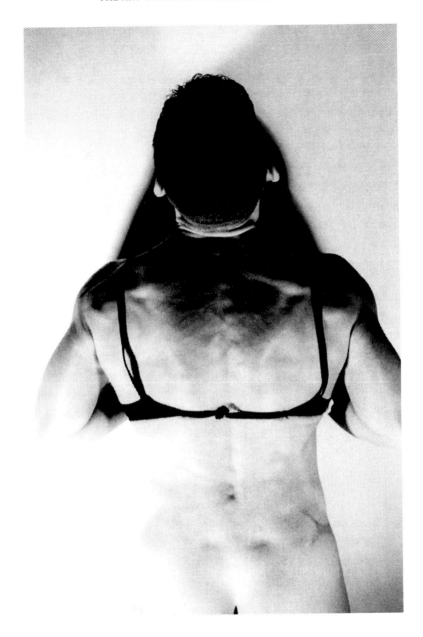

Figure 7.3 **Man in Bra** *by José Batista Loureiro De Oliveira (2000)*
© José Batista Loureiro De Oliveira
Male and female sexual roles are not from biological factors such as neuroendocrine, ana-tomical or genetic features. They are rather social boundaries, limits that were created to force the preservation and survival of sexual labels. A man in a bra is not a sinner or a gender offender.

To understand the social construction of gender it is necessary first to define the term 'gender', as noted by Runyan and Peterson:

> ...gender refers to socially learned behaviour and expectations that distinguish between masculinity and femininity...gender is an acquired identity. We learn, through culturally specific socialisation, how to be masculine and feminine and to assume the identities of men and women. In fact, the socialisation dimension is so powerful that apparently unequivocal gender identities are formed even when biological sex is unclear (hermaphroditism) or mistaken (when the absence of a penis on a genetically male infant leads to a false identification as female). (Runyan and Peterson 1993, p.5)

The creation of gender can alter sexuality and its attributes, changing the notion of female and male identity. Stein states:

> Social constructionism is a belief both in the primary importance of social forces in shaping human behaviour and experience, that knowledge is not in fact a reflection of the world, but rather a product of discourse. According to Gergen (1985, p.266), 'Social constructionist inquiry is principally concerned with explicating the process by which people come to describe, explain, or otherwise account for the world (including themselves) in which they live.

He describes four assumptions that underline social constructionist theory:

1. Existing categories and ideas arise from language and context and do not serve as a map of the world. Thus, commonly accepted concepts, including gender, emotions, childhood, domestic violence, psychological disorder, etc., should not be taken as objective facts derived from observation but rather as social conventions.

2. Common ideas and categories are 'artifacts' of particular societies at particular times and change across time. Even the most fundamental conceptions such as ideas of self, identity, romantic love, emotion, reason, and language should be understood as culturally and historically specific social constructions.

3. The degree to which an idea gains prominence over time should not be understood as a reflection of its empirical accuracy but rather as a function of the processes of social interaction. Thus, according to this view, even methods for attaining truth and knowledge, as represented for example in scientific rules, can serve primarily as a means for achieving social control rather than for acquiring understanding.

4. Forms of descriptions and explanations serve as expressions of social meaning and action. Gergen cites the example within psychology of how conceptions of emotion involving choice or lack of choice significantly affect the implications for treating people who suffer from certain emotional states like depression, anxiety and fear. (Stein 1998, pp.30–1)

The therapist's sexual orientation

Masculinities and femininities are neither universal nor fixed individually. Masculinities are constructed in relation to femininities and express the multiple ways in which gender identity is articulated. Consequently, if masculinities and femininities are not universally constructed then femininity and masculinity might mean different things in different classes, races and nationalities in different periods of time. To put it very simply, masculinities and femininities have local values and attributes. For example, being a working-class immigrant black gay man in the north of Italy is extremely different from being an upper-class white gay man from Sicily. Gender always has multiple forms, roles and performances in different places for different people. Masculinities and femininities imply sexual orientation and this is neither fixed nor acquired but rather continually constructed during one's life. Psychology and psychiatry for a long time have claimed that sexual orientation is innate and have overtly and subtly sustained that society is predominantly heterosexual and any other form of sexual orientation is deviant and perverted.

In *The Three Essays on the Theory of Sexuality* (1985) Freud suggested that gender differences are neither innate nor naturally distributed among male and female children. Obviously, having a vagina or penis is not enough to construct gender identity. In other words, the construction

of gender identity is definitely not just based on a person's biology. The construction of male gender identity has an complex internal system which psychoanalysis has endeavoured to explain. The making of masculinities in the Oedipal crisis was fully documented in the Little Hans and Rat Man case studies.

According to Freud, humans are constitutionally bisexual. Male inverts or homosexuals are those who did not overcome the Oedipal crisis and consequently are sexually immature and not able to identify with male gender identity.

Gender and sexual orientation are still a taboo. Homosexuality in some Mediterranean and South American areas is still viewed harshly because:

> The Catholic Church, a significant influence on Latin culture, can also be seen as an adjunctive structure that supports traditional family dynamics and condemns homosexuality while promoting sexuality in the service of procreation. (Tori 1989 in Gonzalez and Espin 1996)

Although Latin culture is fanatically Catholic, sexual orientation is aggressively heterosexual, but the practice of homosexuality, bisexuality and transsexuality is common. It appears to be a contradiction that where there is Catholic hegemony, there are multiplicities of gender forms. The dilemma is not in this multiplicity but in the historical patriarchal hegemony and homophobia.

Stein (1998) quotes a synthesis of social constructionism views of sexual orientation which helps an approach to the sexual orientation of the therapist:

> 1. Sexual orientation is different in every society and at different times in history. (Stein 1998, p.41)
>
> 2. Sexual orientation is mutable. (Stein 1998, p.43)
>
> 3. Sexual orientation is constructed. (Stein 1998, p.42)
>
> 4. Sexual orientation can to some extent be chosen by the individual. (Stein 1998, p.45)

Stein clearly takes an opposing stance to sex role theory.

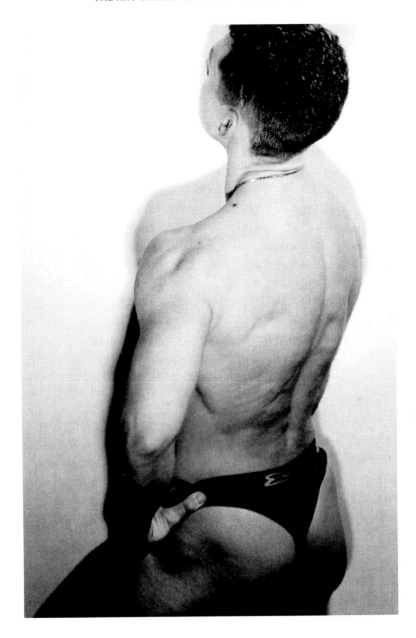

Figure 7.4 **Sinner** *by José Batista Loureiro De Oliveira (2000)*
© José Batista Loureiro De Oliveira

Sexual orientation is neither an innate individual attribute nor a nature aberration. The plu-
ralities of sexual orientation that individuals are to experience are huge. Individuals' bodies
are made from flesh and desire. Powerful institutionalised heterosexism disallows the
presence of any original sinner against 'nature'.

Under Catholicism sexual abnegation turns into sexual normality. In Mediterranean cultures, the notion of gender and homosexuality needs to be reconsidered. Foucault aligns the early development of gender construction with the confessional ritual of Catholicism:

> ...the scope of the confession – the confession of the flesh – continually increased. This was partly because the counter reform busied itself with stepping up the rhythm of the early confession in the Catholic countries, and because it tried to impose meticulous rules of self-examination; but above all, because it attributed more and more importance to penance – and perhaps at the expense of some sins – to all the insinuations of the flesh: thoughts, desires, voluptuous imaginings, delectations, combined movements of the body and the soul, henceforth all this had to enter, detail into the process of confession and guidance. According to the new pastoral, sex must not be named imprudently, but its aspects, its correlations and its effects must be pursued down to their slenderest ramifications: a shadow in a daydream, an image too slowly dispelled, a badly exorcised complicity between the body's mechanics and the mind's complacency: everything had to be told. (Foucault 1978, p.19)

That the Mediterranean area does have a Catholic background is vital to understanding why it has taken so many years to break the sexual silence and bring to light sexual issues that remain outside the dominant and stereotyped gender order. Machismo, homophobia and a religious background are where gender issues lie in this culture and David Gilmore gives an astonishing example of this in Andalusia, Spain:

> First, and of central importance, is virility, the Andalusian ideal of macho. This means being sexually potent in a physiological sense. For married men this includes fathering many children (preferably boys), satisfying one's wife, frequenting brothels and publicly displaying lecherous intentions (though not necessarily actions) towards nubile women. Mistresses, if they are discreetly maintained, are appropriate. For young bachelors, this would naturally include actual attempts at seduction, frequent masturbation, a sexual bravado (usually more impressive in word than deed), and generally, as men say, obeying the peremptory commands of the testicles

(cojones). A 'macho' (that is a real man) is a guy who thinks with his balls. (Gilmore 1986, p.98)

Gilmore thus explains difficulties of gender issues relating to this area. It appears that there is only one sexual orientation: heterosexuality. A plurality of gender voices does not exist. Although:

> ...many gay, lesbian and bisexual professionals in powerful roles did not, and do not, voluntarily come out as gay, lesbian or bisexual, depriving many other professionals of the opportunity to learn from their peers and denying their own capacity to serve as role models for the public. As a result of continued societal homophobia and internalized homophobia, many professionals do not feel able to come out. (Cabaj 1996, p.35)

Implications for practice

In the Mediterranean and South American cultural contexts, where machismo and homophobia is aggressively institutionalised and instigated, the label of sexual minorities does exist and is supported by many departments of national politics and national care.

Should there not be therapists for gays, lesbians and those who are transgendered? Again, there is the possibility of ghettoising clients from sexual minorities and also gay and lesbian therapists. Gay therapists should be able to work with non-gay clients and vice versa. Some Mediterranean therapists do not take gender issues into consideration and when they do it tends to concern the male and female stereotypes. Latino homophobia is the main barrier to be destroyed and only professional commitment and 'finding culturally syntonic ways to allow a greater dialogue in the Latino community about homosexuality would greatly facilitate the difficult journey of self-discovery and affirmation for many Latino gays and Latino lesbians' (Gonzales and Espin 1996, p.596).

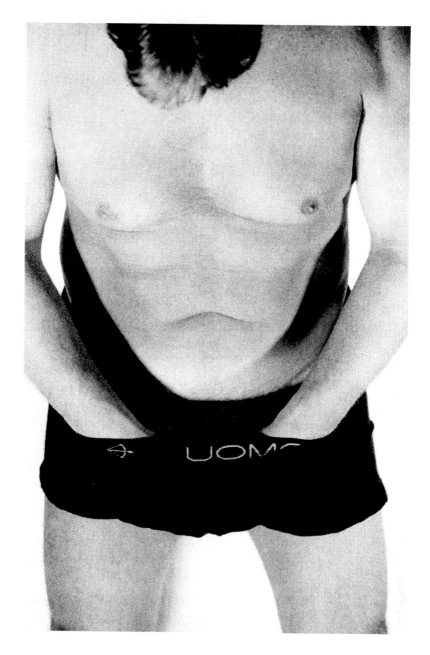

*Figure 7.5 **Macho Man** by José Batista Loureiro De Oliveira (2000)*
© José Batista Loureiro De Oliveira
Socio-biological expectations build men and masculinities. The frontier between macho men and faggot men is not fixed but rather a local arrangement. The sex industry allows consumption, sex and desire to become conflated.

Conclusion

To conclude, when considering sexual orientation it is crucial to understand the social constructionism perspective of the social services. As sexuality and gender are constructed politically, socially, *locally* and historically, this is fundamental for any major change to clinical practice and also for all social sciences, especially regarding those approaching gender, sexuality, power and institutions.

This discussion might sound obvious, but it is not (at least for the Latin culture). The above practices are local, historical and political. Institutional power is clearly a determinant in all our decisions from daily ones to the most complicated ones concerning national issues of healthcare. Institutional constructions dictate social behaviours based only on collective constructions. Individual cases are not normally taken into serious consideration.

Now we are aware of the issues surrounding gender creation, we are no longer tied to a biological representation of subjectivity. There is no further need for the sex role to dominate sexual and gendered personal representation or to assume that men and women are restricted to an unchanging and institutionally constructed sexual orientation.

The therapist's sexual orientation is a difficult issue and there has been very little written about it. We interact with our clients but rarely take our own sexual orientation into consideration. Why should it only be the client who is 'analysed'? Why should the therapist always be a neutral figure who hides himself/herself behind a 'neutral model'? Psychiatry, psychology and art therapy are not 'neutral' clinical practices, but are political, historical and local.

My argument about the importance of the art therapist's sexual orientation is an unusual one, partly because there has been little research on the subject but perhaps mostly because there is no real interest in the topic. It is easier for us to discuss our clients and the difficulties they experience, their dynamics, the pressures they have to cope with. It is not so easy to highlight the figure of the therapist. In some Western cultures sexuality, gender and sexual orientation are still taboo topics, even aggressively so. Sexuality and gender are an extremely important and determinant part of our lives not only within the therapeutic setting but also in the tragic or comic scenes of our daily lives.

Some parts of the world still struggle to acknowledge gender issues. Gendered institutions and gendered therapists still assert that sexual orientation is not an inconsequential but a crucial part of our lives, which has a powerful impact on our relationships and dictates traditional masculinity and femininity configurations.

However, since the 1960s, the pioneering work of feminist scholars, both in traditional disciplines and in women's studies, has made us increasingly aware of the centrality of gender in the shaping of social life. We now know that gender is 'one of the central organising principles around which social life revolves' (Kimmel 1999, p.1).

Acknowledgments

I would like to thank to Emilia Abbate, Arrigo Mercati and Anthony Paul Kennedy for all their encouragement and support during my journey through Europe.

Bibliography

American Psychological Association – Public Interest (1998) *Answers To Your Questions About Sexual Orientation.* www.apa.org/pubinfo/answers.html.

Butler, J. (1990) *Gender Trouble.* New York: Routledge.

Cabaj, R.P. (1996) 'Gay, lesbian and bisexual mental health professionals and their colleagues.' In R.P. Cabaj and S.T. Stein (eds) *The Textbook of Homosexuality and Mental Health.* Washington: American Psychiatric Press.

Connell, R.W. (1995) *Masculinities.* Cambridge: Polity Press.

Foucault, M. (1979) *The History of Sexuality: An Introduction.* London: Allen Lane.

Freud, S. (1985) 'The three essays on the theory of sexuality.' *Case Histories I. Volume 1: 'Dorra' and 'Little Hans'.* London: Penguin.

Gilmore, D.D. (1986) *Honor and Shame and the Unity of the Mediterranean.* Washington: The American Anthropological Association.

Gonzales, F.J. and Espin, O.M. (1996) 'Latino Men, Latino Women and Homosexuality.' In R. P. Cabaj and S.T. Stein (eds) *The Textbook of Homosexuality and Mental Health.* Washington: American Psychiatric Press.

Jornal do Brazil (www.jb.com.br). Rio de Janeiro, Brazil.

Kimmel, M.S. (2000) *The Gendered Society.* New York: Oxford University Press.

Kimmel, M.S (1990) (ed) *Men Confront Pornography.* New York: Crown Publishers.

Kimmel, M.S. and Aronson, A. (eds) (1999) *The Gendered Society Reader.* New York: Oxford University Press.

Pleck, J.H. (1981) *The Myth of Masculinity.* Camridge, Mass: MIT Press.

Runyan, A.S. and Peterson, V. (1993) *Global Gender Issues.* San Francisco: Westview.

Segal, L. (1990) *Slow Motion: Changing Masculinities, Changing Men.* London: Virago.

Stein, S.T. (1998) 'Social constructionism and essentialism: Theoretical and clinical considerations relevant to psychotherapy.' In *Journal Of Gay & Lesbian Psychotherapy 2,* 4, 29–49.

Tori, C. D. (1989) 'Homosexuality and illegal residency status in relation to substance abuse and personality traits among Mexican nationals.' *Journal of Clinical Psychology 45,* 814–821.

West, C. and Zimmerman, D.H. (1999) 'Doing Gender' In Kimmel, M.S. and Aronson, A. (eds) *Gendered Society Reader.* New York: Oxford University Press.

A Discussion of the Use of Art Therapy with Women who are Pregnant or who have Recently Given Birth

Susan Hogan

Many pregnant women share a dread of personal obliteration...[or] worry about the irreversible character of motherhood...

(Matthews and Wexler 2000, p.xi)

Introduction

The poet Adrienne Rich managed to capture aspects of the experience of pregnancy, birth and first time motherhood in her groundbreaking and eloquent text *Of Woman Born: Motherhood As Experience and Institution* (1976). Rich manages to convey something of the tremendous emotional impact of motherhood:

> No one mentions the psychic crisis of bearing a first child, the excitation of long-buried feelings about one's own mother, the sense of confused power and powerlessness, on being taken over on the one hand and of touching new physical and psychic potentialities on the other, a heightened sensibility which can be exhilarating, bewildering and exhausting. No one mentions the strangeness of attrac-

tion – which can be as single-minded and overwhelming as the early days of a love affair – to a being so tiny, so dependent, so folded-in to itself – who is, and yet is not, part of oneself. (Rich 1976, p.36)

It is a platitude to insist that nothing can possibly prepare us for the intensity and power of this experience, but it is also true. Her work captures both beauty and tenderness but also her sense of claustrophobia, terror and rage; it is a very personal account. Invariably, she falls into the trap of generalising about women from her experience though the text has many insights and descriptive potency.

A certain set of reactions to the experiences of pregnancy and childbirth are considered within normal limits and those which fall outside and are defined as aberrant can provoke a range of responses from suspicion and hostility to compulsory medical intervention. A woman who refuses to agree to a planned Caesarean section, thought necessary by her obstetrician, for example, faces the possibility of her obstetrician obtaining a court order forcing her to undergo the *life-threatening procedure* against her will. Women with a history of mental 'dis-ease' are particularly at risk of such interference.

Furthermore, women who are not passively compliant can quickly be characterised as difficult or irresponsible. Even being too inquisitive about facilities and procedures can provoke highly defensive reactions, as I discovered myself when I was first pregnant.

There is a burgeoning literature on pregnancy and birth. Anne Oakley's book *From Here to Maternity* (1981) was one of the first to explore the systematic way in which women's wishes and desires are violated as part of modern obstetric regimes. Anyone who has read Oakley's fascinating interviews with women about their pregnancy and birth experiences will have been chilled-to-the-bone by the recurrent reports made by women, regarding a range of medical interventions: 'I told them I didn't want it *but they did it anyway*'. Over and over these kinds of responses are made: 'I told him no, but ...': a terrifying *leitmotif* running through many of the accounts. The reality of pregnancy and birth for many women can come as a tremendous shock.

Another text employing interviews is *The Woman in the Body: A Cultural Analysis of Reproduction* by anthropologist Emily Martin (1987). However, this research was conducted in the USA and cannot, therefore,

be regarded as reliable in providing information about British women's experience. Some of the accounts are as chilling as those provided by Oakley. Martin's emphasis is on the machinery of obstetrics and the way that this systematically undermines and denigrates women's bodily experiences and impulses. She notes that 'the content of the women's remarks, the substance of what she objects to, escape notice' (Martin 1987, p.125). This research was particularly interesting in its focus on women's acts of resistance in the context of highly regulated and standardised 'technocratic' hospital births.

Another North American text is *Motherhood and Representation: The Mother in Popular Culture and Melodrama* (Kaplan 1992). This book is interesting insofar as it analyses visual 'texts' as well as written ones (mainly providing short analyses of popular films). However, despite its promising title, the book fails to extend the debate about women's changed sense of self-identity and sexuality through motherhood. The nature of Kaplan's material tends to perpetuate cliches about the subject and not all the debates can be seen as relevant to a British context.

Recently, texts such as Kate Figes' *Life After Birth* (1998), attempt to reveal the impact of pregnancy and birth on and for women. Based on a number of informal interviews, the emphasis of the book appears to be to reassure readers that they are not deviant in having certain feelings and reactions (such as the impulse to check that their baby is still breathing – which women constantly act upon) and the book is useful in this respect, though lacking in a critical analysis of the theoretical material presented. A similar and earlier text is Cobb's *Babyshock* (1980), which aims to introduce the harsh realities of early parenthood, in particular, to those expecting children. It is based on the premise that 'women, before the birth of their first child, have little or *no idea* what to expect', so this is a book to give them an idea (Cobb 1980, p.11).[1] The book uses quotations from women from interviews, which are interesting and often moving. However, in terms of narrative analysis, the women's veracity is sometimes undermined by the voice of medical authority; the women's experience is presented in the form of a quotation which is then contradicted by the medical expert.[2] Although the book is useful in pointing out that motherhood can be very stressful, and that caring for a baby can be very demanding (and this is achieved powerfully through the use of

apt quotation of interview fragments) there is, as well as a deep conde-
scension, an offensive negation of women's experience: 'At present there
is no evidence that long labours…labours complicated by induction, or
Caesarean sections have *on their own* been responsible for prolonged
emotional upset' (Cobb 1980, p.132). In other words, the woman who is
deeply traumatised by her birth experience was neurotic in the first place!
Figes, unlike Cobb, does not question the veracity of the women's
powerful testament. Cobb's book devotes only a very small section to the
subject of women's emotions, concluding that women will be 'more liable
to be upset' (Cobb 1980, p.52). Indeed the text appears to perpetuate the
idea that women become rather unhinged during pregnancy.[3] This idea is
perpetuated in all kinds of quarters; here is an example from the historian
David Starkey writing on Catherine Parr (who in the sixteenth century
remarried after the death of her husband Henry VIII): 'Maybe it was the
effects of this pregnancy – her first at the age of thirty-six – which unbal-
anced her judgement' (Starkey 2001, pp.69–70). Here we have an
example of age at conception and potential instability linked. As a woman
who also experienced her first pregnancy at the age of thirty-six I could
not help but wince at this remark.

Figes' book is a better attempt than that of Dana Breen (1989), for
example, who uses transcript fragments in a crude manner as a peg from
which to hang her object relations theory. The theory does not elucidate
the women's experience. Similarly, Ruddick's attempts to define
'maternal thinking' in *Representations of Motherhood* (1994) represent the
kind of reductive essentialism which is not helpful to a critical analysis.

A text worthy of mention is Tess Cosslett's *Women Writing Childbirth:
Modern Discourses of Motherhood* (1994) which is highly entertaining but
which falls into the trap of generalising about women's experience from
analysis of only a small number of mainly literary descriptions of
pregnancy and childbirth (and it is not clear which of the women authors
cited have experienced birth and which have not, so the reader cannot
distinguish between childless women's fantasies about childbirth and
those written from experience). Her main point that women develop a
more fluid sense of self-identity through the experience of pregnancy
and childbirth is very interesting. Maternal processes challenge precon-
ceived ideas about individuality. What all these accounts fail to do is to

give a clear depiction of women's changed sense of self-identity as a result of pregnancy and motherhood. It is perhaps Rich's book which comes closest to providing such an account but as it is autobiographical it cannot necessarily be seen as generalisable to other women. Zadoroznyi (1999) asserts that 'childbirth itself needs to be recognised as a critical reflexive moment which for many women contributes to changes in lived identity' (Zadoroznyi 1999, p.286). Precisely what these entail have yet to be determined.[4] However, a theme of particular interest in this paper is women's sense of loss of self.

Conceptualising pregnancy

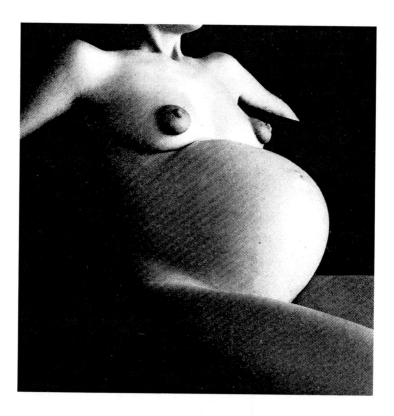

*Figure 8.1 From the **Pregnancy Series** by Ella Dreyfus (c. 1989–1990)*
© Ella Dreyfus
This particular piece is reminiscent of earlier photographic work by Harry Callahan (e.g.
***Eleanor**, 1949, which looks like a moonscape).*

Certainly, some ethical and philosophical difficulties are inherent in the main ways that pregnancy tends to be conceptualised in Britain today. The first way sees the woman as *a woman who happens to be pregnant* (this seems relatively straightforward as her status *appears* to remain fundamentally unchanged); certainly, this is an attitude which could afford maximum liberty to the woman as an individual but it fails to acknowledge the restrictions that exist in law regarding the right of the woman to engage in certain types of employment during her pregnancy as well as the myriad social pressures which begin to constrain and determine her behaviour. However, as far as medical intervention goes, with this model of thinking in mind, unquestionably women's bodily integrity should be respected. (It is not the intention of this paper to argue that women's rights campaigners should be adopting this or that strategy but rather to map out and explore how maternal/foetal space is regarded.) This way of perceiving the foetus has been criticised (Seymour 1995) as failing to take into account the apparent genetic constitution of the foetus as well as its developing physiology which is distinct. However, since this distinctiveness is not independent of the woman these criticisms and nuances appear somewhat abstract.

The second main way of viewing the pregnancy is in terms of *two separate entities: the foetus and the woman,* or the 'baby' and the 'mother' to use the terminology favoured by the politicised and the expectant. (A lot of midwives seem to talk in terms of a 'baby' rather than 'foetus'.) This separation of personhood is very problematic philosophically and ethically because it sets up inevitable conflict between the woman and the physician both during the pregnancy and at the birth when decisions have to be made about what action is to be taken regarding surgical and other interventions with their attendant risks; it allows the woman to be viewed as a potential health hazard to her developing foetus and this in turn could have dire consequences for women's legal rights and civil liberties.

To suggest that it would be legitimate to impose medical interventions upon a woman in the interests of her foetus would be to fundamentally alter the position of women under UK law by according interests to the foetus while it is still within the body of the woman (Elliston 1997, pp.150–151). A recent, very controversial, case of non-consensual

Caesarean section performed upon a competent pregnant woman (Re: S Adult: Refusal of medical treatment) was authorised 'in the vital interests of both mother and unborn child'. Interestingly, this was the same phrase used by my own obstetrician when we were discussing surgical interventions. She emphasised the shared need for intervention. Though the above case of non-consensual Caesarean section generated widespread condemnation, for ethical reasons as well as on grounds of legal principle (Jane Mair in Elliston 1997), it is not surprising to find obstetricians thinking in terms of the linked interests of foetus (or 'unborn child') and 'mother' rather than in terms of the autonomy and well-being of the woman as uppermost (for often pragmatic reasons no doubt, but the attitude is arguably rather contrary in spirit to the current UK legal position). The above example of the non-consensual Caesarean section found in favour of medical intervention and 'against the autonomy of the pregnant woman' (Jane Mair in Elliston 1997).

A third way of viewing the situation and the way the law in Britain currently views the situation (though this is frequently challenged) is that the woman and the foetus constitute *two indivisibly linked entities* (the plural is relevant here, as after the birth a prenatally damaged child has the opportunity to take separate legal action, except against the actions of her mother). Therefore, the foetus is perceived as an entity, a thing in some sense because it has the potential to acquire legal rights. However, UK law is somewhat fuzzy on this point. Whilst the foetus is in some sense an entity it is not, according to barrister Sarah Elliston, an 'other' in UK law. She explains: 'The fetus [sic] has been deemed to have no legal personality. The effect of this is that, since the fetus has not been legally accorded the status of a person, it has no legal rights or interests until it is born… The fetus gains legal personality only when it has achieved an independent existence by being born' (Elliston 1997). So, in legal terms, the foetus is an entity because it will acquire rights but not a personality because personhood commences at birth!

A fourth way of perceiving the process (and perhaps the most plausible way) is to view the situation in terms of *a maternal–foetal unity*. The idea of an interlinked identity (singular) is iconoclastic in terms of the emphasis in our culture on individuality and autonomy, and is therefore difficult to conceptualise.

However, speaking personally, this is how I experienced my own pregnancy: with an awareness of something growing which I knew was not me, yet was at the same time me (in the radical physical changes to my body I perceived a sort of 'otherness', the involuntary foetal movements were more random than the involuntary movements usually produced by my body's functions). However, at the same time the foetus did not feel and was not perceived by me as separate, much to my own surprise.

The sense of being connected continues after the birth, but to a lesser extent, with baby's suckling causing the woman to experience little uterine contractions and bleeding. Even thinking about one's baby can cause one's breasts to flood with milk!

If we accept the proposition, put forward by many social scientists, that bodily experiences are culturally mediated in the way that they are individually experienced, then the debates around these different ways of perceiving pregnancy and their attendant representations must influence the way pregnant women conceptualise their experience.[5]

My emphasis here is on dominant modes of representation, especially those which might be helpful in elucidating the group members' experiences. New technologies and social practices associated with these, such as in-vitro fertilization (IVF), have created alternative ways of perceiving the body. Indeed, all technological advances can have an influence. Endoscopic technology, for example, allowed images of disembodied foetuses to be used for political purposes by anti-abortion groups – the embodied reality of maternal/foetal unity explicitly denied by such imagery (Hogan 1997b, p.30). Kaplan (1992) discusses such imagery thus:

> Displacement of the mother and the world of her actual, material and complex body, is evident in the way photographic discourse renders inception and gestation in cosmic terms. The inside of the woman body is magnified tremendously until it looks like outer space, an Other World. The brightly coloured images of swirls and folds look like the images of earth's creation – conception on a grand scale: the foetus-as-miracle, as the wonder of 'man' [sic], far beyond the mundane scale of the simple, ordinary female body. The body is nowhere in sight, but is rather the repressed vessel for all this wonder. (Kaplan 1992, p.204)

Kaplan appears to be drawing on the idea of woman as essence, woman as nature in the above analysis.

Regarding the topic of surrogacy, Germaine Greer (2000) has pointed out that the womb is often portrayed as an empty space:

> Descriptions of surrogacy often use expressions like 'wombs to let' or 'wombs for rent', as if the woman who agrees to act as a surrogate was running a kind of fleshy boarding house. Any society that can regard asking one woman to act as a surrogate mother, by allowing the fertilized ovum of another to be implanted in her uterus and gestation to continue there until the child is born and handed over, as both feasible and tolerable can attach little importance to the process or the mother's role in it. The woman who thinks that her own conceptus is a stranger taking over her body is supposed to be deep psychic trouble but, if preparing a womb to harbour the progeny of strangers is morally acceptable to us, we must have to some extent accepted the idea of the womb's being an impersonal container. If bodily proximity has anything whatsoever to do with intimacy, there can be no relationship closer than that of the woman to the child developing inside her own body... (Greer 2000, p.53)

Figure 8.2

Figure 8.3
Figures 8.2 and 8.3 Images of pregnancy by members of the art therapy and
support group, Derby, 1999

Theory and method

Anthropologists such as Blaffer Hrdy (1999, p.503) stress that geograph-
ical and social conditions are essential to the construction of attitudes and
behaviours towards infants. Her large study on the subject points towards
tremendous variation across cultures and explodes universalising ideas
such as 'maternal instinct', which are deeply entrenched (Blaffer Hrdy
1999, p.308). Furthermore, her critique of attachment theory indicates
that Bowlby was mistaken in his views regarding the undesirability of
modern women engaging in paid work (Blaffer Hrdy 1999, p.494–504).
He believed that women shouldn't engage in labour outside the home
which caused them to be separated from their infants. Blaffer Hrdy's
detailed analysis points to the possibility of viable attachments between
infants and carers other than the mother ('allomothers'), giving examples
of societies in which as many as fourteen allomothers (male and female)
are involved in an infant's care in any one day (Blaffer Hrdy 1999, p.500).
 Attachment theorists have tended to posit the need for one carer,
preferably the biological mother, for the psychological stability of the

infant. Blaffer Hrdy, in contrast, points to the illusion of this proposal. Drawing on available evidence of existing and documented social practices she suggests that:

> When ecological circumstances permit (or require), mothers readily avail themselves of help... Female primates have always entrusted infants to willing allomothers *whenever a mother could be confident of safely retrieving them*...primate mothers, including human foragers, have always shared care of offspring with others *when it was feasible.* (Blaffer Hrdy 1999, pp.494–498)

Even the most fervent of anti-feminists are willing to concede this point. Sociologist Geoff Dench (1995) states that if some help for mothers can be mobilised:

> ...there are collective bonuses which follow. For when an exchange or pooling of child care takes place the labour of several mothers can be freed for valuable activities which are not easily carried out when there are children around. Rudimentary society is less likely to have been built just on lone motherhood, than on the arrangements women have made to maximise support for themselves in childrearing. (Dench 1995, p.4)

Pregnancy and birth must be seen in a social context with reference to cultural styles which shape women's expectations of the experience and also influence their attitudes towards correct demeanour during the pregnancy and birth. This research proposes that the idea of 'self' is always part of a public commitment. I shall now very briefly present some cross-cultural examples to make this point.

Under Islamic law in some countries, to take an extreme example, a father may kill his daughter for an illegitimate pregnancy. The range of women's responses is likely to be determined by the cultural style in play (which is bound up with the ethnicity and class standing of the woman involved). Khanum and Sharma's research (1999) highlights the effect of caste in immigrant *choto lok* (lower class) Bangledeshi women as of crucial importance in shaping their experiences of antenatal care. Bangledeshi translators and doctors in the hospital tended to be of a different caste and their *bhodo lok* ('respectable people') attitudes had an impact in what the *choto lok* women were willing to divulge and indeed conversely what

the translators were willing to translate and how.[6] To give a further example, whereas working class Bangledeshi migrant women might view pregnancy and childbirth as a means of securing the commitment of husbands (in the context of high divorce rates) and as a way of becoming more firmly established in the in-laws' family, other cultural groups will view the experience rather differently. Similarly, Patel and Sharma emphasize that women's demeanour during their birth, as well as their feelings about it, must be viewed in the context of prevailing social norms and expectations. Patel and Sharma (2000) note that women in some parts of rural India, for example, are exhorted not to cry out during labour. A woman with a good moral character who had performed her duties well should not have to endure excessive pain. Therefore, the emotional meaning of the event must be viewed in social context. Women's expectations are pivotal to their perception of their experiences.

Moving on to a brief discussion regarding the method employed, Oakley (1992, p.227) has pointed out that 'social research is a form of intervention in people's lives', a notion doubly true in this case because as a therapist I provided a service which also acted as a research tool. This project should be regarded as standpoint qualitative research. Oakley (1992) points out that the essence of the quantitative method concerns the aggregation of data: that is the combining of information from different sources in order to arrive at a composite picture. However, Oakley goes on to point out that in the process of doing this, the uniqueness of individual standpoints, what she describes as the 'core' of the qualitative method, is sacrificed. She suggests that the relationship between aggregated data and individual standpoints should be seen as 'dialectical' (Oakley 1992, p.187).

This summary is based on issues which arose in a group which met weekly for twelve weeks with sessions of two hours in duration. This focus is because there is very little research on the benefits of support services offered to pregnant women and new mothers, even though there is evidence (Oakley et al. 1996; Simkin 1992) that birth experiences continue to have long-term consequences for women. There is surprisingly little literature on precisely what women actually experience with regards to a changed sense of self-identity.

The group was located at the University of Derby and operated on a self-referral basis. Advertising for the group was primarily through a research department of the local maternity hospital and via the local newspaper. All participants were informed that the group was part of an ongoing research project, that all artwork produced in the sessions would be photographed and that all sessions were to be tape-recorded. Two of the women were not pregnant but had already given birth (both of these participants had suffered from depression after their babies were born). The majority of women in the group were educated to degree level (three women did not hold a first degree, though there seemed not to be any disparity between the women's ability to communicate in the group based on educational attainment). One participant, apart from the facilitator, held a post-graduate qualification. All of the women were white and most were local to Derbyshire or the North of England.[7]

Advertising described the group as an art therapy and support group which would provide individuals with the opportunity to explore their feelings about their experience of pregnancy, birth and motherhood in a confidential closed group.

The group was 'user led', insofar as the subjects raised were chosen entirely by the group members. I regulated the time to make sure that everyone had an opportunity to speak if they wished, whilst making it clear that they were under no obligation to do so. Although I was curious about many topics I limited my questions to those which facilitated the subjects already raised by the women themselves.

Why offer art therapy?

Women who receive support during their pregnancies experience significantly better health outcomes than those not offered this support (Cohen and Syme 1985; Oakley 1992). These gains include physical health as well as emotional well-being. In a research project involving 509 women, Oakley et al. (1996) provided additional support to pregnant women in a series of meetings with the emphasis on the provision of a 'listening ear'. (The women who received this additional support are referred to as the 'intervention group'.) Whilst it may not be surprising that 'the physical and psychosocial health' of the intervention group mothers was better than that of the control group of women who did not receive the addi-

tional support, it may be surprising to learn that the 'intervention group babies required less intensive and neonatal care and had better health in the early weeks...' The research findings illustrated that the group of women who received additional support had fewer very low birth-weight babies, antenatal hospital admissions, induced labours and obstetric interventions in deliveries (Oakley *et al.* 1996, p.8). A follow-up survey one year later confirmed that these children continued to enjoy better health. 'The psychosocial health of intervention [group] mothers was better, they felt more positive about motherhood and less anxious about their babies [than those in the control group]' (Oakley *et al.* 1996, p.8–9). After seven years there were significant differences evident between the two groups of women with regards to the health and development of the children as well as the well-being of the women (Oakley *et al.* 1996, p.7). Given these research findings it is somewhat surprising to discover that a serious longitudinal study of the implications of offering an art therapy and support group to pregnant women has yet to be undertaken in the UK.

Many women attend prenatal or 'parent craft' classes provided by their local authorities. However, these groups tend to be practical in their focus and do not usually provide scope for the expression of emotions, especially powerful emotions; the tone and ambience is of hopeful cheerfulness and anxieties expressed (in my experience) brushed aside or deflected. Rather, these groups provide basic information on obstetric procedures to a more or less sophisticated degree (in my experience very crudely). Sometimes, they are entirely lacking in critical analysis and debate or they may simply provide information readily available in popular books. In the antenatal group I attended interventions tended to be described as though they had no connection to one another. What was not made clear was the way that one intervention can lead to further linked interventions. The full implications of agreeing to a particular obstetric procedure were therefore not made sufficiently apparent.

A detailed critique of such provision is not the focus of this chapter, though it was the limitations of this service which led me to decide to run a mixed art therapy group for pregnant women and women who had recently given birth, to enable them to explore their feelings about their experiences. An exploration of feelings took place during the making of

artworks (through the manipulation of the materials and the pictorial surface), during formal discussion and analysis of the images after their completion which took place as a group (with the maker of the image speaking about their work and then inviting comment from others if they wished), as well as well as informally during the coffee break. Although the focus of the group was on giving emotional support and the opportunity for self-reflection, group members did also exchange practical information about birthing and child care.

Although, as stated, a critique of these services was not my intention, the women in the group were fairly forthright in their criticisms of parent-craft classes and support services so I shall present their views on the subject. One of the feedback sheets stated, 'I felt that we were playing in parent-craft classes, and I really didn't learn much at all. I certainly did not learn anything about myself'.

There was spontaneous reflection on the group experience in the final session. One woman said that she had found the sessions reassuring: 'It's nice to come and be reassured that you are, that everything that's happened to you is, normal and that you are not going mad and [knowing that] other people are experiencing the same [things]. It's been really good for that'. Of the midwives and health professionals, she said, 'They're all too busy and they're kind of rushing you as well...I felt they don't want you there...'

Another woman said, 'You feel like you have to impress your midwife, you know, make her feel good by saying there aren't any problems or worries. But yet in your head, like you have these questions that you think if I get the chance I'm going to ask about that. Yet when it comes to it she's so happy and bouncy that everything [is] going OK and she can put little ticks all over her boxes that you sort of think – I don't want to spoil it for her'.

Another group member reflected on how reassured she felt to hear that other women also found being with a new baby 'really hard'.

Some of the group members complained about insensitive GPs or childless midwives. The group was highly valued because 'It's the insight – it's the support that comes with the insight...other people might support you but they don't really know what it's like.' Another woman said of the group experience, 'It's the real support that you don't actually

get from anywhere else really, I think you expect it but you don't get it, even if you're asking for it'. Being able to express difficult feelings was considered a benefit of attending the group, providing 'a real support – it's like – on Monday I can go and sound off – because it won't sound like I'm whingeing too much...' Another group member said that she found the group useful in giving her a perspective on things. After the group she was able to go and talk to her husband about her feelings.

It is clear from these reactions that the women found the group very helpful. Oakley's (1996) research suggests that extra support for pregnant women can have long-term benefits, including health gains which should not be overlooked with regard to cost analysis of such provision.

The facilitator speaks

As a new mother I wanted to share my experience with the group without this being intrusive or distracting me from my primary role as facilitator. I decided not to paint but to make one disclosure about my experience per session, if it felt appropriate to do so. My aim was twofold: I wished to make it clear to the group that I did not regard myself as a 'sussed' and totally successful or model mother there to impart wisdom about how it should be done. Rather, I wanted to give permission for the expression of a range of feelings from euphoria to despair. Whilst I *adore* my daughter, I was willing to admit that some aspects of early mothering were appalling!

I also decided to give group members a copy of an article I'd written which explored my reactions to having given birth (Hogan 1997a). I didn't want to be a *tabula rasa* but preferred to be seen as someone up-front about their own issues and agenda. My second reason for deciding to speak in the group was because I wished to get feedback from participants about whether or not they found this helpful (this group being part of an ongoing research project).

Whilst many readers will regard this as quite straightforward, others will be aware that such disclosures from the therapist are regarded as slightly taboo in some therapy circles. The well known psychotherapist Irvin Yalom summarized the reasons why:

> The patients are here for *their* therapy, not mine. Time is valuable in a group…and is not well spent listening to the therapist's problems. Patients need to have faith that their therapists face and resolve their personal problems.

But, Yalom points out 'these are indeed rationalisations. The *real issue was want of courage*.' (Yalom 1989, p.164).[8]
He went on to reveal that:

> I have erred consistently on the side of too little rather than too much self-disclosure; but whenever I have shared a great deal of myself, patients have invariably profited from knowing that I, like them, must struggle with the problems of being human. (Yalom 1989, p.164)

Like Yalom, I am aware that I have a basic commitment to minimising the dichotomy between sick patient and expert healer. As a feminist working with women I feel that such an approach is absolutely essential.[9]

Issues arising: an overview

> We learn, often through painful self-discipline and self cauteriza-tion, those qualities which are supposed to be 'innate' in us: patience, self-sacrifice, the willingness to repeat endlessly the small, routine chores of socializing a human being. We are also, often to our amazement, flooded with feelings both of love and violence intenser and fiercer than any we had ever known. (Rich 1976, p.37)

The reactions of women to their pregnancy and birth experiences are exceedingly complex and the art therapy group gave scope for a multi-levelled exploration of emotions and reactions. The women were able to give each other support and compare and contrast experiences. The use of art materials gave opportunity for the exploration of emotional states and bodily experiences which could not otherwise be articulated. Sometimes the images produced were a springboard for a group discussion; other times the focus was on unravelling meanings. For some women the images were more about emotional release. Empathy was apparent between group members through motifs appearing in images or styles of expression creating echoes between works. The

structure of the group and the fact that I tape-recorded the group discussion at the end also had an impact on the dynamics of the group. The complexity of the total experience is hard to convey but the group offered a tremendous freedom from formal restraints which the participants appreciated. Certainly, fear and the fear of being judged harshly was a dominant issue of women in relation to their interaction with other services. The fact that the art therapy service was discrete (separate from their other antenatal care) and confidential had a liberating impact allowing participants to explore their experience in a profound manner.

Another pronounced feature of the group was the expression of humour. Perhaps it was generated out a sense of relief (as well as potentially embarrassing subject matter) but I have seldom experienced a group which was so funny and in which laughter played such a large part. Although the group was serious it was very enjoyable.

A number of subjects arose quite strongly in the group. A dominant and recurring subject was that of autonomy and the feeling of being manipulated (physically and psychologically). This was linked to perceived coercive threats (professionals having the power to impose unwanted interventions or actually remove the baby). This had an inhibiting effect on the women's openness to the professionals with whom they dealt, and all the women in the group were aware of this to some degree. Linked to feelings around control were feelings towards the baby which were not expressed, these included emotional disengagement or violent impulses. The desire to acknowledge feelings of despair or self-doubt was made harder by discourses about 'maternal insight' or the 'naturalness' of the mothering role. Guilt featured quite strongly. However, group members gained comfort and reassurance from finding out from their peers that they didn't find that it all came naturally.

All of the women were aware of an unprecedented amount of interference in their lives, either from relatives or the medical professions or both. All of the women were experiencing profound changes. These were different for the two groups of women involved. The pregnant women were concerned with bodily changes, changing roles and relationships, and preparations for the impending birth (including dealing with the fear of death). The women who had already given birth were more concerned with their feelings towards their children and adjusting to a new life (not

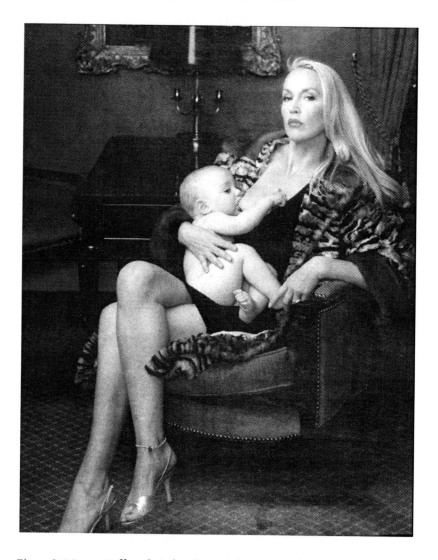

Figure 8.4 **Jerry Hall and Gabriel Jagger** *by Anne Leibovitz (1999)*
© Anne Leibovitz/Contact Press Images
Idealised and fantasy images of motherhood continue to abound. This is a particularly inter-esting example by Anne Leibovitz.

exclusively though as they also had strong feeling about their birth expe-riences). Adjustment was hard as their new lives were not what they had anticipated. It is one thing to know intellectually, for example, that infants cry, but quite another to be in the actual situation of trudging up

and down at four o'clock in the morning with a screaming baby. Aspects of tedium and repetition were acknowledged by group members.

Another theme was that of relationships. Problems already existing before the pregnancy between family members tended to become exacerbated. Parents and in-laws, their expectations and interference, caused the women and new mothers some stress in a variety of ways. Lack of support from husbands and/or the feeling that the experience could not be fully shared or properly understood by spouses caused women to feel alienated from their partners in a number of ways. Some women resented their husband's ability to forget about the pregnancy, though denial also featured, with more than one woman in the group finding it hard to believe that she was *really* pregnant.

Other minor themes and issues which arose in the group, unexplored by this piece of writing, will now be noted in brief. Although the women in the group expressed fears about the possibility of having a mentally or physically handicapped baby, it emerged that three of them had declined to take blood and other tests designed to check for abnormalities. This decision had precipitated feelings of guilt and resulted in pressure to have the tests from healthcare professionals and others. Refusing such screening may be very difficult, especially when tests are presented as both routine and rational.

There appeared to be a consensus among the women that they would have liked a designated midwife whom they could get to know well and who would attend their birth. Several of the women complained about rota systems which resulted in their never knowing who they'd be dealing with for antenatal check ups (or who would be in attendance at the birth).

Two of the women who had had Caesarean sections bemoaned the lack of opportunity to rest after the operation. They were aware that women who have Caesareans are given less chance to rest than other operative cases.

Another subject that arose was the idea of motherhood as a fresh start or a new beginning (and connected with this, for some group members, were feelings of ambivalence about past behaviours). In this context, women expressed positive feelings about pregnancy and being with their

newborn babies along with feelings of great excitement and elation. This included the expression of positive feelings about partners and husbands.

Facilitating and participating: some thoughts

At the group's invitation I did make one artwork. I painted a picture of myself breast-feeding. However, I struggled with the piece. I had wanted the quality of the paint to be very watery, creating an image like a reflection on a pond. Whilst painting it I became aware of the fact that I wanted to depict my baby both inside and outside of my body simultaneously. I imagined her suckling one breast whilst stroking the other with her little hand. But I was not able to achieve a satisfactory result with the materials and I spent the session working and reworking the image – struggling with the boundaries. The finished artwork, unresolved though it was, embodied my experience of merger and separateness. The act of painting brought to awareness and illustrated my feelings of conflict and ambivalence about these processes – my emotional struggle. Indeed, my *inability to resolve the image pictorially* was highly revealing. I had not experienced through conversation the full force of these conflicting emotions. Participating in the group reminded me of the power and poignancy of the art therapy process which yields the possibility for the articulation of powerful embodied feelings and responses which cannot necessarily be experienced or evoked through a verbal exchange alone. The total experience of the art therapy group cannot be conveyed though an examination of transcript fragments alone since the process of making the artworks, the feeling stimulated by this physical engagement, and the women's responses to finished art works were all integral to the total experience. I hope the above example will convince those unacquainted with art therapy of its unique value.

Conclusion

In this chapter I have summarised the main issues which arose in the group. It would be bad research to generalise about women's experience from such a small amount of data. Indeed, I wanted the women's testimony (free of my speculations and analysis) to speak for itself. However, it is interesting to note that the two women who felt particu-

larly depressed after their pregnancies (and regarded themselves as postnatally depressed) both had had Caesareans and neither had been the first to hold their baby after the birth. Both women had issues around needing more personal 'space'.

Given that lack of 'space', or a feeling of having lost a sense of personal space, was a prominent theme, the pictorial space provided by the use of art therapy is relevant. Themes of loss of self and personhood, a disrupted sense of selfhood, translate, as we have seen, into images. The pictorial space afforded an opportunity for the reconstruction of a lost self – indeed, more a 'creation' or tentative discovery of a new sense of being than a 'reconstruction' of a lost self – as the changes wrought by motherhood are irrevocable and very real. A vital process of readjustment was aided by the art therapy.

It is also interesting to observe that all of the women in the group had some difficulty in relating to healthcare professionals. This came as a surprise to me despite my familiarity with much relevant literature. I was anticipating that only a proportion of the group would experience difficulties.

The feedback forms that the women completed after the close of the group indicate that the pregnant women regarded the group as very useful as a preparation for motherhood and as providing a level and quality of support which was not available elsewhere.

To conclude, these are complex topics and it is hard to do justice to them in such a short piece of writing, however, I hope that this chapter has been of interest to those concerned with women's issues in general as well as serving to give art therapists and counsellors an idea of the kinds of topics they might be dealing with when offering support to pregnant women and new mothers. Furthermore, I am ever hopeful that the medical profession will recognise the importance and long-term value of providing emotional support for women as part of antenatal care.

Endnotes

1 My italics.
2 See Cobb 1980, pp.135–136 for an example of this.
3 See Cobb 1980, pp.54–55 for an example.

4 Zadoroznyi asserts that women's changed sense of self was a consistent feature of her interviewees' accounts. However, her focus is on the management of subsequent births and she notes that many women make decisions about the management of subsequent births and develop more definite ideas about how they would like them to be. However, in terms of the sorts of decisions made there is no analysis. Furthermore, it is not clear how birth differs from other major life events such as buying a house for the second time, for example, when one has learned from previous experience, having developed more definite ideas about what is required.

5 For example, see the work of Butler 1990 and 1993; Cornwall and Lindisfarne 1994; Deutscher 1997; Ramet 1996.

6 One interesting example given is of a women fasting during Ramadan whilst pregnant. She wanted some vitamin pills and the translator, instead of translating her request, reminded her that under Islamic law pregnant women are exempted from fasting during pregnancy. Secondly, the translator suggested that she should not make the request for fear of being viewed as an 'uncultured fundamentalist'.

7 One participant was from Scotland and another two from London. Two of the women could be clearly defined as 'house wives'; however, the majority of women in the group would not have felt comfortable with that definition.

8 My italics.

9 Training institutions and the art therapy profession in general seem to lack confidence in the therapist's ability to distinguish between a helpful and an exploitative level of disclosure (and perhaps this illustrates a fundamental lack of confidence in the quality of our practitioners).

10 My italics for emphasis (this phrase is liable to be misread).

11 Italics added for emphasis.

Acknowledgements

First thanks are due to all the women who participated in the group. I am very grateful to the sociologist Dr Martin O'Brien and anthropologist Professor Mary Douglas who were kind enough to read an early draft of this paper and give me constructive criticism. Thanks also to psychologist Dr Sarah Bennett and medical sociologist Professor Ursula Sharma who were generous enough to share some work in progress with me which I cite here. More thanks are due to barrister Sarah Elliston whose terrific

conference paper, along with our subsequent correspondence, stimulated my initial interest in this subject.

A show of gratitude is due to Linda Whieldon, of the University of Derby, for the institutional support which enabled this project and to Teresa Barnard for her astute editorial suggestions.

This is a brief discussion paper; for full details of the themes that arose in the group please see *The International Arts Therapies Journal* (ISSN: 14762900) Volume 1, December 2001–December 2002.

Bibliography

Blaffer Hrdy, S. (1999) *Mother Nature: A History of Mothers, Infants, and Natural Selection.* New York: Pantheon Books.

Bourdieu, P. (1992) *Language and Symbolic Power.* Cambridge: Polity Press.

Boyle, M. (1997) *Re-thinking Abortion: Psychology, Gender, Power and the Law.* London: Routledge.

Breen, D. (1989) *Talking With Mothers.* London: FAB.

Butler, J. (1990) *Gender Trouble: Feminism and the Subversion of Identity.* London: Routledge.

Cobb, J. (1980) *Babyshock.* London: Hutchinson.

Cohen, S. and Syme, L. (eds) (1985) *Social Support and Health.* NY: Academic Press.

Cornwall, A. and Lindisfarne, N. (eds) (1994) *Dislocating Masculinity: Comparative Ethinographies.* London: Routledge.

Cosslett, T. (1994) *Women Writing Childbirth. Modern Discourses of Motherhood.* Manchester: Manchester University Press.

Dench, G. (1995) *The Frog, The Prince and The Problem of Men.* London: Neanderthal Books.

Deutscher, P. (1997) *Yielding Gender, Feminisim, Deconstruction and the History of Philosophy.* London: Routledge.

Elliston, S. (1997) 'Life after death: Legal and ethical implications of the maintenance of post-mortem pregnancies.' In K. Petersen (ed) *Intersections: Women on Law, Medicine and Technology.* Dartmouth: Ashgate.

Figes, K. (1998) *Life After Birth: What Even Your Friends Won't Tell You About.* Harmondsworth: Viking.

Greer, G. (2000) *The Whole Woman.* London: Anchor.

Hogan, S. (1997a) 'Having a Voice: The Role of Advocacy in Childbirth.' *AIMS Journal. Association For Improvements in the Maternity Services (AIMS)* 9, 3, 11–12.

Hogan, S. (1997b) 'A Tasty Drop of Dragon's Blood: Self Identity, Sexuality and Motherhood.' In S. Hogan (ed) *Feminist Approaches To Art Therapy*. London: Routledge.

Kaplan, E.A. (1992) *Motherhood and Representation: The Mother in Popular Culture and Melodrama*. London: Routledge.

Khanum, S. and Sharma, U. (1999) *Working Paper*. Working Paper Series. Centre for Social Research, University of Derby.

Martin, E. (1987) *The Woman in the Body: A Cultural Analysis of Reproduction*. Milton Keynes: Open University Press.

Matthews, S. and Wexler, L. (2000) *Pregnant Pictures*. London: Routledge.

Oakley, A., Hickey, D. and Rajan, L. (1996) 'Social support in pregnancy: Does it have long term effects?' *Journal of Reproductive Psychology 14*, 7–22.

Oakley, A. (1992) *Social Support and Motherhood*. Oxford: Basil Blackwell.

Oakley, A. (1981) *From Here to Maternity*. Harmondsworth: Penguin.

Patel, T., Sharma, U. (2000) *Birthing Mothers, Social Scientists and Subjective Experience of Childbirth*. Working Paper provided by authors.

Rich, A. (1976) *Of Women Born: Motherhood As Experience and Institution*. London: Virago.

Rose, N. (1980) *Governing the Soul: The Shaping of the Private Self*. London: Routledge.

Ruddick, S. (1994) 'Thinking Mother/Conceiving Birth.' In D. Bassin, M. Honey and M. Kaplan (eds) *Representations of Motherhood*. New Haven: Yale University Press.

Russell, D. (1995) *Women, Madness and Medicine*. Cambridge: Polity Press.

Sedgwick, E.K. (1990) *Epistemology of the Closet*. Berkeley: University of California Press.

Seymour, J. (1995) *Fetal Welfare and the Law*. Australian Medical Association.

Seymour, J. (2000) *Childbirth and the Law*. Oxford: Oxford University Press.

Simkin, P.T. (1992) 'Just Another Day In A Woman's Life?' *Birth 19*, 2, 64–81.

Smart, C. (ed) (1992) *Regulating Womanhood: Historical Essays on Marriage, Motherhood and Sexuality*. London: Routledge.

Starkey, D. (2001) *Elizabeth*. London: Vintage.

Turner, B.S. (1992) *Regulating Bodies: Essays in Medical Sociology*. London: Routledge.

Yalom, I. (1989) *Love's Executioner and Other Tales of Psychotherapy*. London: Penguin Books.

Zadoroznyi, M. (1999) 'Social class, social selves and social control in childbirth.' *Sociology of Health and Illness 21*, 3, 267–289.

Re-Visions on Group Art Therapy with Women who have Experienced Domestic and Sexual Violence

Nancy Slater

Introduction

Since the late 1970s, when interventions for battered women were first developed in Western countries, group art therapy has been employed in women's refuges and other supportive services. In the 1980s, as the prevalence of sexual violence against women and children gained more public attention (Courtois 1988; Russell 1986; Slater 1998), group art therapy was used in sexual assault programmes and clinical practices (Anderson 1995; Brooke 1995; Meekums 2000).

Until recently, domestic violence and sexual assault have been viewed as separate research and intervention issues. As the late 1980s approached, there was more awareness of the connections between incest, rape and the physical and emotional abuse of women (Breckenridge 1999; Clark and Foy 2000; Herman 1992, 1995; Slater 1998; Spring 1985). During the 1990s, increasing attempts were made to address the support services and treatment needs for women who had experienced multiple abuse (Brown 1997; Davis *et al.* 2001; Herman 1992, 1995; Roth *et al.* 1997; Slater and Minton 1998). In art therapy,

the combined effects of multiple abuse patterns have been both recog-
nized and addressed (Slater 1998; Spring 1993).

Group art therapy models have been developed to help women
address the effects of domestic and sexual violence (Slater 1998; Spring
1993) and recover from the resultant trauma (Tinnin and Gantt 2000).
For women who have experienced different types of interpersonal
violence, group art therapy has been shown as an effective treatment
option (Anderson 1995; Brooke 1995, 1997; Lagorio 1989; Meekums
2000; Serrano 1989; Spring 1985; Tinnin and Gantt 2000).

Building on the group art therapy efforts that have been implemented
during the past 20 years, this chapter presents selected guidelines for
good practice and offers suggestions for 're-visioning' group art therapy
for those who have been abused.

Re-view on the effects of violence against women

The long-term effects of violence against women include psychological
distress and mental conditions, as well as physical symptoms or illness
resulting from a combination of these (Herman 1992, 1995; Roth *et al.*
1997). Loss of spiritual 'connection' (Chew 1998) and shattered beliefs
(Janoff-Bulman and McPharson-Frantz 1997) can also affect a sense of
well-being and the ability of women to function adequately.

For abused women, difficulties in daily life, such as problems
(including abuse) in family relationships, difficulties at work or school,
maintaining a job, ineffective or harmful parenting, reliance on alcohol or
drugs and eating disorders are common occurrences across all economic
and social groups (Briere 1992; Chew 1998; Courtois 1988; Slater and
Minton 1998).

In describing the effects of abuse on children, Eliana Gil (1998) has
stated that the symptom (response) to trauma (abuse) is 'dis-regulation of
affect, thoughts and/or behavior. This may include relying on rigid
defenses to survive, compartmentalizing pain, and inability to distinguish
between safe and unsafe situations'. She also stated that: 'individual
children may have idiosyncratic response to trauma'.

Gil's description of reactions to violence experienced in childhood
show that different and numerous responses may develop. These
responses may leave abused children vulnerable to further abuse. The

effects of childhood abuse are evident in those adults who have also experienced multiple abuses and repeated interpersonal violence as adults (Davis *et al.* 2001; Herman 1992, 1995; Slater and Minton 1998; Tinnin and Gantt 2000).

One of the most damaging outcomes of both domestic violence and sexual abuse is the tendency to remain silent and the silence brought about by shame and guilt (Herman 1992, 1995; Meekums 2000; Russell 1986) which may be imposed by perpetrators and victims' families and even social institutions (Breckenridge 1999; Courtois 1999; Slater 1998). Thus, as Breckenridge (1999) states:

> Individuals who experience domestic and sexual violence as adults and children are likely to struggle to speak of the 'truth' of these events in ways that make sense of their own experience. (p.6)

These varied and often entrenched responses to multiple abuse from childhood and further victimisation as adults are the effects (responses) and issues (individual, familial and social) that need to be assessed, acknowledged and addressed as part of effective art therapy treatment. Yet, over the past 20 years, government agencies, community programmes and treatment providers have offered varied and all too frequently limited responses to the needs of these women for appropriate and for many, repeated interventions. The result has been 'failure in treatment' which becomes yet another effect of domestic and sexual violence for those seeking treatment that addresses their problems and other interventions (Slater and Minton 1998).

The cultural context in which domestic and sexual violence occurs

A further significant influence regarding domestic and sexual violence is the cultural context in which forms of interpersonal violence occur, including ethnicity, nationality, gender and sexual orientation, age, economic and social levels and values, education, and physical and mental abilities (Chebaro 1998; Hays 1996; Slater 1998).

There is a growing body of literature which acknowledges the importance of cultural influences upon art therapy. This includes art therapy literature which addresses the widespread use of visual art for

therapeutic interventions for domestic violence and sexual assault (see Campbell *et al.* 1999; Hiscox and Calisch 1998; Hogan 1997). However, the connections between interpersonal violence and cultural context have yet to be reflected in the art therapy literature.

While ethnicity and nationality have gained recognition as the important cultural influences on individuals, families and communities, the forms of cultural differences listed above are beginning to gain recognition. In art therapy and other mental health fields, gender has been seen as an important influence on interpersonal violence. The prevalence of violence against women within families and the predominance of sexual violence towards women by men across cultural and social groups suggests that such violence transcends cultural differences. Furthermore, this indicates that greater efforts need to be made in addressing these forms of violence in clinical settings as well as within the larger community. There has also been a growing awareness of the sexual and physical abuse of boys and men (Hunter 1990; Steever *et al.* 2001). Until recently the abuse of boys has lacked social visibility. While more generalised literature on treating men who have been victimised physically and/or sexually has increased, there is virtually no art therapy or creative arts therapies literature that acknowledges these treatment needs.

Cultural theorist Deborah Lupton (1997) considers issues of cultural context in acknowledging the notion of 'multiple subjectivity' of women who are marginalised in Western and other societies. This includes women who are coping badly due to the effects of abuse (Slater 1998). Poverty and lack of access to essential resources such as housing and medical and psychological care are typical problems for women who are thus struggling with daily life. This, too, increases the vulnerability of women and their children to further abuse and violence.

The art making in women's groups can be seen as a reflection of the women's perceptions of themselves and their experiences. A pictorial representation of women – many kinds of women – illustrates cultural influences on their identity and their understanding of their experience of abuse. Thus, as Martha Haessler (1992) states: 'The sensitive therapist who is well-trained in cultural differences is less likely to impose his or her values and biases on clients'. And, as a cautionary note she continues: 'This issue becomes complicated in groups, however, where it may be

easier for the therapists, like the clients, to come under [the sway] of majority opinion' (p.3). Haessler's recognition of the value of awareness of cultural diversity training and the ways in which bias can affect the art therapist and the group participants is a solid rationale for training in this area.

Re-view on group art therapy for women with histories of abuse

Over the past twenty-five-plus years, support groups and various art therapy and other psychological interventions have addressed interpersonal violence with a focus on a single issue such as domestic violence. While many of these interventions are not only useful, but life-saving, there was a growing awareness that for many women more help was needed. Some women have disclosed multiple abuses; others returned repeatedly for help or reported further psychological difficulties after treatment. This was particularly evident in alcohol and drug programmes where women reduced or stopped using drugs, but developed other problems such as symptoms of post-traumatic stress disorder (Clark and Foy 2000; Slater and Minton 1998; Spring 1985).

Addressing all of these abuses and their effects simultaneously would not, in my opinion, be effective. Awareness of multiple abuses and their effects is needed. Appropriate interventions are essential for women who have experienced domestic and sexual violence (Herman 1995; Meekums 2000; Slater and Minton 1998; Stevens 1997). A brief look at group art therapy practice with abused women here is intended to lead to a 'Re-View' of group art therapy which acknowledges cultural diversity and multiple abuses.

One of the first American art therapists to recognise the long-term effects of childhood sexual abuse was Dee Spring. She was also the first art therapist to recognise connections between substance abuse in women and their histories of childhood sexual abuse. Spring noted that substance abuse can be a way to disconnect from both everyday feelings and memories of childhood abuse (Spring 1985). In my view, therapeutic art making becomes a way for women to reconnect with such feelings and thoughts; their inner lives and memories.

While Speert (1993) described group art therapy specifically with women who experienced sexual abuse, her observations about the value of art making are relevant to all types of group art therapy:

> We have labored under the misconception that creativity is a solo act, yet the response of our image to another within the group, and the rituals that emerge from our group process, are more creative than the sum of our individual expressions. (p.351)

Women who have been abused have stated that group art making stimulates the recognition of similarities between their lives and those of the other women in a group (Slater 1998). The art making itself builds group cohesion and the group discussions support women in understanding their artwork. As Meekums (2000) notes, the process of art making facilitates the group in moving from a collection of individuals to a group where members support one another.

In my view, art making by non-artist adults (and children) is an effective way to reach images from memory. Making art allows the individual to express and record these images in a way that facilitates healing and recovery from abuse.

If women can include art making activities in their daily lives, a positive and effective means of problem solving can result. When women with histories of abuse learn healthy ways to express themselves they can reduce the likelihood of revictimisation.

From 1995 to 1997 I was involved with the project *Women's Recovery Groups* in Seattle, Washington, which was developed with state funding to address the multiple abuse of women. The project staff recognised: '[T]he high incidence of childhood sexual abuse among women who abuse alcohol and other drugs and that childhood sexual abuse issues, when left untreated, frequently sabotage all other recovery efforts and increase the likelihood for further victimization'. Art therapy was an integral part of this group therapy programme and its importance was demonstrated in the following ways:

- The art making initiated verbal communication.

- Spontaneous and directed art making activities helped participants to recall positive and negative memories.

- Group art therapy supported women in identifying personal strengths developed to survive painful and difficult childhood experiences.

- The art making helped participants to recognise patterns of victimisation and the potential for revictimisation.

- The group art therapy activities helped participants to connect anger with pain and hurt, thus preparing them to experience emotions in new and healthier ways.

- The sexual imagery evident in many of the participants' art making can reveal their disconnection with (or the intense focus on) sexual feelings and sexual abuse.

The women involved drew attention to cultural differences that existed among themselves and cultural identity became a source of pride for many of them. They also helped the group leaders to acknowledge the wider context of an oppressive society that regards the women as a drain on public coffers. Further developments and improvements to good practice in group art therapy with culturally diverse women who are victims of abuse have resulted from this particular programme.

Visions for group art therapy with culturally diverse abused adults

Art making is challenging. Participants are provided with an environment in which to express thoughts, feelings and reactions to current and past experiences.

Views from the present to the future

For art therapists, the cultural identity and world view held by their clients is reflected in the art making process and the images made including influences of domestic and sexual violence. Chebaro (1998) asserts the importance of the art therapist maintaining sensitivity to the different meanings which may be evident in the clients' work.

Art therapists need to keep in mind that their clients' artwork involves the client/artists' internal and external experiences. The

approach to picture interpretation may differ with foreign [sic] clients due to the influence of their ethnic background. Art therapists need to see what the picture is saying and not resort to an unfounded psychological analysis. Art therapists impede the growth of the foreign [sic] clients by stereotyping the meanings of their art symbols. (p.253)

Chebaro's remarks suggest that art therapists risk misunderstanding clients' art making and the meaning that clients give to their work when the art therapist is not attuned to relevant cultural values and practices. Art therapists also risk misunderstanding their clients' non-art-making behaviour and verbal responses if they lack awareness of culturally based beliefs, values and practices.

Any understanding of cultural identity and influences involves the art therapist's own cultural identity (Lewis 1997). For the art therapist it can be exciting personally and can also contribute to good art therapy practice to develop awareness of one's cultural prejudices. Thus the cultural contexts in which we live and practise art therapy become clearer and more relevant to our engagement with it.

Although impossible for an art therapist to understand all cultures, an openness to learning and to engaging with those who are different from you, and willingness to consult with those who have specific cultural knowledge, can assist any art therapist in creating and maintaining essential good standards of culturally based art therapy practice. Ongoing supervision provided by those who have the necessary clinical experience can also give an art therapist the essential tools for good practice.

Figure 9.1 **Memories of Childhood** *by Nancy Slater (1991)*
Drawing by the author as part of supervision in response to witnessing the art making and
stories of the women who participated in one of the 'Women in Recovery' groups.

The significance of cultural context in interpersonal violence and the complexity of the effects of multiple abuse necessitates collaboration by treatment providers and social service agencies. This collaboration enhances the possibility of successful outcomes for participants/clients and increases the opportunity for good practice.

In the aforementioned women's recovery groups the staff formulated training and community outreach work in an effort to help colleagues and agencies to provide a 'supportive referral system'. When the group programme was underway, we implemented a monthly training and consultation group on working with clients who have histories of multiple abuse. All professionals were welcomed. These efforts not only increased our visibility in the community, they also fostered recognition of the patterns of abuse experienced by women seeking services from community agencies and the value of art therapy in working with them (Slater 1998).

Conclusion

The art therapy literature now available offers excellent guidelines for setting up group art therapy programmes. And now resources are available to address the long-term effects of domestic violence and the effects of sexual assault with Judith Herman's (1992/1995) work providing the criterion for treating abused women. Meekums' (2000) thorough discussion on art-based assessment and treatment for women with histories of childhood sexual abuse provides excellent guidelines that can be applied to forms of interpersonal violence and combinations of abuse.

There is much to be learned about the treatment of female victims of multiple abuse. Art therapy, particularly that involving group participation, is a prime vehicle to explore and research the complexities of the connection between violence against women and its long-term effects.

Bibliography

American Psychiatric Association (1994) *Diagnostic and Statistical Manual of Mental Disorders* (4th ed). Washington, DC: APA.

Anderson, F.E. (1995) 'Catharsis and empowerment through group claywork with incest survivors.' *The Arts in Psychotherapy 22*, 5, 413–427.

Breckenridge, J. (1999) 'Subjugation and silences: The role of the professions in silencing victims of sexual and domestic violence.' In J. Breckenridge and L. Laing (eds) *Challenging Silence: Innovative Responses to Sexual and Domestic Violence.* St. Leonards, NSW: Allen & Unwin.

Briere, J. N. (1992) *Child Abuse Trauma: Theory and Treatment of the Lasting Effects.* Newbury Park, California and London: Sage.

Brooke, S.L. (1995) 'Art therapy: An approach to working with sexual abuse survivors.' *The Arts in Psychotherapy 22*, 5, 447–466.

Brooke, S.L. (1997) *Art Therapy with Sexual Abuse Survivors.* Springfield, Illinois: Charles C. Thomas.

Brown, J. (1997) 'Working toward freedom from violence: The process of change in battered women.' *Violence Against Women 3*, 1, 5–26.

Campbell, J., Liebman, M., Brooks, F., Jones, J. and Ward, C. (eds) (1999) *Art Therapy, Race and Culture.* London: Jessica Kingsley Publishers.

Chebaro, M. (1998) 'Cross cultural inquiry in art and therapy.' In A. Hiscox and A. Calisch (eds) *Tapestry of Cultural Issues in Art Therapy.* London: Jessica Kingsley Publishers.

Chew, J. (1998) *Women Survivors of Childhood Sexual Abuse: Healing Through Group Work*. New York and London: Haworth.

Clark, A.H. and Foy, D.W. (2000) 'Trauma exposure and alcohol use in battered women.' *Violence Against Women 6*, 1, 37–48.

Courtois, C.A. (1988) *Healing the Incest Wound: Adult Survivors in Therapy*. New York: W.W. Norton.

Courtois, C.A. (1999) *Recollections of Sexual Abuse: Treatment Principles and Guidelines*. New York: W.W. Norton.

Davis, J. L., Petretic-Jackson, P.A. and Ting, L. (2001) 'Intimacy dysfunction and trauma symptomatology: Long-term correlates of different types of child abuse.' *Journal of Traumatic Stress 14*, 1, 63–79.

Gil, E. (1998, November) *I'm crying and no one can hear me*. Keynote address at 29th annual conference of the American Art Therapy Association, Portland, Oregon.

Haessler, M. (1992) 'Ethical considerations for the group therapist.' *American Journal of Art Therapy 31*, 1, 2–9.

Hays, P. (1996) 'Addressing the complexities of culture and gender in counselling.' *Journal of Counselling and Development 74*, 332–338.

Herman, J.L. (1992/1995) *Trauma and Recovery*. New York: Basic Books.

Hiscox, A. and Calisch, A. (eds) (1998) *Tapestry of Cultural Issues in Art Therapy*. London: Jessica Kingsley Publishers.

Hogan, S. (ed) (1997) *Feminist Approaches to Art Therapy*. London: Routledge.

Hunter, J.A. (1991) 'A comparison of the psychosocial maladjustment of adult males and females sexually molested as children.' *Journal of Interpersonal Violence 6*, 205–217.

Hunter, M. (ed) (1990) *The Sexually Abused Male: Prevalence, Impact, and Treatment. (Vol. 1)*. Lexington, Massachusetts: Lexington Books.

Janoff-Bulman, R. and McPharson-Frantz, C. (1997) 'The impact of trauma on meaning: From meaningless world to meaningful life.' In M.J. Power and C.R. Brewin (eds) *The Transformation of Meaning in Psychological Therapies: Integrating Theory and Practice*. New York: John Wiley.

Lagorio, R. (1989) 'Art therapy for battered women.' In H. Wadeson, J. Durkin and D. Perach (eds) *Advances in Art Therapy*. New York: John Wiley.

Lewis, P. 'Multiculturalism and globalism in the arts in psychotherapy.' *The Arts in Psychotherapy 24*, 2, 123–127.

Lupton, D. (1997) Foreword in S. Hogan (ed) *Feminist Approaches to Art Therapy*. London and New York: Routledge.

Meekums, B. (2000) *Creative Group Therapy for Women Survivors of Child Sexual Abuse: Speaking the Unspeakable*. London: Jessica Kingsley Publishers.

Roth, S., Newman, E., Pelcovitz, D., van der Kolk, B. and Mandel, F.S. (1997) 'Complex PTSD in victims exposed to sexual and physical abuse: Results from the DSM-IV Field Trial for Posttraumatic Stress Disorder.' *Journal of Traumatic Stress 10*, 4, 539–547.

Russell, D.E.H. (1986) *The Secret Trauma: Incest in the Lives of Girls and Women.* New York: Basic Books.

Serrano, J.S. (1989) 'The arts in therapy with survivors of incest.' In H. Wadeson, J. Durkin and D. Perach (eds) *Advances in Art Therapy.* New York: John Wiley.

Simonds, S. L. (1994) *Bridging the Silence: Nonverbal Modalities in the Treatment of Childhood Sexual Abuse.* New York: W.W. Norton.

Slater, N.A. (1998, November) *Art Therapy's Power in the Treatment of Chemically Dependent and Abused Women.* Paper presented at the 29th annual conference of the American Art Therapy Association, Portland, Oregon.

Slater, N.A. and Minton, M.F. (1998) 'An innovative program to serve low income women with histories of chemical dependency and childhood sexual abuse.' *The Source: National Abandoned Infants Assistance Resource Center 8*, 5, 6–9, 12.

Speert. E. (1993) 'Women and art therapy.' In E. Virship (ed) *California Art Therapy Trends.* (pp.350–357) Chicago: Magnolia Street.

Spring, D. (1985) 'Symbolic language of sexually abused, chemically dependent women.' *American Journal of Art Therapy 24*, 1, 13–21.

Spring, D. (1993) *Shattered Images: The Phenomenological Language of Sexual Trauma.* Chicago: Magnolia Street.

Steever, E., Follette, V.M. and Naugle, A.E. (2001) 'The correlates of male adults perceptions of their early sexual experiences.' *Journal of Traumatic Stress 14*, 1, 189–204.

Stevens, L. (1997) 'Bringing order to chaos: A framework for understanding and treating female sexual survivors.' *Violence Against Women 3*, 6, 27–45.

Tinnin, L. and Gantt, L. (2000, March) *Treating psychological trauma.* Keynote address at the La Trobe University International Art Therapy Conference, Bundoora, Victoria, Australia.

Weston, S. (1999) 'Multicultural art therapy.' In J. Campbell, M. Liebman, F. Brooks, J. Jones and C. Ward (eds) *Art Therapy, Race and Culture.* London: Jessica Kingsley Publishers.

Decolonisation: Third World Women and Conflicts in Feminist Perspectives and Art Therapy

Savneet Talwar

Twenty-first century societies are increasingly diasporic in nature. Cultural pluralism, as current immigration trends indicate, is becoming a distinct feature of Western demographics. For instance, the people of colour constitute the fastest growing section of the population in the United States. It has become apparent that cultural pluralism needs to be addressed in the delivery of mental health services (Comas-Diaz 1994). This chapter seeks to explore differences between 'Third' and 'First World' women in relation to gender, race and culture and also to the challenges faced by practising art therapists who have been trained in white, Western psychoanalytic models.

An increasing number of graduating art therapists in the United States are women who begin their careers working with low income populations: primarily ethnic minorities and women. As mental health professionals, art therapists should understand and develop increased sensitivity towards clients from diverse backgrounds, especially in issues of gender, race and culture. I propose a more inclusive theory for art therapists, one that offers new ways of considering the large numbers of women who remain outside the psychological definition of the white,

Western paradigm. I also discuss the importance of helping clients find their own voice through artistic expression and argue that art therapists must avoid generalisations about the meaning of symbolic content.

There are few publications on feminist practice in art therapy (Hogan 1997; Talbott-Green 1989; Wadeson 1989). A white, male perspective in the conception of human relationships dominates the field of art therapy and the theories of psychological development and psychopathology. As noted by feminist scholars Espin and Gawelek (1992), research has neglected to include cultural variability and issues of gender. They claim that data on white women and ethnic minorities of both sexes has either been excluded as 'nuisance variables' or included only as 'difference', and frequently conceptualised as deficiencies.

Several cultural theorists (Bhabha 1994; Fanon 1952; Said 1993; Spivak 1988) have discussed the ways in which the coloniser/colonised relationship is normalised in psychology. Racism, as a harmful social construct, blinds the oppressed to the subjection of the oppressor.

'Third' versus 'First World' feminism: different agendas

The term 'Third World', asserts Johnson-Odim (1990, p.314), refers not only to 'underdeveloped' and overexploited geographical areas, but perhaps more importantly to oppressed minorities living in First World countries. In this chapter I shall use the term to define both. Johnson-Odim further states that oppression of impoverished and marginalised Euro-American women links to gender and class issues, while that of Third World women also links to race relations and imperialism.

According to Comas-Diaz (1994) the recognition of a 'colonised mentality', which negates women's cultural diversity, is vital to a decolonisation process. Freire (1952) describes this as dichotomous thinking that produces ambivalence towards oneself and others. According to Fanon (1952), being colonised by language has larger implications for one's consciousness because to speak means above all to assume a culture. For example, when immigrants in the United States speak English they are becoming part of the collective consciousness of the Americans who identify blackness with evil and sin. People of colour don a white mask.

Although there are several schools of thought among First World feminists, a widely held perception among Third World women is that feminist thought of white, middle-class, Western women 'narrowly confines itself to a struggle against gender discrimination' (Johnson-Odim 1990, p.315). hooks (1981, 1984), Moraga and Anzaldua (1981), Joseph and Lewis (1981), Okeyo (1981) and many other Third World feminists argue for a wider agenda; a broadening of feminist concepts to challenge racial oppression and become more relevant to Third World women. Alice Walker (1983) summarises this viewpoint in her term 'womanism', which embraces the struggle against economic exploitation, discrimination and racism.

At many major international women's conferences, First and Third World women have disagreed over the definition of what constitutes a feminist issue. Unlike Western feminists, who may consider mainstream politics extraneous to their cause, African-American and Third World women link their progress to the local, national and world economic order. This has led to a distancing from Euro-American feminist organisations where gender-based theory has no impact on oppression (Johnson-Odim 1990). As art therapists, we should be aware that feminist theory must reflect the lived experience of women.

Feminist therapists use several approaches to respond to the various mental health needs of women. For Third World women, issues of class and race can prove more centrally determining factors to mental health needs. Where a female client is part of the dominant culture, her race and class are not normally acknowledged and therefore her gender becomes the predominant characteristic. For other women, the need to identify with ethnicity and class is paramount. Thus a working-class, black woman may have more in common with a working-class, black male than with white, middle-class women. She is equally able to relate better to other women of colour than to black males (Espin and Gawelek 1992).

As art therapists, our primary challenge is to broaden the psychology of women to include *all* women. By understanding that gender is one variable that can shape the lives of women and that the notion of femaleness changes according to intrapsychic variables created by social context, we will understand the wide range of female experience (Espin and Gawelek 1992, p.93).

White privilege and the therapeutic relationship

Several researchers of female psychology have suggested that most research relates to white, middle-class women. Psychology has a tendency to study difference as abnormality rather than as diversity. This can camouflage oppressive structures and 'naturalise' difference. Espin and Gawelek (1992, p.88) find that feminist psychological theory 'assumes that psychological characteristics exhibited by white, middle-class women (such as connectedness, empathy, nurturance, facilitative orientation and emphasis on the value of human interaction) is core of [sic] the psychology of women'. Therefore these characteristics are assumptions which do not take into account the possibility of the consequences of a defence mechanism developed specifically to deal with oppression.

In my view, the works of feminist theorists contribute greatly to the psychological understanding of women, but we run the risk of marginalising women from different cultures. I have to question whether this theory either witnesses or acknowledges the differences and experiences of cultural diversity. The ethnocentric perspective of the psychology of women has largely been neglected with little attempt to translate the works of feminist scholars from areas other than America and Europe. Feminist perspectives developed by African-American writers remain unknown to many white feminists (Espin and Gawelek 1992; hooks 1981, 1984; Joseph and Lewis 1981). Similarly in the field of art therapy there are few publications on feminist approaches and even fewer that focus on women of colour. The field of art therapy often ignores the impact of race, culture and class factors on women of colour and on white women. McIntosh (1988) asserts that most female, white art therapists are unaware of the importance of racial privilege on their lives and on their therapeutic relationships. Campbell and Gaga (1997, p.218), who are black British art therapists, state that the race, colour and ethnicity of the therapist influence 'aspects of the therapeutic relationship such as identification and transference in unique and challenging ways'.

The 'first image' to be explored is how the client and therapist are reflected in each other's eyes during the initial encounter. The therapeutic relationship that is central to the treatment process has been identified as a critical variable in working with people of colour (Comas-Diaz 1994;

Jenkins 1990) as well as with women generally (Comas-Diaz 1994; Jordan *et al.* 1991; Kaplan 1979). This relationship is dependent on the awareness of the therapist's knowledge and self-awareness of ethnocultural and racial factors and how they affect the therapist and client (Comas-Diaz 1994).

If we are to promote trust and understanding, the issues of race, gender and culture should be addressed by both client and therapist. Each clinician should also consider their own countertransference and internalised ethnocultural and gender biases to be able to provide an environment conducive to healing through images.

Therapeutic decolonisation

Comas-Diaz (1994) has noted the emerging need to integrate psychotherapeutic techniques. By selecting methods from different theoretical schools, clinicians can engage in integrative approaches, helping them towards a greater flexibility in the treatment of clients (Comas-Diaz 1994; Goldfried and Castonguay 1992; Okun 1990). 'The integrative approach is conceptualized as a therapeutic decolonizing and empowering perspective that is aware of ethnicity, race and gender' (Comas-Diaz 1994, p.288).

This approach advocates the 'intellectual' liberation of women. Burt (1997, p.100) envisages the initial step being:

> [to] encourage clients to exercise more control over their therapeutic experience by being active in selecting a therapist, setting their own goals and evaluating therapy. As well as examining the power differential between men and women and its effects on women's mental health, feminist therapists also pay attention to power as a component in the therapeutic relationship.

A decolonisation process for women involves an awakening of consciousness. This process, according to Freire (1967, 1970) emphasises the importance of the therapeutic relationship which functions as a dialogue to facilitate the process of critical thinking.

Comas-Diaz (1994) claims that the process of psychotherapeutic decolonisation begins with the recognition of the social context of colonisation and oppression and the acknowledgement of colonised

mentalities. The dichotomous thinking that stems from colonisation (us against them, black versus white) can also help reaffirm the multiple identities of women of colour by developing a more integrated and less fragmented sense of identity. Through the process of decolonisation, the client is more able to identify differences between external and internal colonisation and thus achieve autonomous dignity. If women of colour are empowered within their personal spheres, they can make informed decisions, thus working towards transformation of the self and the colonised condition.

Ways of seeing: the art therapeutic relationship

The foundation of any human relationship is the creation of shared meaning. As art therapists we enter into the world of the client through their images. We begin to form a complex communication through the use of art, language and interpretation to give meaning to the unconscious aspects of the client's world that is revealed through their images. In any therapeutic relationship empathy, trust and support are the foundation of building and maintaining a therapeutic alliance with our clients. Imposing Western theoretical constructs in treatment risks a form of oppression where 'the victims take on the role of the devalued opinion imposed upon them through the dominant group' (Freire 1972, p.38). Spaniol and Cattaneo (1994) explore the use of language within the art therapeutic relationship and how it absorbs and reflects all aspects of the human experience. In my opinion, the notion of language reflecting cultural difference is an important element to art therapy, although there are potential risks for misinterpretation. Becoming aware of how language has moulded the experience of women of colour and the meta messages related to their ethnicity in the process of acculturation will reflect how the dominant culture has been assimilated by the client.

According to Webster's dictionary, 'to interpret' means to make understandable, to translate, to give one's own perception. As art therapists, our own socio-political choices and theoretical orientations determine our use of interpretation. Franklin (1990) cautions art therapists to become aware of the intricacies of the hybrid nature of art therapy. Training, culture and past experiences can easily influence one's attitude towards empathy. He further states that, due to inadequate

training, many art therapists lack the ability to apprehend visual information and tend to operate from a place of judgement rather than empathy. Their interpretations constantly intrude on their observations.

As art therapists, our primary objective is to become empathic towards female clients from all cultural backgrounds. Our clients will be better served if we suspend our clinical judgements and open ourselves to experiences portrayed through art, however impoverished or unique. Fabre-Lewin (1997, p.117) states 'a significant part of our liberation lies in the recognizing how we collude with sexism by accepting the role of victim'. The core of our work lies in the shedding of internalised oppression, sexism and victimisation.

The art process within the art therapeutic relationship has the capacity to hold a polytheistic view of the clients' inner world. Thus, the process of healing has many sources of meaning, direction and value. The process of art making and dialoguing between the client and therapist is a way of focusing thoughts and images by which the therapeutic relationship begins to evolve. The changing images reflect both internal and external realities of the client and the art therapeutic process. In an established space, a woman of colour can reclaim her voice and sense of self. If we can shed reductionist models of thinking, we can find ways to create new models that meet the needs of the increasing diversity within the field of mental health. Integrated and pluralistic art therapy approaches will create an inclusive, flexible and receptive environment for an increasing multicultural population.

Bibliography

Bhabha, H. (1994) *Interrogating Identity: Frantz Fanon and the Postcolonial Prerogative in the Location of Culture.* London: Routledge.

Burt, H. (1997) 'Women, art therapy and feminist theories of development.' In S. Hogan (ed) *Feminist Approaches to Art Therapy.* London: Routledge.

Campbell, J. and Gaga, D.A. (1997) 'Black on black art therapy: Dreaming in colour.' In S. Hogan (ed) *Feminist Approaches to Art Therapy.* London: Routledge.

Comas-Diaz, L. (1988) 'The future of psychotherapy with ethnic minorities.' *Psychotherapy 29*, 88–94.

Comas-Diaz, L. and Green, B. (1994) *Women of Color.* New York: Guilford Press.

Comas-Diaz, L. (1994) 'An Integrative Approach.' In L. Comas-Diaz and B. Greene *Women of Color*. New York: Guilford Press.

Espin,O.M. and Gawalek, M.A. (1992) 'Womens diversity: Ethnicity, race, class and gender in theories of feminist psychology.' In L. Brown and M. Ballou (eds) *Personality and Psychopathology: Feminist Reappraisals*. New York: Guilford Press.

Fabre-Lewin, M. (1997) 'Liberation and the art of embodiment.' In S. Hogan (ed) *Feminist Approaches to Art Therapy*. London: Routledge.

Fanon, F. (1952) *Black Skin White Mask*. New York: Grove Press.

Ferire, P. (1967) *Pedagogy of the Oppressed*. New York: Seabury Press.

Franklin, M. (1990) 'The aesthetic attitude and empathy: A point of convergence.' *The American Journal of Art Therapy 29*, 42–47.

Gilligan, C. (1982) *In a Different Voice: Psychological Theory and Women's Development*. Cambridge: Harvard University Press.

Goldfried, M.R. and Castonguay, L.G. (1992) 'The future of psychotherapy integration.' *Psychotherapy 29*, 4–10.

Harre-Mustin, R.T. and Marecek, J. (1987) 'The meaning of difference: Gender theory, postmodernism and psychology.' *American Psychologist 43*, 455–464.

Hogan, S. (1997) *Feminist Approaches to Art Therapy*. London: Jessica Kingsley Publishers.

hooks, b. (1981) *Ain't I a Woman? Black Women and Feminism*. Boston: South End Press.

hooks, b. (1984) *Feminist Theory: From Margin to Centre*. Boston: South End Press.

Hurtado, A. (1989) 'Relating to Privilege: Seduction and rejection in the subordination of white women and women of color.' *Signs 14*, 833–855.

Kaplan, A.G. (1979) 'Towards an analysis of sex-role-related issues in the therapeutic relationship.' *Psychiatry 6*, 339–367.

Jenkins, A.H. (1990) 'Dynamics of the relationship in clinical work with African-American clients.' *Group 14*, 1, 36–43.

Johnson-Odim, C. (1990) 'Common Themes, Different Contexts: Third World Women and Feminism.' In R.N. Okun *Seeking Connections in Psychotherapy*. San Francisco: Jossey Bass.

Jordan, J.V. (1984) *Empathy and Self Boundaries, No. 16*. Wellesley, MA: The Stone Center.

Jordan, J.V., Kaplan, A.G., Miller, J.B., Stiver, I.P. and Surrey, J.L. (1991) *Women's Growth in Connection: Writings from the Stone Center*. New York: The Guilford Press.

Joseph, G.I. and Lewis, J. (eds) (1981) *Common Differences: Conflict in Black and White Perspectives*. New York: Anchor.

Joyce, S. (1997) 'Feminist-perspective art therapy: An option for women's mental health – an Australian perspective.' In S. Hogan (ed) *Feminist Approaches to Art Therapy*. London: Routledge.

McIntosh, P. (1988) *White privilege and male privilege: A personal account of coming to see correspondence through work in Womens Studies. No. 189*. Wellesley, MA: The Stone Centre.

Miller, J.B. (1976) *Towards a New Psychology of Women*. Boston: Beacon Press.

Miller, J.B. and Stiver, I.P. (1997) *The Healing Connection*. Boston: Beacon Press.

Moraga, C. and Anzaldua, G. (1981) *This Bridge Called My Back: Writings by Radical Women of Color*. Watertown, MA.: Persephone Press.

Okeyo, A.P. (1981) 'Reflection and development myths.' *Africa Report* (March/April): 7–10.

Okun, R.N. (1990) *Seeking Connections in Psychotherapy*. San Francisco: Jossey Bass.

Said, E. (1993) *Culture and Imperialism*. New York: Vintage Books.

Spaniol, S. and Cattaneo, M. (1994) 'The power of language in the art therapeutic relationship.' *Art Therapy: Journal of the American Art Therapy Association 11*, 4, 266–270.

Spivak, G. (1988) *In Other Worlds: Essays in Cultural Politics*. London: Routledge.

Surrey, J.L. (1991) 'The self-in relation: A theory of women's development.' In *Women's Growth In Connection: Writings from the Stone Centre*. New York: Guilford Press.

Talbott-Green, M. (1989) 'Feminist scholarship: Spitting into the mouths of the gods.' *The Arts in Psychotherapy 16*, 4, 253–261.

Walker, A. (1983) *In Search of Our Mother's Garden*. New York: Harcourt, Brace, Jovanvich.

Wadeson, H. (1989) 'In a different image: Are male pressures shaping the female profession?' *Arts in Psychotherapy 16*, 4, 327–330.

Challenging Invisibility – Outrageous Agers

Rosy Martin

In this chapter I explore my own reflections upon my ageing process and offer some examples of how ageing is represented within popular culture. My response to these issues was to embark upon a process based art project, using photography, video and phototherapeutic methods, resulting in a body of work which seeks to challenge and subvert simplistic and stereotypical representations of the ageing woman. Audience responses to the artworks have included recognition, celebration and a re-evaluation of how it might be to envision the ageing process differently. This work has been extended by developing workshops in which groups of older women share their experiences and discover ways of articulating their stories. In this approach, I have started from a personal issue, explored it as a route to creating artwork collaboratively with Kay Goodridge and then used these experiences as a basis for developing therapeutic workshops, which mirror the experience of creativity and the exploration of complex issues for the participants.

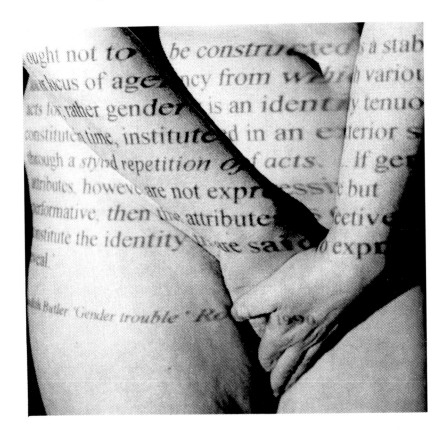

Figure 11.1. **Gender Ought Not to be Constructed as a Stable Identity...**
from Outrageous Agers series by Rosy Martin and Kay Goodridge (2000)
Original in black and white
© Rosy Martin and Kay Goodridge

A shifting self-identity

When my hair started to grow white streaks when my father died in 1990, I decided to keep it like that, as a mark of mourning. As the bright red colour of my hair fades slowly, imperceptibly, day-by-day to white, my familiar reflection in the mirror becomes that of someone I suddenly do not readily recognise: an older woman. Not merely a question of image, this prompts a time for inner reflection, as Sylvia Plath explores in her poem 'Mirror' (Plath 1961)

Now I am a lake. A woman bends over me,
Searching my reaches for what she really is.
Then she turns to those liars, the candles or the moon.
I see her back, and reflect it faithfully.
She rewards me with tears and an agitation of hands.
I am important to her. She comes and goes.
Each morning it is her face that replaces the darkness.
In me she has drowned a young girl, and in me an old woman
Rises toward her day after day, like a terrible fish.

What marks this transition? Perhaps it was my fiftieth birthday. Perhaps it was the 'change of life', this non-negotiable change, as the flow ebbs away. Perhaps it was the realisation, as I completed my therapy studies, that I was projected as 'mother' in that role, in the transference relationship. Do I want to mother, when I never chose to mother a child? Empathy and good mirroring are nurturing qualities that I bring to my therapy work, and I aim to enable the client to identify, develop and use their own inner nurturer. Within the transference relationship I may not only need to offer a sense of 'the good enough mother' (Winnicot 1971, pp.137–8), but also be required to be the 'not good enough' mother figure in order that the client can be angry, whilst I survive that anger without retaliation.

An extract from my diary, on turning fifty: 'To party or not?'

It happens, it happens all the time, continuously, without us looking for it or requesting it. It is the only guarantee – you will get older.

Hope I die before I get old.

(*Pete Townshend*, My Generation, *The Who 1965*)

Did my generation, who so happily sang along, so long ago, really agree? Do they now? As grey and white overwrite black, blonde and red, first dancing at the temples, then advancing, gaining ground. To dye or not to dye? It shouldn't matter of course. Just like it shouldn't matter what you wear or whether you are considered beautiful or not. But it does. How much do you prejudge on the basis of what you see? How does that

change? What a frivolous concern appearance is. Yet we live in an age of appearances, surface, immediacy – where disguise is at a premium, because, in haste, what can I know but what is in front of me. What you see is what you get.

Forever young, forever young, may you stay forever young.

(Bob Dylan, Forever Young, 1973)

So who will take the time to discover the richness, or even the bitterness, that lies behind grey? Grey skies, men in grey suits, it was a grey day – grey does not inspire much joy. Yet, grey is such a versatile colour, almost chameleon, changes so subtly, according to which colour is beside it, flexible and open to interpretation.

Reinvention, yes, it's the task of my generation to re-invent what ageing can be. Take back the power of knowledge, the tolerance of having seen it all, the forgiveness of practice.

But, a voice in my head moans, but. It is a miserable, panicked voice – the voice that realises that there is an ending, only finite time left, and that instead of issuing a pass to freedom screams the fear of lost opportunities. Is that then the tragedy of ageing? The mountains I will never climb, the lakes I will never swim in, the people I will never meet again.

When young I saw it all as limitless possibility and potential. Now, with the heavy feet of clay of middle age, is the progression of loss, of letting go and learning the skills of good-byes hard to celebrate? How can each of us sit with these inevitable changes, having argued a need for inclusion and the acceptance and welcoming of difference all our lives, now to find ourselves in the one group that is so despised, overlooked and feared. What is so terrifying? Is it the sudden flash of recognition of the reflection of my mother, my father, in the mirror – all that I thought I had left behind, grown away from in the search for my singular identity, now reasserting itself in the all too familiar? Is this return to roots a cause for celebration?

Since we belonged to the generation who said 'Don't trust anyone over 30' (slogan from May 1968, Paris), how do we cope with being the people we fought against? A generation who, by force of numbers and self-assurance, pushed their agenda all the way; first youth culture, then

feminism, then the concerns of middle age, now the issues of an ageing population – ourselves.

Since the 'Other' is always the repository of negative projections, the old person becomes the ultimate 'Other' that we each fear the most, since this is the 'Other' that perforce we will each become...

The cultural construction of the ageing woman

To write, as a woman in her fifties, of experiencing ageing may seem a little premature, living in a Western society in which life expectancy for women is approaching eighty and my own mother is in her ninety-second year. Yet this is an experience of the internalisation of Western culture's denial of and distaste for ageing, which is characterised in terms of decline, not in terms of growth and change. It is not the ageing process itself which prompts these anxieties, but the cultural attitudes that accompany it. For women, these pejorative attitudes towards ageing cast their shadows earlier than for men. The rhetoric may be found within medical discourses upon the postmenopausal woman. Dr Reuben here describes a medical model of sexual degeneration (which he characterises as 'tragic') once the reproductive function is lost:

> The vagina begins to shrivel, the breasts atrophy, sexual desire disappears... Increased facial hair, deepening voice, obesity...coarsened features, enlargement of the clitoris, and gradual baldness complete the tragic picture. Not really a man but no longer a functional woman, these individuals live in the world of intersex. (Reuben 1969, p.292)

For Freud a woman of fifty was 'elderly' (Freud 1900), dysfunctional in sexual reproductive terms and therefore sexually invisible.

> After women have lost their genital function their character often undergoes a peculiar alteration. They become quarrelsome, vexatious and overbearing, petty and stingy; that is to say that they exhibit typically sadistic and anal-erotic traits which they did not possess earlier, during their period of womanliness. Writers of comedy and satirists have in all ages directed their invectives against the 'old dragon' into which the charming girl, the loving wife and tender mother have been transformed. (Freud 1913, pp.323–4)

The representations of ageing women within most popular cultural forms amplify such distaste and dread. I chose to research the collection of comic seaside postcards published by Bamforths, which are held at the Hudderfield library, as a vivid example. The stereotypes of the rolling pin wielding, middle-aged, formidable, monstrous harridan and her half-pint-sized, meek, hen-pecked husband are replayed down the years.

'Does the climate here disagree with your wife, sir?'

'No Mister, it wouldn't dare.'

'That's the mother-in-law – if she lived in India she'd be sacred!'

'Grannie – tell granddad his fire's gone out.'

'Yes – I know dear – it went out ten years ago.'

Stereotypes of older women abound include formidable seaside landladies that are not to be argued with, ugly and pathetic 'old maids' searching in vain for men under their beds and older women trying on new looks and failing miserably.

Under a sign stating 'Any old bird stuffed and mounted' the male assistant asks of the ugly older woman, 'And what can I do for you, Madam?'

'Have I got past the fare stage, conductor?'

'You sure have, Missus!'

Alongside these, there are many examples of female camaraderie and a celebration of the carnivalesque in the representation of large, laughing women having a good time on holiday, escaping everyday pressures, refusing the judgements of others.

A large woman in stretched bathing suit with the number 13 emblazed. Behind her is a sign 'Beauty competition' and the two male judges raise their eyebrows in horror. She beams at us.

'I'm having a go at everything this week – while there's life there's hope!'

A visit to the cosmetics counter at any department store, or even Boots and Sainsbury's, quickly demonstrates the advertisers' and marketers'

capacity to play to the fears of ageing that are foregrounded in our youth centred culture. For women, ageing is presented as a pitched battle to be fought in an attempt to retain youthful firmness, elasticity and beauty, target marketed to all women over the age of twenty-five. The discourses of science, war, cosmetic surgery and magic are evoked as intoxicating lures to prompt the purchase of 'youthfulness in a jar' and a 'victory of science over time'. Cosmetic companies remind us that after a certain age our facial tissues weaken, our skin becomes looser and less toned and wrinkles increase. The dangers of a polluting environment containing UV rays and free radicals and the effects of a modern lifestyle are also stressed to widen the potential market. To oppose the effects of time and exposure to pollutants, these companies offer us high-tech potions which contain, for example: 'Nanosomes' of 'Pro-Retinoal A', 'Par-Elastyl', 'Micro-Protein' and other scientific sounding active ingredients, along with assurances that these produced a very high percentage of positive results in clinical trials. The packaging and advertising texts assure the purchaser of renewed beauty and radiance, with younger-looking skin, which is more able to fight the signs of the ageing process.

Some products, aimed at younger women, offer revolutionary formulas of 'Optitelomerase' and antioxidants to produce 'magical effects' of skin renewal. These are said to create a new skin system, which can plump up and re-texturise the skin to which it is applied. The promises of an 'age-proof' defence and the ability to 'say no to aging' are indeed seductive, if a disavowal of the 'ravages of time'. The reassurance of a 'face-lift in a jar' is addressed to an audience of middle-aged women. This 'face sculptor' is said to instantly firm and lift the skin and to smooth away fine lines, echoing the language of cosmetic surgery. Cosmetic products offer the 'power and precision to act directly', echoing the language of war. Yet the newest fashion for intervention, discussed in life-style and women's magazines, is 'Botox' (a product of military bio-technical research) injections. These cause a temporary paralysis of the muscles, producing a smooth, but expressionless face adorned with the mask of youth, unmarked but static.

The fashion department offers little solace; there is barely room for manoeuvre amongst the dominance of highly sexualised skimpy club scene youth styles – all else is marginalised. If our places in the hierarchies

of consumer culture are established and contested around our consumer choices, then the few options offered to mature women preclude finding a variety of styles with which to present ways of being powerful women. The demand for constant change which fuels the fashion cycle itself holds implicit messages of redundancy and obsolescence, through which we are taught to despise and cast off the styles of previous years. Gullette (1999) has analysed consumer culture and the 'life cycle' of clothes, in which 'dissatisfaction is our most important product' (fashion marketer quoted in Gullette 1999, p.46), as an arena in which each of us is taught to discard once-loved garments with which we identified and, by so doing, learns unconsciously to accept a lesser identification with an ageing and declining self, long before any physical debility is experienced.

> The fashion cycle suggests that as we master a technology of remaining fashionable, within the current economic and discursive climate, we practice identity stripping and learn decline unconsciously... It's not the past that is shameful, it is we who incur shame if we ally ourselves with the past, the unwanted, the 'old'... Once we recognise our location in a cultural war centred on age, we need to experience ourselves consciously as both targets and resisters. (Gullette 1999, p.52)

The deeper fear is of oneself being passed over, passi, past it. No, not yet, just give me some more time... The awesome archetype is the crone, too long characterised as the hag/witch of fairy stories and folklore, as a cultural disavowal of the once respected role of wise woman and matriarch. Everyday language is full of derision for the old: 'Old bag', 'old hag', 'old maid', 'saga-louts', 'grumpy old', 'silly old moo', 'boring old', 'dirty old', 'stupid old', 'foolish old'. My mother's voice echoes in my mind, her litany of attempts to displace societal scorn: 'keep on smiling', 'mustn't grumble', 'keep your chin up'. My mother's extreme frailty now focuses me upon the source of these projected fears, the fear of death itself.

> Are we not dealing with a myth of old age – an accumulated deposit of everyone's fears of the uncertainty of life, which all of society has pushed ahead each year until it is compressed into the farest end of

our lives – and we, who are old, are expected to live out everyone's fear – not of old age – but everyone's fear of the uncertainty of life itself. (Macdonald 1987)

The process of developing the artwork

As I enter another difference, as I take up my position amongst the (middle) ageing population, it became imperative to me to consider this new positioning through my artwork, through my photography. What might it mean to be 'older' – the process of becoming so is so gradual and yet for a woman loaded with cultural meanings few would readily embrace.

I chose to work collaboratively with Kay Goodridge, who is also a photographer and has many years of experience as a co-counsellor and as a community artist. Kay has a daughter who has recently left home to go to university. Kay brought to our explorations this experience of mothering a daughter, and what it means to offer support as her child becomes a woman, and the difficult transition of separation, which brings with it new-found freedoms. For so many middle-aged women these years represent an opportunity to move on from the day-to-day responsibilities of full-time mothering to rediscovering a sense of autonomy.

We spent many hours together, using therapy techniques, to uncover our own fears and prejudices about our own ageing processes. We offered each other the therapeutic space to explore our contradictory feelings and through this connection we created for a ourselves a safe space in which to work.

We used many of the techniques I had developed within phototherapy (Martin and Spence 1985, pp.66–92, Martin and Spence 1988, pp.2–17, Martin 1991a, pp.34–49, Martin 1991b, pp.209–221, Martin 1993, pp.7–9, Martin 1997, pp.150–176). We were seeking to use photography to intervene in cultural debates about the constructions of identities, as I had, for example, in my explorations of my lesbian identity (Martin 1991c, pp.94–105).

Re-enactment phototherapy moves way beyond the always already impossible notion of finding any 'ideal', 'real', or 'positive' image, an

idea which ignores how meanings are constructed or subjectivities are produced. Far from being eternally fixed in some essentialist past, identities are subject to the continuous interactions of history, culture, and power. The subject as the site of the articulation of representations, inscriptions, and meanings can be explored in the freedom of the potential offered by re-enacting, playing with, and subverting identities, rather than seemingly being fixed, defined, and contained by them. Phototherapy enables clients themselves to make visible what it is to be subjected to and subject of the discourses within society. (Martin 1996, pp.4–8)

Our intention in our work was to confront stereotypes of the ageing woman, which currently leave little space for negotiation and suggest decline, loss of sexuality and redundancy. Consequently, ageing is seen as a problem to be overcome, hidden or denied. We wanted to challenge and contest these stereotypes. This work is about the unruly, carnivalesque, even grotesque, body, which refuses to be ignored. We chose to use irony, humour and transgression to subvert clichés, for example, 'mutton dressed as lamb'. We asked ourselves the question, what does it mean to inhabit an ageing, unstable body – as a woman? – as artists/photographers using our own bodies as a medium for exploring social and psychic realities?

To play with mimesis is thus, for a woman, to try to recover the place of her exploitation by discourse, without allowing herself simply to be reduced to it. It means to resubmit herself – inasmuch as she is on the side of 'perceptible', of 'matter' – to 'ideas', on particular ideas about herself, that are elaborated in/by masculine logic, but so as to make 'visible,' by an effect of playful repetition, what was supposed to remain invisible: the cover-up of a possible operation of the feminine in language. It also means to 'unveil' the fact that, if women are such good mimics, it is because they are not simply reabsorbed into this function. (Irigaray 1985, p.76)

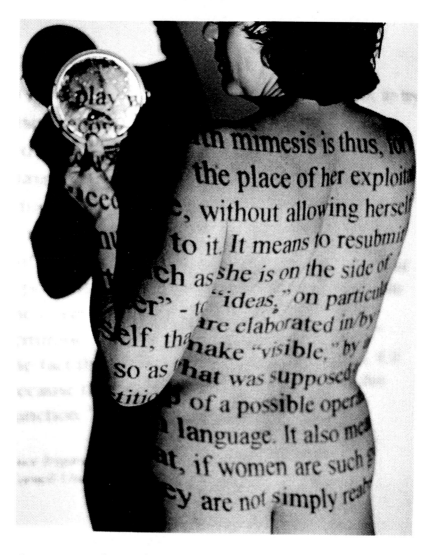

Figure 11.2 **To Play With Mimesis...** *from the Outrageous Agers series by*
Rosy Martin and Kay Goodridge (2000)
Original in black and white
© Rosy Martin and Kay Goodridge

We started by making a series of portraits of one another, taking turns to
be in front of the camera, with the other as supporter, confronter,
phototherapist. We needed to get used to how we now looked in photo-
graphs. We then went on to explore a series of portraits that were multiple

exposures, of multiple selves. As the trust within the working relationship between us grew, we took more risks. We were thus able to let go of the images we held in our heads, of how we used to look, and take a more objective gaze at our own self-representations. Yet still the 'body beautiful' message haunts…what of the body I now have?

Exploring the body as a site of inscriptions

> The body must be regarded as a site of social, political, cultural and geographical inscriptions, production or constitution. The body is not opposed to culture, a resistant throwback to a natural past; it is itself a cultural, the cultural product. (Grosz 1994, p.23)

As one of our strategies we decided to concentrate on parts of our bodies which may be characterised for many women as sites of bodily anxieties, for example, flabby bellies, crepey bosoms, cellulite pitted buttocks and thighs, love handles and triple chins, and sought to find ways to re-present them. We photographed each other's bodies, accentuating the 'ugly' bits. We then experimented with double exposures, to intensify the notion of becoming, and overlapped the images, for example, photographing the effect of breathing out and relaxing muscles with breathing in and tensing muscles on our flabby bellies. We cropped in very close to the body, seeking out sites of displeasure to make these images transgress the boundaries of the frame. We discovered that when we made selections from the photographs we had produced and placed images together as a continuous frieze of colour photographic prints, in which one image appeared to merge with the next, they became aesthetically gorgeous bodyscapes. It became possible to look at these fragmented parts of our bodies, which we had previously viewed 'as if' through the judgemental eyes of others, in startling new ways; no longer 'ugly', they rather bore the traces of lives lived, inscribed by time. The response to these images, when they were exhibited as a huge frieze at the Lighthouse Gallery in Wolverhampton, included:

> The act of looking at the undulating folds and contours of the skin becomes pleasurable and manifold, as though the artists are playfully interrogating our assumptions of how the ageing body should appear. By juxtaposing a visual exploration of how it feels

and looks to inhabit an ageing body with a sense of liberation (corporeal, aesthetic and political) Martin and Goodridge question the stigma of growing old, which so often becomes a process of de-eroticisation under the gaze of contemporary society.

Furthermore, by engaging with the dynamics of representing the old(er) female nude, the absence of the older woman in visual art is challenged. Within a patriarchal frame, only the smooth, healthy body is considered an appropriate body type for art: anything other than this is out of bounds/monstrous.

(Gear 2000, p.29)

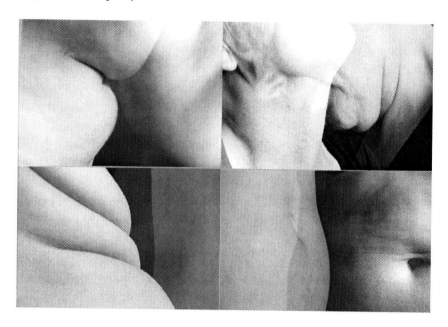

*Figure 11.3 Extract from **Bodyscapes** from the Outrageous Agers series by Rosy Martin and Kay Goodridge (2000)*
Originals in colour
© Rosy Martin and Kay Goodridge

We also chose to examine the sense of having an unstable body, foregrounded by our own experiences, for example, of feeling one day fit and healthy, the next crippled by rheumatism and straining knee joints when running. By overlapping images of movement to represent instability with images frozen by flash light, we used multiple exposures to

confront notions of the unstable body, containing echoes of its history, projections towards its future, within itself.

> On the inner screen of ageing, these shadows – memories of younger selves, anticipations of older selves – meet, conflict, interact... Incorporating previous states we become the sum of what we have been. It is, paradoxically, a permanent inchoate process. As a rule loss and mourning accompany the discourse of ageing. Yet loss's travel companion is accumulation – of imaginary selves, of psychic objects, of all the 'baggage' of the past. (Cristofovici 1999, p.269)

We also used these multiple exposure ideas to make portraits of each other, combining movement and statis to make visible ideas of change and instability. We created traces of both the past and the future within the images, for example, in one image of myself, the movement gave back the bright auburn-red colour to the hair, in another the loose movement of the jaw offered up an image of a premonition of old age.

Trying it on: the performative body

> Gender ought not to be constructed as a stable identity or locus of agency from which various acts follow; rather gender is an identity tenuously constituted in time, instituted in an exterior space through a stylised repetition of acts... If gender attributes, however, are not expressive but performative, then these attributes effectively constitute the identity they are said to express or reveal. (Butler 1990, pp.140–41)

Ignoring the implicit notice 'no woman over 30 need enter' we revisited Top Shop to engage with and perform the stereotype of 'mutton dressed as lamb' by trying on a range of trendy clubwear, lycra-stretched sequins, leopard skin print and PVC. Squeezed into the frame, our bodies mirror the desire and discontent of the loss of the anyway already impossible 'perfect' body. Trying on youth in a changing room, the flesh of the body reasserts itself through the stretched fabric, it cannot be contained or forced to fit within fashion's parameters. But alongside this unease, we were celebrating the carnivalesque fun and ambiguity of the images, as tendrils of hair fall upon plunging necklines, and bums most definitely do look big in this.

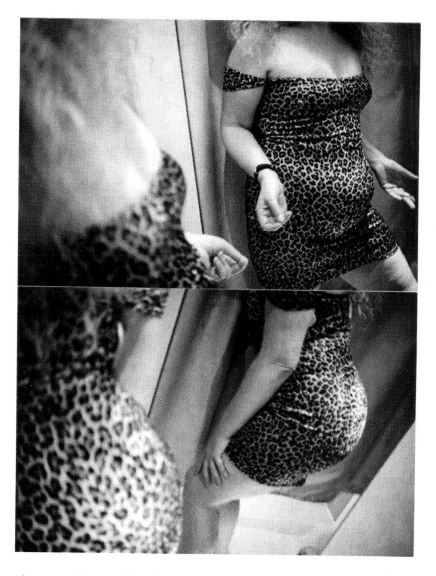

Figure 11.4 **Trying it On** *from the Outrageous Agers series by Rosy Martin and*
 Kay Goodridge (2000)
Original in colour
© Rosy Martin and Kay Goodridge

The mirrors of the changing room reflected back the performative aspects
of the work and reinforced the act of looking, both of the viewer as
voyeur inside the changing room and the artists as both fashion model

and photographer. When we exhibited this work, we made large (60" x 40") light-boxes, montaging together series of images, to cite, challenge and create a parody of fashion and advertising photography. Arnot (2000, p.12), reviewing the show, had a mixed response:

> A large bottom stretches tight leopardskin to comic postcard parody. A big, bare thigh, pitted with cellulite, protrudes from a short skirt below a bare bulging midriff. The unsightly lumps are juxtaposed with lovely feminine shoulders and hints of cleavage.

What d'ya think you're looking at?

In an exhibition that focused so much upon the female nude and the subversion of popular cultural forms, we then decided that we could not ignore the striptease, but needed to make it 'outrageous'. Our performative approach was intentionally carnivalesque and transgressive, drawing its inspiration from engagement with Bakhtin's (1965) work on Rabelais and his notions of 'grotesque realism'. The grotesque body he addresses is the open, protruding, extended, secreting body, the body of becoming, process and change, in opposition to the Classical body, which may be characterized as monumental, static, closed and sleek, the idealised body that haunts the psyche of desire, the always impossible to physically embody ideal.

> In the famous Kerch terracotta collection we find figurines of senile pregnant hags. Moreover, the old hags are laughing. This is a typical and very strongly expressed grotesque. It is ambivalent. It is pregnant death, a death that gives birth. There is nothing completed, nothing calm or stable in the bodies of these old hags. They combine a senile, decaying and deformed flesh with the flesh of new life, conceived but as yet unformed. Life is shown in its two-fold contradictory process; it is the epitome of incompleteness...it is unfinished, outgrows itself, transgresses its own limits. (Bakhtin 1965, p.25–6)

This image of the pregnant hag is highly ambivalent from a feminist reading, but it does allow for exuberance and a celebration of the transgressive aspects of the monstrous feminine, which counters idealisations of certain kinds of female beauty. It offers a space, for play and for a

broader notion of self-expression and self-acceptance than the entrapment of forever seeking the impossible Classical perfection.

We moved to using video, and worked in Kay's all white studio in Cambridge, which mirrored the white cube of the typical gallery space, and we dressed in the obligatory, ubiquitous black of the private view. In 'What d'ya think you're looking at?' our gestures and poses mirror and subvert the striptease act, as we teasingly removed layer upon layer of black clothing, whilst humming and singing 'The Stripper'. Underneath the multiple layers of black lies another visual twist, inspired by my experience of a sprained ankle: tubi-grip covered our arms and legs.[1] Although this is usually connected to notions of the damaged unhealthy body, we used it as a second skin, tubi-grip as the new lycra, also making a visual reference to Victorian silk stockings, and peeled it off seductively, whilst laughing.

The critic Rachael Gear said of the work:

> Several key words spring immediately to mind: riotous, positive, powerful and, of course, outrageous... Martin hums and sings 'The Stripper' throughout, bawdy at first and then slowing down to a rhythmic gasp which evokes an excited heartbeat... Most significantly, they are both laughing which firmly roots this performance in the tradition of the carnivalesque with its associations of risk and excess as the artists reveal themselves, literally, to the audience. What is most appealing is that they look and sound as if they are enjoying themselves, as though they are revelling in peeling off the stigma of old age. (Gear 2000, p.29)

The second part of this piece was more confrontational, engaging with the dangers of exposure, in the style of a flasher, and also in terms of exposing the ageing 'othered' body. We took turns to advance towards the camera, removing a full length black coat to reveal our naked bodies, asking 'what d'ya think you're looking at' of the viewer. Our intonation became more angry and challenging as we walked towards the camera, until only our mouths appeared pressed against the lens, disembodied and distorted.

> The real threat posed by older women in a patriarchal society may be the 'evil eye' of sharp judgement honed by disillusioning experi-

ence, which pierces male myths and scrutinises male motives in the hard, unflattering light of critical appraisal. It may be that the witch's evil eye was only an eye from which the scales had fallen. (Walker 1983 quoted in Cooper 1988, p.62)

Bodies that Matter (Butler 1993)

In a series of ten scripto-visual works, theoretical texts by Reuben, Freud, Bakhtin, Plath, Irigaray, Gullette, Butler, Grosz, Macdonald and Walker (included within this article), carefully chosen as exemplars of defining or defiant texts, were projected onto our fragmented naked ageing bodies to challenge, subvert and make visible the inscriptions of medical, psycho-analytic and cultural discourses upon the body. The aim was to shift the territory across the positions taken by Reuben to Walker, through the theoretical strategies of Bakhtin (ambivalent), Irigaray (the chosen quote sets out the questions to be addressed), Grosz and Butler (who offer routes through positioning by discourse). The intention is to stress the multiplicity of texts and images and the shifting ground, the destabilised body. Meskimmon's (2003) critique explores this relationship between text and body:

> The texts neither construct a singular nor wholly negative discursive field which must be rejected for the body to be liberated. On the contrary, the multiple exchanges between the voices in these texts and the bodies they materialise, make it clear that inside and outside are not adequate terminology by which to think this textual/bodily interface or, echoing Elizabeth Meese, that 'language is like a skin, both on the side of the body and out-side the body, between the body and the world, but also of the body, in the world' (Meese 1992, p.3 quoted in Meskimmon 2003).

> The series enacts this skin in particularly visual, aesthetic formula-tions, materialising the bodies and the texts as the effect of light and shadow. The skin's surface is the very premise of visibility for the text and the bodies emerge in the works through their scription. Each is interpellated, indeed, made to matter, at their point and process of contact. Moreover, their materialisation is particular to the photographic process itself which draws/writes with light. These photographs are not of objects, but are the condition by

which this text/body exchange can take place. As viewers, we are invited to engage actively with this materialisation, working to read the bodies, envisage the texts and make their interface meaningful. For example, the seventh photograph of the series casts a text by Elizabeth Grosz across the undulating surface of a woman's torso – we see/read each as a function of the other. I would argue that this powerful aesthetic performance of the text makes its meaning more fully material and sensually viable than any printed version could (Grosz 1994, p.23). As the words describe and inscribe the sensual surface of a woman's skin, literally and letterally, they materialise female desire and subjectivity as embodied, sentient knowledge. (Meskimmon 2003)

The authority of the normative and clinical prescriptions of Reuben (1969) and Freud (1913) is undermined by the exuberance and presence of the vitality of the living, breathing body. Not all of the text is easily visible, and is distorted by the disruptive and excessive body upon which it is projected. Flesh overpowers word. The body answers back.

> The confrontation between real flesh and a text such as David Reuben's diatribe on the rapid decline of the older woman is a particularly challenging image as the body effectively swallows the words whole. (Gear 2000, p.292)

The poses were carefully chosen with reference to key, well-known art historical sources and to comment upon the texts projected upon them. For example, the word 'play' in the Irigaray (1985) quote from 'This sex which is not one' is caught in a mirror, raising issues of mimesis, visibility, reflection and the mirror's use by artists as a symbol of vanity (Nead 1992). By so emphasising the word 'play', we both give form to the ideas within the quote, and our own artistic processes. In the image using the quote from Butler (1990) on the performativity of gender, the pose is that of the Venus Pudica (Salomon 1996, pp.69–88), covering the pubis with the hands, performing the Classical pose of femininity, with the excessive, transgressive body of middle age. 'Pudica' means shameful or modest. 'Female nudes fashioned as covering their pubises were and continue to be the most favoured subject/pose/gesture in the art of the western world. The subject/pose/gesture was first mainstreamed into western culture by the fourth-century Greek sculptor Praxiteles

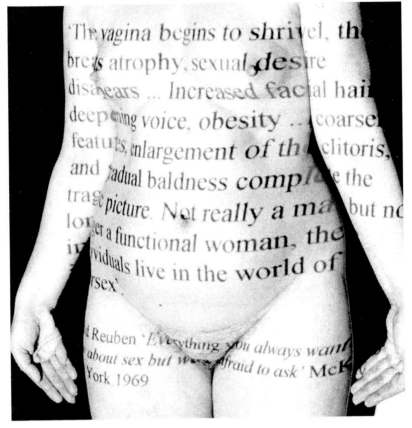

Figure 11.5 **The Vagina Begins to Shrivel***... from the Outrageous Agers series
by Rosy Martin and Kay Goodridge (2000)*
Original in black and white
© Rosy Martin and Kay Goodridge

(Salomon 1996). For a discussion on the meanings of this pose see
Salomon (1996, p.69–88). The Venus Pudica pose is challenged in the
image using the quote from Freud (1913). The image is taken from a low
angle, which gives a sense of power to the figure, defying the quote. The
hand does not cover, but rather, in the form of a fist, resists and contests
any 'loss of genital function' (Freud 1913, pp.323–4).

> The third photograph of the series voices alterity as a critical dislo-
> cation between visual citation and text. ... It is also the body of an
> older woman, strong, beautiful and sensuous. The changes wrought
> over time have not placed this body beyond what the text describes

as women's 'period of womanliness', but begin a challenging process of re-defining what 'womanliness' can mean. (Meskimmon 2003)

In using the quote from Walker (1983), the word 'eye' is caught and enlarged by a magnifying glass, to emphasise the notions of detailed, penetrating, insightful looking and to reference the associations of the magnifying glass with old age. We chose to use black and white prints for this series to formally echo the idea of the authority of the printed word, which we subverted. We exhibited the chosen texts as a separate artwork, in a different part of the gallery.

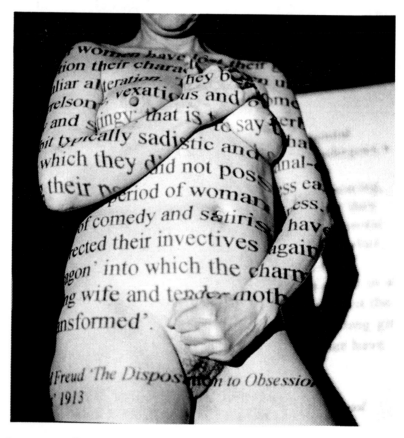

*Figure 11.6 **After Women Have Lost Their Genital Function**... from the Outrageous Agers series by Rosy Martin and Kay Goodridge (2000)*
Original in black and white
© Rosy Martin and Kay Goodridge

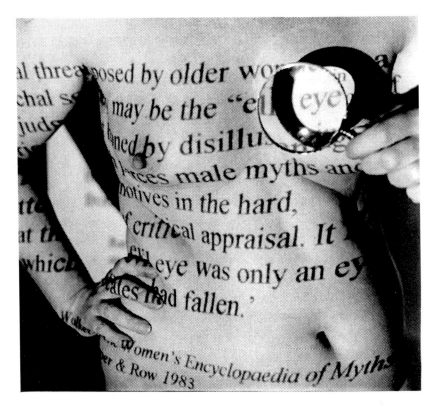

Figure 11.7 **The Real Threat Posed by Older Women in a Patriarchal Society May Be the 'Evil Eye' of Sharp Judgement...** *from the Outrageous Agers series by Rosy Martin and Kay Goodridge (2000)*
Original in black and white
© Rosy Martin and Kay Goodridge

Workshops on ageing using phototherapy techniques and digital manipulations

When this work was exhibited at the Lighthouse Gallery, Wolverhampton (2000), Kay and I ran workshops with older women to encourage them to engage practically with some of the concepts we had worked upon, using the exhibition as a catalyst for their own ideas. We introduced them to collaborative phototherapy methods, which they used to create self-portraits with digital cameras. The participants then used Photoshop (the industry standard software for digital manipulation of photographs and images) to manipulate their self-portraits, to create

composite, layered images that reflected upon their notions of self, and the complexity of their identities. We shared the images produced, within the group. Each participant spoke about the aspects of self-identity and ageing they were working through, within the supportive and experimental environment we had created.

Workshops using photography and video with the 'Freudian Slips'

As our work became more performative, we decided to run a series of workshops with a women's theatre group, 'The Freudian Slips',[2] on issues of ageing. We wanted to share our experiences based upon the re-enactment phototherapy approach of using photography and video performatively. 'The Freudian Slips' have been working together for a number of years, devising, writing, directing and producing their performances. These workshops offered the opportunity to work with the improvisational and physical theatre skills of actors. Kay and I planned and ran these workshops, using phototherapy techniques and incorporating feedback and responses from the 'Freudians'. We circulated our plans amongst the group, well ahead of each workshop, to enable participants to prepare and collect ideas, props and clothes for each session. Throughout the workshops, we built in time for emotional processing, feedback, support and reflection. We recorded the workshops, using video and photography. This allowed the participants to re-view the work, after the workshops, and work through the issues raised. Every participant worked on the themes during the time between our meetings, it was a very intense experience. We used the workshops as a springboard, to explore issues within a safe group and also as a route to allowing creative ideas to develop over the course of the four workshops.

In the first workshop, after a warm-up, we brainstormed ideas on our fears and joys with regard to ageing. We then took it in turns to take one of these aspects, and improvised scenarios, which were halted at the director's call of 'freeze', whereupon one left, and another took her place, beginning a new scenario. This exercise enabled us to begin to enter into our fears and to begin to challenge these through exploring aspects that the group had identified as joys. By using role-play we were able to create some distance and objectivity. We then used 'found photographs' (a phototherapy technique) to open up ideas of storytelling and photo-

graphs as fictions. A selection of old, found family album photographs was laid out and participants were asked to choose one.[3] Counselling in pairs, the one who is speaking uses the photograph to tell a story. The one who is listening can ask some key questions to help their partner focus. Participants are asked to study the photo. Why did you choose it? What drew you to this photo? They are invited to freely associate around the image, and assured that there is no right or wrong perception and asked to choose someone in the photo to identify with, to tell their story. They are requested to speak from the first person, as if it were you, for example, 'I am standing beside… I am at a studio having my photo taken, I feel…' After counselling in pairs, each participant was invited to tell their story to the whole group, entering into the imagined history of the person within the image that they had chosen. A further exercise, in which participants stayed within the roles they had developed, explored attitudes to difference. The feelings that this aroused were processed within the group. For the final exercise of the day, participants were invited to stand on a plinth and become a powerful middle-aged woman. Each explored what that represented for them, using the props and clothes they had brought with them if they so chose, how it felt and what it was like to become this powerful embodiment. This exercise was both celebratory and cathartic.

We started the second workshop with a warm-up. Then each participant introduced themselves to the group by means of an object, which they had chosen. This offered the opportunity to explore aspects of the self through association and metaphor. It was a very powerful exercise, which moved into aspects of personal histories. We then used mime to explore the fears and joys, allocating one of each, randomly from the list. Everyone brought dressing up clothes to share, and we played with these, entering into different roles. Once we had all decided upon an outfit, we then entered into the characters evoked, through guided exercises. We then worked with the joys and fears, allocating them randomly. We emphasised the importance of being with the feelings evoked, a certain stillness and intentionality that allowed the body to communicate powerfully, without language.

We then worked with the idea of afflictions. Each participant had brought props which helped to focus and make their chosen affliction

visible, and presented their performative piece to the group. Again, personal stories were very resonant, with some real insights and passion, whilst the permission giving of the group dynamics which we had created enabled everyone to take risks. A closing circle and feedback ended the day.

In the third workshop we built upon the personal pieces, and the ideas that each individual wanted to pursue in more depth out of the previous workshops. After a warm-up, we introduced ourselves through a very personal object. Each participant offered a performative piece to the group, developed from whichever exercise had produced the most resonance.

The group offered feedback and containment. We used the dressing up clothes and props again, in free improvisation, allowing ideas to spark from one another. In the final session of the day, we set up the video camera, and did a free improvisation to camera, in which we took turns to speak and step into the performative space. At times riotous, at times playful, at times so poignant, we each dug deep into our feelings about ageing and our life experiences.

In the fourth workshop, after a warm-up, we each introduced ourselves to the group through an object which represented a pivotal time in our lives. We spoke in the first person about the object as if we were living in the time it symbolised. Again each took the perfomative space to work up a piece, and received feedback and support from the group. We then did a group improvisation, using the video camera as the audience, on the theme of teaching each other what you have to do to be an old person. In retrospect, this exercise did not work as well as the previous group improvisation, perhaps because we found a wheelchair, and acted into projections, rather than drawing upon our own experiences.

In the closing circle, we took time to evaluate the whole process and what each individual had learned from it. I observed that the work that had touched upon personal histories was the most powerful. Feedback from the 'Freudian Slips' was that these workshops were much more personal than their usual workshops, because we were using phototherapy and dramatherapy techniques.

Kay and I decided to develop some individual pieces, as video performances, with the intention of exhibiting them. We set aside four days for this filming, and invited those participants who wanted to take their work further to take part. The pieces evolved during the process of filming (Martin 2001a, pp.17–20), through feedback, support, and the therapeutic gaze (see Martin 1997, p.158) which we offered, to become the final artworks.

'Time will Tell'

Sue Knight brought her poem to the third workshop. Reading it standing, naked, the power of the text resonated. We cheered, in support and in recognition. The poem held both celebration and loss, anxiety as well as joy in inhabiting an ageing body:

'Ode to My Post-Menopausal Body'

O post-menopausal body,
Shall I tell thee how I love thee?
I shall begin here at thy feet
O feet so nimble and shapely
Art thou alone untouched?
O legs, once sturdy,
How fast canst thou run?
What are these veins that cluster about thee
Like the vine that entwines the pergola?
O Fanny – art thou dry?
Who used to run with lusty juice
Where is thy unfettered passion,
Insistent that all should bow to thy desire?
And Grecian waist so sweetly curved
Lost beneath mounds of sub-cutaneous-ness
Thickened out of recognition
Art thou faire?
These breasts now ample, once were small
As ripening plums upon the tree
Now falling heavy with a swinging gait
Dost thou recall the sweetness that was thee?

But ah, to thee oh neck I must recite:
As time hast drawn and stretched
Thy loosening skin,
Shall I compare thee to a feathered friend?
Or to a roasting fowl with all thy feathers plucked!
Head perched aloft, that aches too oft
The fount of wisdom stares
From eyes still blue behind the double lens
And canst thou say thou never shalt forget
When memory plays tricks at ev'ry turn?
O post-menopausal body so divine
I love thee still
If thou wilt still be mine!

(Knight 2001)

I wanted to find a way of making the image as powerful as the text. Given that the poem highlights the ageing process, I decided that it would be confrontational to site the speaking subject, the postmenopausal woman, on a plinth, next to the Classical ideal, within a museum. This strategy is to highlight an absence, a body that is not represented within the canon. I went to the Victoria and Albert Museum, to find a suitable location and chose the sculpture court and *The Three Graces*[4] as the foil. We gained permission to video there, and filmed an establishing pan, and *The Three Graces* themselves, both in long shot and close-up. We then filmed both long shot and close-up of Sue Knight's performance of her poem, whilst she stood on an improvised plinth, against a Chroma blue screen (this allows the two video takes to be combined: during the editing process, the blue background was erased, replaced by the filming in the museum). This enabled the performance itself to take place within a 'safe' space, over which we had control. Combining the shots from the two locations in the editing process, the animated, enfleshed, lived-in body of the speaking subject directs her address to the cold, white marble of sculptural perfection, challenging the object of the look, and highlighting the transitory aspect of youth as the ideal.

Figure 11.8 ***Time will Tell*** *by Kay Goodridge. Installation shot from*
Outrageous Agers by Rosy Martin and Kay Goodridge (2001)
Performer/writer – Sue Knight
Video still – original in colour
© Rosy Martin and Kay Goodridge

'Mouthpiece'

During the workshops, Kay Goodridge had explored the themes of
silencing and speaking out. In the powerful middle-aged woman
exercise, Kay had spoken of how she had felt silenced, and had found her
voice and her creativity through her photography. In the afflictions
exercise, Kay had wound bandages around her mouth, and painfully
struggled to speak through them, until she pulled them off with a
wrenching movement. We talked this through in depth, and it became
clear to Kay that she was touching upon issues of abuse. She had a mouth
shape sculpture, formed of tiny red lights, that a friend had given to her
which she chose to use as a prop to explore this silencing in experiencing
childhood sexual abuse in the third workshop. Kay had previously
written very powerful texts,[5] in the voice of herself as a child, trying to
make sense of these experiences, which she worked with in the fourth

workshop, again using the mouth of lights. We worked together, one-to-one, to find a form to give power to her performance, when we were making the video. We came up with the idea of illuminating just her mouth, with red light, speaking her powerful text, of her childhood experiences of sexual abuse, and her anger.

Here are some excerpts from 'Mouthpiece':

> Writing this – it feels like a statement, a confessional, as if I am the guilty one. Let's get this straight. I AM GUILTY OF NOTHING.

> You say you have a camera and want to take some pictures of me with no clothes on. I enjoy stripping off and you take photos but there comes a point when it has all gone too far. I am very scared and start to cry. I want to leave and feel very guilty in case my parents find out. But I cannot leave. You have hidden my clothes and I am naked. Did you touch me then?

> I was so frightened after that. Frightened that other people might find out. You stole my innocence. You destroyed a side of me which could trust people.

> I must have held on to so much, hidden so much. I could talk to nobody about anything that had happened. I had to keep silent.

> At other times it seems like all this happened to someone else, someone who was not me. The school photo – a group of innocent children playing out the best years of their life. I think not.

> I am angry now. I am a ball of rage. Your face is bleached out by my anger. Bleached out, burnt, distorted. You become part of the background. My background. The effects are in my unconscious, disturb my dreams.

> My rage is at YOU – who seem to have escaped the humiliation, the fear, the guilt, the absolute terror of being found out. And rage at any abuse of power, of people using their strength over others. (Goodridge 2001)

All the emotions are focused in, as the tightly framed close-up of the disembodied mouth confronts the audience with the necessity of speaking out, of saying what could not be heard at the time.

A donkey's tale

A figure that had haunted me for many years, the bag lady, found form in the second workshop. The idea of being a reincarnation of a donkey was an old joke I'd made to describe how it feels to transport things if you are not a car owner. My shopping trolley is my solution, but I found it acts as a symbol for middle age. I used it as my prop, for the afflictions exercise. In the dressing up session, I found the role through which I could express these ideas, the voice of a working-class woman (which is the background from which I come). The text from the performance developed as improvisation in the workshops and was refined in the process of the filming:

> I think I must have been a donkey in a previous life. You see – I've always got too much to carry. Now, when it comes to carrying too much, this comes in handy. Now, I tell you, people laugh at me, people scorn me, people jeer, but, this represents liberation. Now, this, I tell you, is a liberating object. When you've got too much to carry. Now the thing about carrying stuff is, you've got to feel the weight, got to really feel it, you know, in the shoulders, in the back, when you're carrying stuff. Always carrying stuff. And there's another thing, if I haven't got enough weight, what I do is, I pick up other people's; other people's distress, other people's pain, other people's grief. You see, it's very important to keep worrying. Just got to keep on worrying about other people, other people's concerns. Got to keep up the excess baggage, 'cause it stops you thinking about other things. You see, the thing about all this excess baggage is – it stops you – having your own life (Martin 2001b)

The simple and direct use of language emphasises the absurdity of the all too familiar position. In the performance, I am laden with bags, yet go round collecting even more, as a metaphor for the stereotypical woman's role as carer. I walk around and around within a confined space, pulling the shopping trolley, in long shot, turning to the camera/audience to deliver the text, in close-up. Finally I let all the bags fall, walking out of the frame, unburdened.

Conclusion

So the body 'speaks': the work is about embodying feelings and is in dialogue with the constructions within culture and discourse that surround the ageing woman. Exploring issues of ageing, using both photography and video, within a therapeutic framework of containment, safety and support enabled both Kay and myself, and subsequently the participants within our workshops, to take risks to counter cultural stereotypes and confront our own fears. Although at times it was very personally challenging, by using strategies which embraced the carnivalesque and celebrated the complexities of the ageing process, we created a powerful body of artwork and a methodology that may be shared in therapeutic workshops, using photographs and video performatively..

For more images and texts, see the website *www.var.ndirect.co.uk/outrageous*

Endnotes

1 Tubi-grip is an elasticated tubular support bandage, designed to provide firm, effective support for sprains, strains and weak joints. When I sprained my ankle, my mother sent me some of her stock of tubi-grip, which she uses to protect and support her severely arthritic knees.

2 The 'Freudian Slips' are a Women's Theatre Group, based in Cambridge, who have been working together for a number of years. The members are: Sue Ifould, Sue Knight, Cathy Dunbar, Kay Blayney, Veronica Thornton, Allie Spicer, Gill McLeod, Helen Patterson.

3 It is important that these are found photographs, rather than from the individual's personal family album. This allows for a much freer interpretation, since there are then no aspects of personal loyalty, nor silencing evoked. An insight that I have gained by using this exercise in many workshops is that participants do address key personal issues, and do draw upon their own histories in this storytelling. Often this exercise acts as an opening up to key themes for an individual, which reoccur during a series of workshops.

4 Antonio Canova's sculpture *The Three Graces* (the hand-maidens of Aphrodite) depicts three adolescent young female bodies, as in the perfection of white marble in a Neo-Classical style. This sculpture is also very well known, having been saved for the National Collection in Britain by

donations. Close by this sculpture is *The Sleeping Nymph* by Canova, which we used as the opening shot.

5 Kay Goodridge had an exhibition 'Our silence is your comfort' in 'Revealing' at Focal Point Gallery (1997), using images connected to the abuse but did not use the text then. It was a group show on the theme of secrets with Charlie Murphy and Roz Mortimer.

Dedication

I would like to dedicate this chapter to my mother, Olive Maude Martin, now aged ninety-one.

Bibliography

Arnot, C. (2000) 'Cellulite for sore eyes.' *The Guardian* 3 February 2000, p.12.

Bakhtin, M. (1965) *Rabelais and His World.* Trans. H. Iswolsky, 1968, Cambridge, MA: MIT Press.

Butler, J. (1990) *Gender Trouble.* London and New York: Routledge.

Butler, J. (1993) 'Critically Queer.' In J. Butler *Bodies that Matter: On the Discursive Limits of 'Sex'.* London and New York: Routledge.

Cristofovici, A. (1999) 'Touching surfaces.' In K. Woodward (ed) *Figuring Age.* Indiana: Indiana University Press.

Fashion marketer quoted in Gullette, M.M. (1999) 'The other end of the fashion cycle: practicing loss, learning decline.' In K. Woodward (ed) *Figuring Age.* Indiana: Indiana University Press.

Freud, S. (1900) *The Interpretation Of Dreams, S.E. 4–5.* London: Hogarth Press.

Freud, S. (1913) *The Disposition to Obsessional Neurosis, S.E. 12* pp.323–4. London: Hogarth Press.

Gear, R. (2000) 'The old hags are laughing: A response to Outrageous Agers.' *Make* No. 87, March–May.

Goodridge, K. (2001) 'Mouthpiece.' Text from performance in 'Outragous Agers' Exhibition at Focal Point Gallery, Southend.

Grosz, E. (1994) *Volatile Bodies.* Indiana: Indiana University Press.

Gullette, M.M. (1999) 'The other end of the fashion cycle: Practicing loss, learning decline.' In K. Woodward (ed) *Figuring Age.* Indiana: Indiana University Press.

Irigaray, L. (1985) *The Sex Which is Not One.* Trans C. Porter. Cornell: Cornell University Press.

Knight, S. (2001) 'Time will Tell.' Video performance conceived and filmed by Rosy Martin and Kay Goodridge in 'Outrageous Agers' Exhibition at Focal Point, Gallery, Southend.

Macdonald, B. (1987) 'By and for old lesbians.' Speech at conference California State University quoted in Cooper, B (1988) *Over the Hill: Reflections on Ageism Between Women.* Freedom, CA: The Crossing Press. p.93.

Martin, R. (2001a) 'The performative body: Phototherapy and re-enactment.' *Afterimage 29,* 3 November/December.

Martin, R. (2001b) 'A Donkey's Tale.' Text from performance in 'Outrageous Agers.' Exhibition at Focal Point Gallery, Southend.

Martin, R. (1997) 'Looking and reflecting: Returning the gaze, re-enacting memories and imagining the future through phototherapy.' In S. Hogan (ed) *Feminist Approaches to Art Therapy.* London and New York: Routledge.

Martin, R. (1996) 'You (never) can tell: Phototherapy, memory and subjectivity.' *Blackflash 14,* 3, 4–8.

Martin, R. (1993) 'Home Truths? Phototherapy, memory and identity.' In *Artpaper.* March 1999.

Martin, R. (1991a) 'Dirty linen.' *Ten8,* 2, No.1.

Martin, R. (1991b) 'Unwind the ties that bind.' In J. Spence and P. Holland (eds) *Family Snaps: The meanings of domestic photography.* London: Virago.

Martin, R. (1991c) 'Don't say cheese, say lesbian.' In T. Boffin and J. Fraser (eds) *Stolen Glances.* London: Pandora.

Martin, R. and Spence, J. (1988) 'Phototherapy – psychic realism as a healing art?' *Ten8,* No.30.

Martin, R. and Spence, J. (1985) 'New portraits for old: The use of the camera in therapy.' *Feminist Review, 19,* March.

Meese, E. (1992) *(Sem)Erotics:Theorizing Lesbian Writing.* New York University Press, quoted in M. Meskimmon (2002) *Women Making Art: History, Subjectivity, Aesthetics.* London and New York: Routledge.

Meskimmon, M. (2003) *Woman Making Art: History, Subjectivity, Aesthetics.* London and New York: Routledge.

Nead, L. (1992) *The Female Nude: Art, Obscenity and Sexuality.* London and New York: Routledge.

Plath, S. (1961) 'Mirror.' In *Collected Poems.* London: Faber and Faber.

Reuben, D. (1969) *Everything You Always Wanted to Know About Sex but Were Afraid to Ask.* New York: McKay.

Salomon, N. (1996) 'Uncovering art history's "hidden agendas and pernicious pedigrees".' In G. Pollock (ed) *Generations and Geographies in the Visual Arts.* London and New York: Routledge.

Walker, B. (1983) *The Women's Encyclopedia of Myths and Secrets*. San Fransisco: Harper & Row. Quoted in B. Cooper (1988) *Over the Hill: Reflections of on Agism Between Women*. Freedom, CA: The Crossing Press, p.62.

Winnicot D.W. (1971) *Playing and Reality*. London: Tavistock.

The Contributors

Donna Addison is a licensed clinical professional and registered art therapist (ATR). She is currently working at a community mental health agency which serves the chronically mentally ill. She also serves as the HIV Prevention Project Co-ordinator providing gay, lesbian, bisexual and transgendered youth with a variety of therapeutic and educational opportunities. She was the recipient of the David McKay Award in 1994. Donna is an active member of Diversity of Rockford, and was co-founder of the Lesbian/Bisexual Counsellors Networking Group. Donna resides in Loves Park, Illinois, USA.

Hilary Bichovsky is not an art therapist. She has worked as a journalist and has written for *Marxism Today*, *The Guardian*, *The New Statesman*, *The Pink Paper* and other journals. Her chapter was written during her part-time art therapy training at the University of Sheffield, a training she didn't comlete. She currently works part-time as an Editorial Assistant for *Red Pepper* magazine and runs 'Introduction to Art Therapy' classes for Manchester Adult Education as well as studying to teach yoga.

Nancy Viva Davis Halifax is an artist and an art psychotherapist. She is a faculty member in the graduate art therapy programme at Vermont College of Norwich University.

Jean Fraser's early work focused on issues of domestic violence. Then, after completing a degree in Film and Photographic Art in 1984, she exhibited and curated as a freelance photographic artist, supporting campaigns opposing homophobia. In 1991 she co-edited (with Tessa Boffin deceased) *Stolen Glances: Lesbians Take Photographs*. During her art therapy training, Jean also worked in a medium secure unit facilitating a photography group. She currently works as an art therapist in adult mental health and has a particular interest in the effects of childhood trauma.

Susan Hogan is a registered art therapist and a cultural historian (PhD in Cultural History from the University of Aberdeen). Susan also has a background in art history: attending the University of Sydney, Power Department of Art History, where she conducted research on European and Australian Expressionism, during 1991 and 1992, whilst teaching twentieth-century European art history and theory at the University of New South Wales, and the National Art School, Sydney.

In Australia Susan also taught art therapy at Macquarie University. As a consultant, she assisted in establishing the MA Art Therapy at Edith Cowan University, Perth. Susan served as Vice-President of the Australian National Art Therapy Association (ANATA) and as Chairperson of the Professional Standards of Practice and Code of Ethics Committee. On her return to Britain Susan collaborated in the development of the Scottish art therapy training programme (now housed at Queen Margaret's University College) and served as Course Organiser (1992 to 1995).

Susan is currently University Reader in Cultural Studies and Art Therapy at the University of Derby. She is also a member of the Centre for Social Research (School of Education, Human Sciences and Law). Her publications include *Healing Arts: The History of Art Therapy* (2001, Jessica Kingsley Publishers) and, as editor, *Feminist Approaches to Art Therapy* (1997, Routledge).

Maggie Jones was born in England in 1955 and trained first as a teacher of art and then completed the post-graduate Diploma in Art Therapy at The University of Sheffield. She is a registered art therapist (CPSM) and a professional member of BAAT. She has worked in the area of adult mental health and in education with disaffected young people in England and New Zealand. Maggie is author of 'Alice, Dora and Constance From The Eve of History', a chapter in *Feminist Approaches To Art Therapy* (Hogan 1997).

Marian Liebmann has worked as a teacher, community worker, probation officer and art therapist. She is currently working as an art therapist with an inner city mental health team. She is author of *Art Therapy for Groups* (1986, Croom Helm); editor of *Art Therapy in Practice* (1990, Jessica Kingsley Publishers); *Art Therapy with Offenders* (1994, Jessica Kingsley Publishers); editor of *Arts Approaches to Conflict* (1996, Jessica Kingsley Publishers); *Community and Neighbour Mediation* (1998, Cavendish) and *Mediation in Context* (2000, Jessica Kingsley Publishers) and has contributed many chapters to other books. She also jointly edited *Art Therapy Race and Culture* (1999, Jessica Kingsley Publishers) with Jean Campbell *et al.*

Marian teaches art therapy at Bristol University in the Counselling Department and has been a visiting lecturer on the Bath and Sheffield Diploma

in Art Therapy courses. She also undertakes freelance work in meditation training and has developed courses using art therapy approaches to explore conflict.

José Batista Loureiro De Oliveira is a Brazilian independent researcher, photographer, teacher of Latin American Studies and writer living in between Bologna, London and Rio de Janeiro. His education includes a BA Honours in Psychology degree from UNISINOS University, Brazil and postgraduate studies at the Universities of Bologna and Padova, Italy. He has conducted research on the prevention of AIDS for the State Health authority of Porto Alegre/RS, Brazil. In 1994 José worked using Art therapy with psychotic male clients in Lugano and was also a research fellow at the University of Geneva working on cognitive psychology at the Jean Piaget Archives. He is currently editing a book on gender, race and class in Brazil.

Rosy Martin is an artist/photographer, lecturer, writer and therapist. Starting in 1983, together with the late Jo Spence she evolved and developed a new photographic practice – phototherapy – based on re-enactment. In her work she examines the overlaps between photography, memory, identity and unconscious processes using phototherapy, self-portraiture, still-life, video and digital imaging. She works both as an artist and as a phototherapist with clients. Themes explored in exhibitions and articles since 1985 include: gender, sexuality, ageing, desire, memory, location, class, shame, family dynamics, power/powerlessness, health and disease, bereavement, grief and loss. She has lectured and run workshops in universities and galleries throughout Britain, USA, Canada, Eire and Finland. She has also run workshops in community settings including a women's prison, projects with survivors of sexual abuse and schools-based projects on digital identities. She currently lectures on art and visual culture at Loughborough University and has a private practice as a therapist.

Nancy Slater, PhD, ATR, AATR, is Visiting Lecturer in art therapy at Ben-Gurion University, Beer Sheva, Israel. Previously she was Senior Lecturer and Programme Co-ordinator of the Master of Art Therapy programme at La Trobe University, Melbourne, Australia. In the USA she was Assistant Professor in Graduate Counselling Psychology and Art Therapy Instructor at Antioch University, Seattle, Washington. Dr Slater has more than twenty years' experience as an art therapist and psychotherapist with a clinical focus on domestic and sexual violence and substance abuse treatment. Since working internationally, she has provided training and consultation in art therapy programme development and teaching within cultural and global perspectives.

Savneet Talwar MA, ATR-BC, is Assistant Professor and Clinical Director of the Art Therapy Counselling Clinic at Southern Illinois University, Edwardsville, USA. She received her Bachelor of Arts from Punjab University, Chandigarh, India in 1986 and Master's degree in Art Therapy at Southern Illinois University, Edwardsville (SIVVE) in 1991. She further trained at the St Louis Psychoanalytic Institute in the Child Development Programme in 1992. In the last nine years Savneet has worked with at-risk children, adolescents, women and families. In addition, she designed and implemented a 'Preventative Clinical Art Therapy Programme' in collaboration with SIUE for the Head Start Programme in Madison County, Illinois. Her current research interest is in the integration of psychoneuroimmunology and art therapy and is also involved in working with individuals with life-threatening and chronic illnesses, exploring the ephemeral nature of 'image-making' and the process of healing.

Judith Waldman received her BA in Psychology in New York, and her Master's degree in Sociology in Frankfurt, Germany, at the School of Social Research. Her Jewish background has provided her with a personal appreciation of racial politics. Judith has worked as a translator, a television interviewer and a decorative artist. She qualified as an art therapist at Goldsmiths College, where she completed her Master's degree in Art Psychotherapy, focusing on the use of clay in facilitating the expression of repressed traumatic experiences. Judith has been working full-time with female survivors of childhood sexual abuse in adult mental health settings within the National Health Service for the past ten years.

Diane Waller is Professor of Art Therapy at Goldsmiths College, University of London. She has a background in Fine Art, Ethnography and the Sociology of Professions, first becoming involved in art therapy while at the Royal College of Art. After a year of research on a Leverhulme European scholarship in the Balkans, Diane started the art therapy programme at Goldsmiths College and was active in the move towards establishing art therapy as a profession in the UK – the topic of her DPhil thesis at the University of Sussex. She has also been involved in the development of art therapy within Europe, including in Bulgaria, Hungary and the former Jugoslavia and more recently in Italy, Switzerland and Germany. Diane is also a group analytic psychotherapist and has introduced programmes in both group and intercultural therapy to Goldsmiths College. Currently, she is the arts therapist registrant member of the new Health Professions Council, and was elected Chair of HPC's Education and Training Commitee. She has written several books on both sociological and clinical aspects of art and group psychotherapy and numerous chapters and papers.

Subject Index

abuse, sexual
 of men 114, 116–18, 176
 Mouthpiece (silencing), phototherapy
 workshop 221–22
 reparation process 102–3
 of women 26, 87, 177–78
acceptance, message of 67, 84
adolescent unit, experience of placement in
 47–52
ageing woman
 body
 performative 207–9
 poses, meaning of 212–14
 as site of inscriptions 205–7
 and text, exploring relationship
 between 211–15
 cultural construction of
 cosmetics, and fear of ageing process
 199–200
 crone, archetype of 201
 death, fear of 201–2
 fashion, and 'life cycle' of clothes
 200–201
 life expectancy 198
 sexual degeneration 198
 fears and prejudices, uncovering 202
 mimesis, to play with 203–4
 outrageous images, creating 202–5
 'grotesque realism' 209
 pregnant hag image 209–10
 striptease act, subverting 210–11
 self-identity, shifting 195–96
 stereotypes, challenging 199, 203,
 207–9
 turning fifty, author's thoughts on
 196–98
 see also phototherapy workshops
AIDS 65, 78
alienation, sense of 97–98
ambiguity, potential for in art therapy
 98–100
American Art Therapy Association (AATA)
 56, 58
American Journal of Art Therapy 31n1
American Psychological Association (APA)
 57
androgyny 57, 58
 see also bisexuality
anger management group 122–23
animus/anima (Jung) 111
art

connective aesthetic for 38, 40
 importance of attending to 31–32
 and modernity paradigm 37–38
 theory of 36–37
Art Therapy, Race and Culture (Campbell *et al.*)
 13
attachment theory, critique of 157–58
aversion therapy 82

Babyshock (Cobb) 150
binarism 82–83
biological determinism, versus social
 construction of gender 14, 127–29,
 134, 135, 145
bisexuality 73–76
 'polymorphous perversity' (Freud) 80,
 140
 unconscious 86
body
 ageing women's 26
 complexity of discourses surrounding
 18–19
 dominant representations of 155
 experience of as culturally mediated
 155
 as ideological battleground 19
 misogyny, internalisation of 22
 performative 207–9
 and text, exploring relationship
 between 211–15
 'ugly' bits as bodyscapes 205–6
 as unstable 206–7
body hair, taboo against female 46–47, 50
'body without organs' (BwO) 19
borderline personality disorder 99, 104–5
boundaries
 and control 100–101
 exceeding paper 101–2
 GBLT clients, social encounters with
 24
 and 'peninsula' of homosexuality
 24–25
 self, suspension of 101
 therapist's presentation, ambiguity of
 102–3

Catholicism 128, 130, 140, 142–43
colonialism 128, 131–32, 186
 see also decolonisation
coming out
 Pat, case study 73–75
 public and private self, journeying
 between 95–96
'conversion' therapy 54, 58
countertransference, homoerotic 24, 69,
 85–89

232

Author Index

Addison, D. 24, 53–67, 63, 64, 84, 228
Anderson, F.E. 173, 174
Anzaldua, G. 187
Arnot, C. 209
Auden, W.H. 104

Bakhtin, M. 209, 211
Bartky, S. 16
Bass, E. 57
Bayes, M. 12
Beer, G. 104
Bell, D. 96–97, 98
Berzon, B. 57, 65
Bhabha, H. 186
Bichovsky, H. 21, 46–52, 228
Biddulph, S. 110
Blaffer Hrdy, S. 157–58
Bohm, D. 34
Bowlby, J. 157
Bowlby, R. 103, 104
Brah, A. 19
Breckenridge, J. 173, 175
Breen, D. 151
Bridget, J. 78
Briere, J. 123, 174
Brill, S. 36, 39
Brody, B. 65
Brooke, S.L. 173, 174
Broverman, I.K. 34
Brown, J. 173
Burt, H. 189
Butler, J. 15, 20–21, 134, 207, 211, 212

Cabaj, R.P. 143
Calisch, A. 176
Calisch, A.C. 13
Cameron, L. 22, 23
Campbell, J. 13, 71, 176, 188
Castonguay, L.G. 189
Cattaneo, M. 190
Chebaro, M. 175, 179–80
Chew, J. 174
Clare, A. 111
Clark, A.H. 173, 177
Cobb, J. 150–51
Cohen, S. 160
Comas-Diaz, L. 185, 186, 188, 189
Connell, R.W. 128, 131, 133, 134, 136
Cooper, E. 89
Cornwall, A. 14
Cosslett, T. 151

Courtois, C.A. 173, 174, 175
Cristofovici, A. 207

D'Augelli, A.R. 78
Davies, D. 19
Davis Halifax, N.V. 21, 31–44, 228
Davis, J.L. 173, 175
Davis, T. 95
Deleuze, G. 19
Dench, G. 158
Derrida, J. 72
Deutscher, P. 15, 20
Dreyfus, E. 152
Dudley, J. 71
Dworkin, A. 14–15, 16, 18
Dylan, B. 197

Eliot, G. 92
Elliston, S. 153, 154
Espin, O.M. 140, 143, 186, 187, 188
Etherington, K. 109, 116

Fabre-Lewin, M. 191
Falco, K. 55
Fanon, F. 186
Figes, K. 150, 151
Forrest, D. 17
Foucault, M. 13, 17, 25, 72–73, 95, 127, 142
Fox, N. 14, 19
Foy, D.W. 173
Frame, J. 106
Franklin, M. 190
Fraser, J. 24, 69–89, 228
Freire, P. 186, 189, 190
Freud, S. 79–80, 139–40, 198, 211, 212, 213

Gablik, S. 37, 38, 40
Gaga, D.A. 188
Gair, S.R. 85
Gantt, L. 174, 175
Gawalek, M.A. 186, 187, 188
Gear, R. 206, 210, 212
Gil, E. 174
Gilmore, D.D. 135, 142–43
Glancey, J. 98
Goldfried, M.R. 189
Golding, J. 76, 87
Gonzalez, F.J. 140, 143
Goodridge, K. 194, 195, 202, 204, 206, 208, 210, 213, 214, 215, 219, 221–22
Gould, D. 88
Greer, G. 156
Grosz, E. 205, 211, 212

Printed in the United States
122075LV00001B/286-294/A